AFRO
SURF

TEN SPEED PRESS
California | New York

MAMI WATA

In the spirit of normalizing the terms in Afrosurf, we have chosen not to capitalize descriptions of race or skin color, such as black, brown, or white.

THE TERM "COLOURED" IS WIDELY USED IN SOUTH AFRICA TODAY, DESCRIBING PEOPLE OF MIXED AFRICAN, EUROPEAN, OR ASIAN ANCESTRY. IT IS NOT CONSIDERED DEROGATORY.

Ten Speed Press and the Ten Speed Press colophon are registered trademarks of Penguin Random House LLC.

Originally published in trade paperback in South Africa in 2020 by Mami Wata.

All photographic copyrights are held by the photographers as indicated in captions. All rights reserved. No part of this book may be used or reproduced in any manner whatsoever without written permission from the publisher and copyright holders. Requests should be emailed to afrosurf@mamiwatasurf.com. Cover photograph by Lupi Spuma

Library of Congress Cataloging-in-Publication Data is on file with the publisher.

Hardcover ISBN: 978-1-9848-6040-8
eBook ISBN: 978-1-9848-6041-5

Printed in Italy

Editor: Sarah Malarkey | Production editor: Ashley Pierce
Designer: Peet Pienaar | Art director: Peet Pienaar
DTP for Mami Wata: Christopher Bisset
Production designers: Emma Campion, Mari Gill, and Faith Hague
Production manager: Serena Sigona
Copyeditor: Andy Davis | Proofreader: Carolyn Keating
Publicist: Natalie Yera | Marketer: Windy Dorresteyn

10 9 8 7 6 5 4 3 2

First U.S. Edition

Mami Wata is an African surf brand based in Cape Town, South Africa. Our mission is to share the power of African surf with the world. The production and creation of AFROSURF was enabled by funds raised through Kickstarter and the support of photographers, writers, and thinkers from Africa and beyond.

All the profits from this book are going to two African surf therapy organizations:

Waves for Change is an award-winning NGO that uses surfing to create community-owned safe spaces through inclusive, evidence-based surf therapy in Africa and beyond.

Surfers Not Street Children is a world-renowned organization based in Durban, South Africa; Tofo, Mozambique; and Devon, UK. It empowers ex-street children and at-risk children through surfing and mentorship.

"*You can't fight the sea, man, you just go with it.*

My arms are too short to box with God, it's too great a force."

Sidiq Banda

Contents

Much of the last sixty years has told us that you need to emulate being from Southern California, or the south coast of Australia, to fit the description of being a surfer.

African surf culture will redefine the manner in which people perceive the activity known as surfing and the lifestyle that comes with it.

Africa is a continent with more accessible coastline than any other place on the planet, inhabited by people with rich indigenous cultures that carry traditions that have been passed down for thousands of years and new influences received on wifi just minutes ago.

It's unique and you can feel it.
And it's going to change everything.

Selema Masekela

and the Mami Wata team

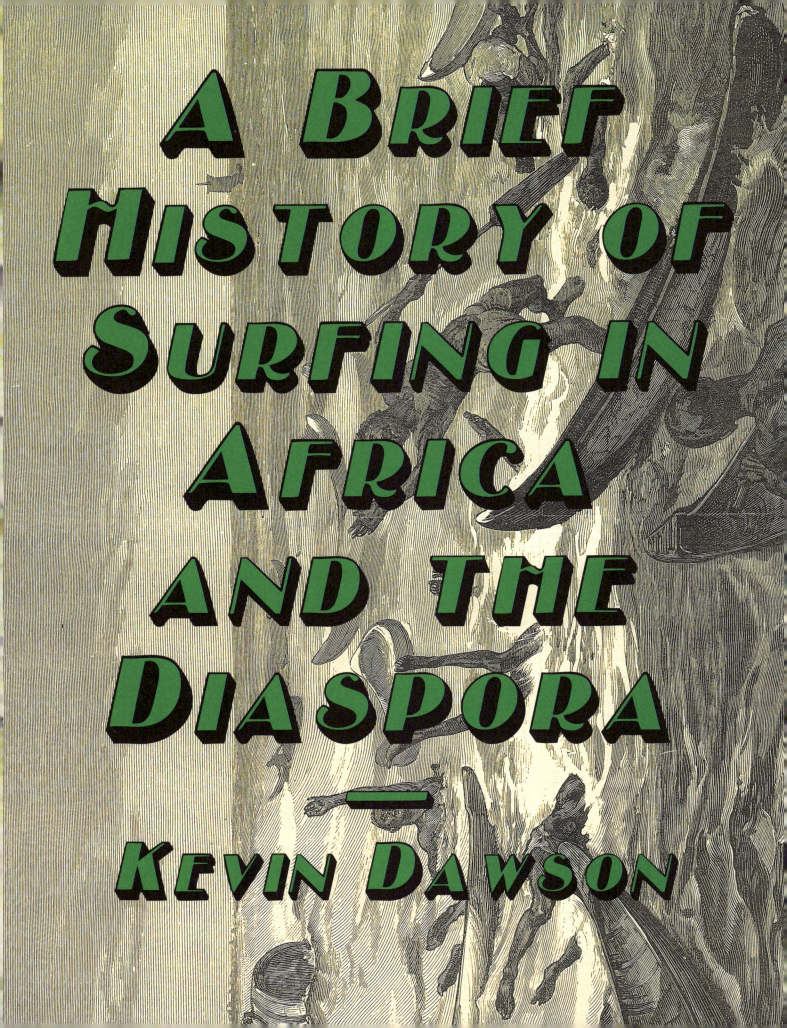

A Brief History of Surfing in Africa and the Diaspora

Kevin Dawson

POPULAR

histories of surfing tell us that Polynesians were the only people to develop surfing, that the first account of surfing was written in Hawaii in 1778, and that Bruce Brown, Robert August, and Mike Hynson introduced surfing to West Africa. All these claims are incorrect.

The modern surf cultures currently developing along Africa's long shoreline are not something new and introduced; they are a rebirth — the remembering and reimagining of 1,000-year-old traditions.

The first known account of surfing was written in 1640, in what is now Ghana. Surfing developed independently from Senegal to Angola. Africa possesses thousands of miles of warm surf-filled waters, and populations of strong swimmers and seagoing fishermen and merchants who knew surf patterns and crewed surf-canoes capable of catching and riding waves upward of ten feet high.

Africans surfed on three- to five-foot-long wooden surfboards in prone, sitting, kneeling, or standing positions, and in small one-person canoes. Despite Brown's claim that The Endless Summer (1965/1966) introduced surfing to Ghana, if viewers shift their eyes away from August and Hynson they will see the Ga youth of Labadi Village, near Accra, Ghana, riding traditional surfboards, which can still be found at some beaches. The ability of Ga men, in the film, to stand on the Americans' longboards illustrates their surfing tradition.

Africans also rode longboards, about twelve feet in length, and used them to paddle several miles. English anthropologist Robert Rattray provided the best description and photographs of paddleboards on Lake Bosumtwi, located about one hundred miles inland of Cape Coast, Ghana. The Asante believe the anthropomorphic lake god Twi prohibited canoes on the lake. Keeping with divine sanction, people fished from paddleboards, called "padua" or "mpadua" (plural), and used them to traverse this five-mile-wide crater lake.

German merchant-adventurer Michael Hemmersam provided the first known record of surfing, which is problematic, as he described a sport that was new to him. Believing he was watching Gold Coast children — who were probably Fante, in the Cape Coast, Ghana, area — learn to swim, he wrote that parents "tie their children to boards and throw them into the water." Other Europeans provided similar descriptions. However, most Africans learned to swim when they were about sixteen months old, and with more positive reinforcement; such lessons would have resulted in many drowned children.

Later accounts are unambiguous. For instance, in 1834, while at Accra, Ghana, James Alexander wrote; "From the beach, meanwhile, might be seen boys swimming into the sea, with light boards under their stomachs. They waited for a surf; and came rolling like a cloud on top of it."

There are also accounts of Africans bodysurfing. In 1887, an English traveler watched an African man named Sua, at home "in his element, dancing up and down and doing fancy performances with the rollers, as if he had lived since his infancy as much in the water as on dry land." As a wave approached, "he turns his face to the shore, and rising onto the top of it he strikes out vigorously with it towards land, and is carried dashing in at a tremendous speed after the same manner, as the [surf-canoes] beach themselves."

Fishermen often surfed their six-foot-long paddleboards and surf-canoes that weighed about fifteen pounds. Accounts describe both from the Cape Verde Islands, Ivory Coast, Congo-Angola, and Cameroon, with the "Kru" canoes of Liberia particularly heavily documented. In 1861, Thomas Hutchinson observed Batanga fishermen from southern Cameroon riding surf-canoes "no more than six feet in length, fourteen to sixteen inches in width, and from four to six inches in depth" and weighing about fifteen pounds. Describing how work turned to play, Hutchinson wrote:

During my few days' stay at Batanga, I observed that from the more serious and industrial occupation of fishing they would turn to racing on the tops of the surging billows which broke on the sea shore; at one spot more particularly, which, owing to the presence of an extensive reef, seemed to be the very place for a continuous swell of several hundred yards in length. Four or six of them go out steadily, dodging the rollers as they come on, and mounting atop of them with the nimbleness and security of ducks. Reaching the outermost roller, they turn the canoes' stems shoreward with a single stroke of the paddle, and mounted on the top of the wave, they are borne towards the shore, steering with the paddle alone. By a peculiar action of this, which tends to elevate the stern of the canoe so that it will receive the full impulsive force of the advancing billow, on they come, carried along with all its impetuous rapidity. ▶

THE FIRST KNOWN ACCOUNT OF SURFING WAS WRITTEN IN 1640, IN WHAT IS NOW GHANA

Surfing was a means for opening up economic opportunities. It allowed Africans to critically understand surf-zones so they could uniquely traverse them in surf-canoes, linking coastal communities to offshore fisheries and coastal shipping lanes. Atlantic Africa possesses few natural harbors, and waves break along much of its coastline. The only way many coast people could access the ocean's resources was by designing surf-canoes that sliced through waves when launching from beaches. The surf canoes were also fast, agile, and maneuverable, allowing them to surf waves ashore.

Surfing was the intergenerational transmission of wisdom that transformed surf-zones into social and cultural places, where the youth holistically experienced the ocean. Suspending their bodies in the drink and positioning themselves in the curl, they learned about surf-zones by seeing and feeling how the ocean pushed and pulled their bodies. The youth learned about wavelengths (the distance between waves), the physics of breakers, and that waves form in sets, with several-minute intervals between sets.

Importantly, surfing taught these youth that to catch waves, one needed to match their speed; something Westerners did not comprehend until the late nineteenth century. Documenting how surf-canoemen utilized childhood lessons, an Englishman noted that they "count the Seas [waves], and know when to paddle safely on or off," often waiting to surf the last and largest set wave.

In an age with few energy sources—when societies harnessed wind, animal, and perhaps river power—Atlantic Africans used waves to slingshot surf-canoes laden with fish or tons of cargo ashore, being the only people to bridle the energy of waves as part of their daily productive labor. Surf-canoemen floated colonial economies, transporting virtually all the goods exported out of and imported into Africa between ship and shore from the 1400s into the 1950s, when modern ports were constructed.

During the 1400s, surf-canoemen introduced Europeans to the pleasures of surfing, since at the time, few Europeans could swim well enough to surf. In 1853, Horatio Bridge provided an exaggerated account of surf-canoeing at Cape Coast, he wrote, "The landing is effected in large canoes, which convey passengers close to the rocks, safely and without being drenched, although the surf dashes fifty feet in height. There is a peculiar enjoyment in being raised, by an irresistible power beneath you, upon the tops of high rollers, and then dropped into the hollow of the waves, as if to visit the bottom of the ocean." Some surf-canoemen attached a chair to the front of their canoes, where especially intrepid white passengers could sit.

Surf-canoemen knew Europeans feared drowning and being devoured by sharks the instant they fell into African waters. Using this knowledge, they inflated the tips received from passengers by engaging in nautical games of chicken, as Paul Isert observed on October 16, 1783, at Christianburg Castle, Accra:

In vain have Europeans tried to breast the breakers and to land in their own small pointed boats. These have almost always capsized . . . The blacks now started to prepare themselves to breast the breakers. The captain of the canoe made a short address to the sea, after which he sprinkled a few drops of brandy as an offering. At the same time he struck both sides of the canoe several times with his clenched fist. He warned us Europeans to hold fast.

The whole performance was carried out with such gravity that we felt almost as if we were preparing for death. An additional cause for alarm is that, having started to go through the breakers, they must often paddle back again because they had not timed it to the right moment. They are said to do this often deliberately in order to torment the whites in the breakers for a long time, so that in acknowledgment of their great struggle they would be given a larger bottle of brandy. In a few minutes, however, we were safely across and our boat was on the sand.

As surfers must realize, these Ga surf-canoemen prolonged Europeans' time in surf-zones by pretending their timing was off, as "it is customary" on such occasions for "each passenger" to "make a handsome present" to the surf-canoemen.

* * *

Surf-canoes were sacred objects, carved—with iron tools—from sacred silk cottonwood trees, and the ocean is a spiritual place. Tall and majestic, cottonwoods connected the heavens and earth, and some societies believed the souls of children waiting to be born resided within them.

Surf-canoes had a gender that determined how they surfed waves, while the cottonwood's soul continued to dwell in the surf-canoe, communicating with water spirits. The ancestral realm lay at the bottom of the ocean, whose waters were populated with spirits and deities. Fishermen and maritime merchants made sacrifices to surf-canoes and aquatic deities who rewarded them with safe passages and prosperous voyages.

AFRICA

People from Senegal to South Africa and as far inland as the Dogon of Mali and Burkina Faso believed in deities who resemble mermaids, with Mami Wata, meaning "Mother Water," being the most celebrated of these finned divinities. She is a benevolent protective spirit with great powers, including the ability to move between the present and the future. She protects followers from drowning and pulls individuals—who are swimming, canoeing, and conceivably surfing—down into the spirit realm to reveal its mysteries to them, returning them to the surface with enhanced spiritual understanding, good health, and success, while also making them more attractive. Waters possessing distinguishing characteristics, such as surf-zones, whirlpools, and waterfalls, are the favorite abode of water spirits, including Mami Wata, with the sound of moving water echoing the spirits' voices.

Like surfboard shapers, canoe makers designed surf-canoes to better surf particular types of waves. There were hundreds of surf-canoe variations, with each distinct enough to warrant its own name. Design nuances were informed by local conditions, such as the steepness of the beach and the size, shape, and power of the waves. The Ga fishermen of Labadi used three types of surf-canoes along a couple miles of beachfront: the "Ali lele," the "Fa lele," and the "Tfani lele."

The Fante developed and disseminated the three-pronged surf-canoe paddle, which resembled a spork. When paddled quickly, its three slightly spread fingers increased the blade's surface area, as little water passed between them. The design also reduced resistance if the blade hit a wave during the forward stroke. The Fante traveled widely, ranging as far north as Liberia and down to Angola, spreading their surfing prowess and maritime designs. Indeed, the Ga adopted the Fante paddle during the 1700s, causing Bruce Brown, in The Endless Summer, to joke problematically about cannibalism, saying that when surf-canoemen come *"paddling toward you, you think they're coming out with their forks to have you for dinner."*

To the north, there were distinctive-looking Senegambian pirogues, with their protruding bow and aft sprits. These surf-canoes were apparently developed by Niuminka or Niumi mariners living on the Djomboss Islands north of the Gambia River, with Lebu (also Lébou) from the Cape Verde Peninsula and members of other ethnic groups making important contributions. Pirogues surfed waves well and were particularly designed to ride the larger, steeper, hollow waves that broke along the Senegambia's western-facing beaches.

The currents of the African diaspora forcibly transplanted enslaved Africans and their cultures to the Americas. There, Mami Wata and other deities found new waters to roam, and the captives re-created their aquatic traditions. Accounts indicate that by the 1700s, enslaved Africans were surfing and surf-canoeing from South Carolina down to Brazil. ∎

Kevin Dawson is an associate professor of history at the University of California, Merced. See Kevin Dawson, Undercurrents of Power: Aquatic Culture in the African Diaspora (Philadelphia: University of Pennsylvania Press, 2018); Kevin Dawson, "Surfing Beyond Racial and Colonial Imperatives in Early Modern Atlantic Africa and Oceania," in The Critical Surf Studies Reader, ed. Alexander Sotelo Eastman and Dexter Zavalza Hough-Snee (Durham, NC: Duke University Press, 2017), 135–152.

THE
LONGING
NOBODY
FROM
BULAWAYO
SURFS.

KUNYALALA NDLOVU

Indeed, it is an impossible task. But before I get ahead of myself: you have probably never heard of Bulawayo, so I should state its genesis. This hidden diamond tucked away in the southwest of Zimbabwe was founded in the early nineteenth century by Mzilikazi, the chief of the Ndebele. After a conflict with the great Shaka Zulu, the Ndebele nation turned their back on the ocean and fled over 1,200 miles (2,000 km) into the interior, settling in a landlocked capital they named Bulawayo. History chose this nation to be my ancestors, for reasons I came to appreciate only later in life.

Here I am, age 12, surrounded by suburbs or bush, with no ocean in sight. My father stands before me holding the gift that'll change my life forever . . . a Billabong T-shirt. On the back is a photo of a surfer tucked away neatly into a barrel at the Billabong Pro Kirra in 1996, accompanied by the words "Only a surfer knows the feeling." I cannot describe the precise nature of the feeling I had, but I can say that it was on that day that this black kid from the suburbs of Bulawayo decided that he would rebel and become a surfer.

But where to begin . . . ?

It started in Botswana. In the mid-'90s to early 2000s, this desert jewel became a gateway to South African popular culture, without the need for a visa that the latter required. My mother worked in Francistown for a number of years, so fortnightly trips, accompanied by the sounds of Hugh Masekela, were common. CNA, the Central News Agency bookstore, was a mecca for all the magazines we couldn't get in Bulawayo. At age 13, I'd discovered street skating, and was pleasantly surprised to find two magazines from South Africa about surfing and skate culture—Zigzag and Blunt. I'd found the next stage toward becoming a surfer—culture on a printed page.

A year later, I started watching Tony Hawk's Gigantic Skatepark Tour on ESPN. I had the T-shirt. I had the magazines. I had the skateboard. I'd read about the culture. But I hadn't witnessed it. Beautifully shot travel essays revealed to me how globally relevant the culture was. For a kid trapped in the suburbs, this was pure escape. One of the hosts was also black. In almost all the board sports I'd witnessed up until that point, this had always been a white man's domain—especially surfing. But watch me squinting into the screen in disbelief, for not only is this presenter black but his name sounded Southern African: Selema Masekela, son of Hugh Masekela, whose music my father played when we traveled to Botswana. ▶

ZIMBABWE

photo by Delali Ayivi, set by Bubby Nurse

photos by Kunyalala Ndlovu

If the culture was the fuel, Selema was the match that lit the bonfire. Though my room was covered in surf and skate posters, outside of the visions of American skateboarding, it was a struggle to recognize anyone in these pictures who looked like me. I tried to ignore this great emptiness by doubling down on how much the "freedom" that the culture stood for meant to me. But the day I saw Selema, that shattered every myth—because if he could exist in there, so could I.

Fast forward a few years, and I find myself in southeast London. I still buy magazines, I'm still watching films, I've even begun to paint imagined scenarios of the ocean; anything that might keep my dream alive. My overt enthusiasm is embarrassing at times. I'm like the man at once too poor to travel and too black to surf, who sits at the airport dreaming, because dreams cost nothing.

Like that good second wave in a set, a friend lends me her dad's old foam beater for an afternoon. I hustle around for a wetsuit, and within a day I find myself in the murky waters of Muizenberg. Another kind soul gives me my first free lesson. Observe from the backline as I attempt (poorly) to realize a ten-year-old dream, without the strength to paddle. Slightly knocked and with a dismal session in hand, I wake up on the flight back to London, without a wave caught and with a dream deferred.

Sometimes you pick off a wave in the spot you least expect. A chance encounter in Cape Town introduced me to Mike. What started as a conversation about hip-hop developed into a long friendship that revolved around life, art, and, curiously, surfing. In 2012, Mike invited me to work at the company he had just started. I just needed the visa. Always the visa. I promised myself that if I could get it, I'd commit to getting strong and fully immerse myself in surfing.

And so it was that in December of 2013, I began to work with the skateboarders, surfers, and artists I'd only ever read about as a kid in Bulawayo. I did life with surfers, and learned to read the water patiently: channels, rips, winds, currents, swell. I got into the water as often as I could. I had different surf crews, went on road trips, surfed every season. I hurt myself, laughed, cried, faced racism in the water, felt love and frustration, and, in a beautifully silent reveal, I also began to see other young surfers of color, and not just black. They had always been there; they just weren't seen that often.

One particularly gray winter morning at the Shipwreck in Big Bay, at the age of 26 and after fifteen years of dreaming, the heavens opened up and a little black kid from Bulawayo caught his first green wave, a run along the breaking face, and finally became that thing he'd always dreamed of—the one who knew the feeling: a surfer.

As I write this, I'm back in London, with a little family in tow. I still dream of surfing every day. Do I rip? Not at all. Do I have fun? Every damn time.

The journey all surfers take is a fine metaphor for life: desire, acceptance, adaptation, discomfort, and finally a bit of luck—to pick off the right wave, at the right time. Not every wave is worth paddling into. Sometimes the wind is off. Sometimes you're too late. Or too early. Your board, body, or head might not be right. But then there's the golden moment when all the years of thinking and dreaming pull together and suddenly disappear, as you pop up and glide in silence.

I waited almost fifteen years to ride that silent wave in Big Bay. It came at the perfect time. And just like my rebellious ancestors, the wave took me home. ▪

photo by Delali Ayivi, set by Bubby Nurse

MICHAEL FEBRUARY

When I qualified for the WSL (World Surf League) Championship Tour and had to choose a jersey number, I wanted something with real meaning and symbolism behind it. I'm one of those people who loves to have meaning behind everything. I won't just pick something randomly. There must be a story behind it. I thought long and hard—what is significant, what is true to who I am, and what is a good representation of who I want to be on tour?

During that time in my life, exploring Africa and learning all I could about it became really important to me. I mean, you spend your whole life trying to get out and go to places abroad, like Australia and America, where surfing is big. But then, once you've done that, you look back on where you're from and how much home means to you. And for me, that was Africa as a whole.

I had done some traveling, bits and pieces of exploring the continent, but I feel like at that time when I chose that number, I wanted it to be more than just about me. I was trying to figure out something symbolic and representative of the whole of Africa. I mean, when I qualified I had lots of things such as "Africa" written on my boards. I was just starting to realize how incredible and different Africa is. How many amazing waves there are, how amazing the people are . . . and I wanted to share that. I think that was the motivation.

So I checked out how many countries there are in Africa, and chose the number 54. Unfortunately there are a few disputed territories, and some controversial debates on whether there are fifty-six or fifty-four countries in total; but I went with fifty-four. I wanted to represent the whole of Africa. I wanted to stand for something that collectively represented all Africans.

At the time I didn't fully appreciate how much the choice would mean to me and others. A lot of people didn't know what the 54 was at first; but once people heard that it represented all the countries in Africa, they started taking notice, and started asking me about it in interviews. People were stoked. Personally, I think having a number like that is, you know . . . it's quite a big thing. I didn't feel pressure wearing it on my shoulders, but it was quite a big responsibility, putting on a jersey that represents the whole of a continent. Rather than feel pressure to perform, it actually gives you that extra bit of support and fire; because you know what you're representing, and you obviously want to do the very best.

I think I just wanted to share Africa with the rest of the world. Obviously people know about Africa, but I want to share it in a positive way. And also, to give people from Africa something to relate to and be part of, even in a small way, through this global platform that is the World Championship Tour.　▶

WE LIVE MOSTLY IN A "WESTERN WORLD" WHERE WE SO OFTEN ARE TRYING TO BE LIKE EACH OTHER.

I loved being on the World Tour, but I also love being a free surfer and seeing the positive impact I can make on surfing. Having first-hand experience of how amazing Africa is, you just want to share that with the rest of the world.

I love how the expressive nature of Africans translates to our music and surfing. The surfers I've seen are so expressive, and it's often an extension of their expressiveness on land, whether it's through their music or dancing or whatever they create and do. We are very much influenced by where we are from. Maybe this is more so than other places in the world? Maybe it's because there aren't too many outside influences. We kind of do our own thing, and in our own rhythm and mood. Not having that outside influence, you're free to do things in a way that you feel is the best reflection of yourself. African expressionism is very raw, and very honest.

Growing up, I didn't really know what my own style of surfing was, or how to be expressively true to myself. It's funny . . . you grow up wanting to be like others. I obviously looked up to all the same people my friends did, who were all the guys on tour at the time—like Mick Fanning, Kelly Slater, and Rob Machado. For me personally, it was more a thing that my body just didn't allow it, or fit into that form of surfing. I couldn't be as "textbook," or whatever, like the rest of the competitive

surfers. So yeah, I just think it was the realization that because I loved surfing so much, if I couldn't do it one way, I found another way that worked for me. It's just that . . . not being too influenced by others, and having fun with the way it works for you.

As a kid, I would spend every day after school in my dad's design studio just being around all those incredibly creative people. I remember for my first custom surfboard, one of my dad's illustrators did the most amazing graphic. It blew my mind. Growing up, my dad always said to me, "You don't want to be the same as everyone else." And you don't want to try to be different either, but it's perfectly okay; and it's not a bad thing to be different from everyone else. Do what feels right and good, and be true to who you are.

With my parents' support, I was allowed to discover and be who I was. Otherwise I might have tried to continue mimicking the rest of the surfers on tour. It sticks with you, you know; especially when you're young, and it comes from the people you love and who you know love you back. It's these little things, at the time—but they become big things later on—that just stick in your mind and make a world of difference.

I've never been more excited about African surf culture, and Africa in general, than I am now. I feel like Africa has mostly been "hidden" or

overlooked by the rest of the world for a long time, but now people are seeing how much Africa has to offer. I also think that the people from the various surf communities around Africa are starting to realize what gold they are sitting on in their respective regions. The waves, of course, but also the talent. Whether it's amazing surfers or artists and musicians, I feel like this is the time when the rest of the world takes notice. And at the same time, these young surfers who didn't really have much opportunity before, now have the opportunity to grow and do what they want, and be recognized globally.

Obviously there are amazing waves in Africa, and more people going to these places are going to do a lot for those communities. Slowly but surely communities will grow, in a positive way, and create lots of opportunities.

It's interesting; we live mostly in a "western world," where so often we are trying to be like each other—especially in surfing. And we think that modern Western culture is always going to be the main influence. But if anything, I feel like African surf communities are going to be the ones to influence a lot of people around the rest of the world instead. It's a very exciting time. To the rest of the world, Africa seems so small—but it's huge! I'm just super excited to be able to discover more about Africa, and to share Africa with the world. ■

My FATHER

CASS COLLIER

gave me his love of the ocean.

He was a strong swimmer, and saw surfing as the next progression. Even after he moved from Durban to Cape Town, his love of the ocean remained. The beaches are a lot harsher here, but there's more beauty. My dad loved the Cape's beaches and made sure we explored them all.

The Hoek is a very secluded beach, and when I was 10 years old—young—the whole family went down to the beach there. When we arrived, the vibe changed. My dad paddled out and my older brother, Junior, followed my dad out, and I was hanging back, because you have to be at a certain level to surf a wave like that. When the police van drove up the beach, we knew someone had reported us, and we had to leave.

Apartheid's Group Areas Act told people where they could and couldn't go— white only, colored only, black only. And the places we could go as black or brown people were usually horrible. Still, my dad wanted to discover all of these beaches. Surfing is powerful. It's not something that can be controlled. But whenever my dad said, "Come, let's go surfing!" I'd always think, "Oh no, here comes trouble. . . ."

Because of that traumatizing experience at The Hoek, I was wary and cautious whenever we went surfing. My mom stopped coming on those trips with us. She would only go to Nine Miles Beach in Strandfontein, because of the community and because we were welcome there.

In January 1989, I went on the World Tour, and in Hawaii I smoked marijuana for the first time. Every night the family I was staying with would pass it around. But when it came to me, I didn't want it. I didn't even want to touch it. It had such a bad connotation: "Dagga." A friend pulled me aside and told me that I was being disrespectful, that even if I didn't want to smoke I should still pass it on, that the circle can't be broken. I realized there was more to it than I'd originally thought. That these people were proud of their plants. They gave me seeds, and the moment I got back home, I started to grow it. ▸

photo by Imraan Christian

After we became world champions in Mexico, we wanted to continue to dominate and trained hard to do that. Ian Armstrong, Mickey Duffus, and I were a team. We trained together, we ate together, we did everything together. To invite the world back to Africa for our own event here, that was beautiful. A lot of people wanted to host it at the Crayfish Factory because it's such a beautiful wave, but we wanted a horrible, crazy wave that only a hardcore few had surfed. That was Dungeons. It wasn't a wave you could just paddle out to. We had a lot of respect for it. We called it the Sentinel, because of how that mountain hangs over you when you're in the lineup. The fishermen told us, "No, don't go out there, we just saw the biggest sharks." Not a shark. Sharks.

We pioneered a wave on Robben Island. I even named it. We were coming back after the perfect day there, and the journalist who was writing the story said, "One problem, guys." And we looked at him like he was crazy, because how could there be any problems, we'd just had the perfect day. He said, "There's no name for this wave." So, after some thought, I said, "What about Madiba's?" Because in my mind I envisioned Madiba watching each wave roll by. He had a sharp mind, and wouldn't let a wave just roll by without watching it.

In Tahiti there were killer waves. A friend of mine went backward over the falls at Teahupoo, hit the reef, and died on impact. Instead of respectfully putting the event on hold, three hours later I was called to surf in the same conditions. At that point I realized that I didn't want to do this anymore. I had a vision of teaching underprivileged kids to surf. Using the ocean to heal people, spiritually, emotionally . . . surfing is sanctuary.

People say to me, "How can you be at Muizenberg? The Dune is firing right now, come—let's go get barrelled!"

But teaching someone else to surf is sometimes a bigger reward. Riding big waves, I feel the energy; winning the world title, I felt the energy; teaching others to surf, I feel the energy. When I took a blind woman surfing once, the next day I could still feel the energy.

Riding inside the tube, you have to learn to control the energy. Time stands still; but it doesn't, it moves fast, and at that moment you have to control it. It's almost like you're controlling the whole world. I appreci-love it. I don't say "appreci-hate." You see? Same when we greet. I don't say, "Hello." Hell. Low. That's not a way to greet someone. That's why I say, "Greetings," or "Praises," or "Hi."

This triangle I make with my hands is about energy and balance. Do it, and you'll feel a different energy. It's your points coming together to seal off your energy. The hands are powerful. Everything we do is with our hands.

* * *

Surfing is the epitome of nature. There are also links to being Rasta. His majesty is Christ in his kingly character. The King of Kings, the Lord of Lords, the Conquering Lion of the tribe of Judah. He's Christ in the second coming. There's a prophecy— the half that's never been told. Don't just look at what's being forced down your throat. What you learn in school, universities, libraries . . . His Majesty's story's not there. You have to seek it.

When I became Rasta, my dad was heartbroken. But he eventually came around. He told me to follow my path. I'm 49 this year, but I feel 25. Age is important in life. Everything matures with age. You can't smoke fresh bud; you need to cure it. As in life. That's why cannabis and surfing go hand in hand. You wait for your next wave; and then, when you get it, whether it's one foot or fifty feet, you must ride it to its fullest. ▶

photos by Nic Bothma

I APPRECI·LOVE IT.

BLACK

Rastafari was born in the 1930s as a rejection of the British imperial culture dominating Jamaica. Instead, a new identity based on a reclamation of African heritage, and the purging of any belief in the superiority of whites from the minds of its followers, resulted in this proudly Afrocentric movement spreading throughout the diaspora.

Many Rasta acknowledged Haile Selassie, the emperor of Ethiopia between 1930 and 1974, as the Second Coming of Christ. On being crowned, Haile Selassie was given the title of "King of Kings and Lord of Lords, Conquering Lion of the Tribe of Judah"; and although he publicly denied being the Jah (God) incarnate, his followers saw this as further proof of his holiness.

Rasta believes it is oppressed within Western society, or "Babylon," with many Rastas calling for this diaspora's resettlement in Africa, which is considered the Promised Land, or "Zion." With no single administrative structure or any single leader, Rasta has no dogma and eschews typical hierarchical structures, so as not to replicate the structures of Babylon.

Rasta believes in personal experience, and intuitive understanding determines its truth, it is an ultra-individualistic ethos that places emphasis on inner divinity. Today there are an estimated 700,000 to 1,000,000 Rastas across the world, with the largest population in Jamaica. ■

photo by Nic Bothma

IS KING

46

ROGER VUANZA
IS MY NAME

I'm from Congo, DRC. My favorite food is pap with fish and vegetables, called Pondu. I love it so much, especially when my mom makes it. I'm a very focused person—anything I put my mind to I can do it; my mental state is strong, and it would be hard for someone to break me down. I love training hard, jogging, hiking, and surfing—these are the things that keep me relaxed. I learned swimming and surfing by myself, by watching videos and friends around me. I then followed some friends to Gary's Surf School in Muizenberg, Cape Town. He helped us with free boards and wetsuits. Gary became such an inspiration for me.

Growing up, I was always scared of sharks in Muizenberg. It was normal. One time, my friend Papi and I were surfing Kalk Bay Reef, and we had an encounter with a great white shark. Luckily, we both got to stand on top of the reef. I turned around and told him, "Bro, I just shit myself in my wetsuit!" We both started laughing, just glad to get away with our lives. The fear was real, but it was also the funniest moment in my life. That shark was so close, if we didn't stand on that rock. . . . Papi is a childhood friend; we went to the same primary school, we lived close to each other in Muizenberg, and both went to Gary's. Papi is now sponsored by Quiksilver.

When I'm in the water, people respect me; and they taught me how to respect them back. Everything is peaceful when I'm surfing. It's amazing; everyone is friendly. Just don't drop in on anyone. First time you get a warning; second time I'll make sure you have the worst surf until you go in. But I normally prevent dropping in by making a funny bird sound.

One day I was teaching surfing, and a friend told me I should try modeling. "You have the perfect face and height for it." He knew some people in the industry and hooked me up. My first day modeling I was doing a fashion show, and I was nervous. Then I did a shoot for Castle beer, and I had to do waterskiing for the first time in my life. The first two tries, I hit the water so hard, everyone was silent. But then I somehow managed. Surfing has allowed me to do many things in my life, such as traveling to judge surfing competitions, make friends, and work.

I came to Cape Town as a refugee. At the time, we were running away from war. They started forcing young boys to go fight the war, which made my mom bring us to South Africa for safety.

There is xenophobia here. We ran away from war. We are all Africans, you know? We should love each other instead of fighting. During apartheid, most South Africans were welcomed in other African countries. Many of them still live there. We never treated them differently; we lived in harmony. I just don't understand what's happening here.

I wish I could change places with the president of Congo, Felix Tshisekedi, because he has a great position of power; but greed is overwhelming him and he's not helping the people of Congo, DRC. He is only doing things to benefit himself. I want to change that. I want to help my people build roads, hotels, and schools. We are one of the richest countries— we have minerals, diamonds, gold, and many other things; but we don't even have roads, water, or electricity. That messes with my mind every day. All I want is to help my people make Congo better again, so our generation doesn't have to experience xenophobia, and we can live in peace in our own country. This is my dream. I miss my country, and I would love to go back one day.

I'm Christian, but what keeps me strong is my mom and my little sister. I want to do better in my life so I can help them get a better life. ▪

photo by Ricardo Simal

photo by Alan van Gysen

the light that must suffer

KUNDALALA NDLOVU

I saw Teju Cole in a packed auditorium at the Directors Guild Theatre in Manhattan, in late October 2019. He had taken part in an evening conversation with fellow author Zadie Smith, talking through a number of ideas of public interest. The one that struck and stuck with me: you have the right to reimagine your own world through another individual's narrative—in particular a photograph. On reflection, I consider surfing to be one of the most visual cultures, which is probably the only reason you, dear reader, are here. Surfing is one of the few recreational activities where a number of its devotees decided to take part in the culture in part after experiencing a film or seeing a photograph. These framings of light are the gateway drug to the greater experience, and have always been portrayed in such a manner that desire sits at its core.

But perhaps there is more. Allow me to peel back the wax backing to make this stick. Observe this photograph I'm looking at from Teju Cole (above), simply named "Brazzaville, 2013." A young black boy not much older than 12 sits on the outside of a river, but on the inside of a wall holding a red pole in the middle, with the cold water churning behind him. In the top right corner, we can see in soft focus some other boys playing in the water in the distance. He looks poised, not too dissimilar to a grom in the lineup waiting for his moment of action—only he knows the precise moment. When you view this image before you, all at once you're compelled to fill in the gaps of what is unknown, including the obvious—no surfboard or surfer in sight. Yet all it made me think about was the experience of surfing in Africa. Is he playing, or is he waiting? With who, or for who? Where is this spot? Most important, how close is he to the ocean?

▶

photo by Teju Cole

Still from The Endless Summer

The African continent, depending on who you speak to, holds a duality: of being both the first and the last place one might consider for good surfing, let alone a different type of surf culture. Surfing on the whole has remained essentially a Western trope that seemed to only bed down in South Africa, a land that notoriously kept anyone who wasn't fair-skinned off all the good beaches for many years. Waves were still found elsewhere, but were not as well documented, and this perception has been driven by an overly saturated bank of surfing photography and film that drives surf culture through a Western gaze. So far so good.

Then came our first visual cloudbreak moment in surfing image culture — the glorious 1966 16mm masterpiece, The Endless Summer, shot on the holy grail of celluloid cameras, a Bolex H16. This was an object I personally desired, after discovering the surf films of Thomas Campbell. This clockwork beast is robust, light enough for one person to operate, and — like every good surfer has to use their arms to paddle into a wave — it is entirely hand wound. In a world of cumbersome equipment, this was an A-bomb going off — so much so that a young David Attenborough, elsewhere

on the African continent, simultaneously reframed how the world experienced wild animals — with no one's permission, just an inappropriate curiosity.

Remarkably, the first stop of the film shows our expected white male voyagers Michael Hynson and Robert August arrive at bustling Labadi beach, in Ghana. For the record, and my peers, I'll state that this scene stuck in my mind, over the ever-clichéd Cape St. Francis scene. Notice the two outsiders arriving with their logs and no wax — famously using hair wax, which melted off instantly in that blistering sun. Fully confident in the waves before them, they start a session in front of a number of young boys and men on the beach, who had apparently never experienced surfing before. But when one pauses the moment the two outsiders walk down toward the water, you can see in the background, in soft focus, little boys playing with what appear to be flat pieces of wood in the water. They were in fact surfing; they just didn't have that name for it yet. But who gets to decide that, anyway? The remaining onlookers could have their moments of observation posited as their own form of inappropriate curiosity. Freeze-frame on a young black boy, not much older than 12, holding on to some rope, looking into the distance with a big

smile, and the hot West African waters churning behind him. His name was Samuel Assam Adjeijo and he was one of the Head Coil Ropers — young fishermen who form massive teams to cast their spiderweb of nets out into the ocean.

The most compelling part of that composition is this: Samuel Assam and his friends, by accident, became some of the first visual framers of African surf in popular culture. All things considered, and when one can look past the pinch of racist commentary in this film, it pulls forward a clear picture of outsiders bringing in a new interest that locals should theoretically fall in love with. It is at once all about African surfing, and at once nothing to do with surfing in the typical sense. If one can reimagine aspects of African visual culture on the periphery of surfing, we open up a myriad of avenues for driving a new culture for the continent as well. Samuel assumes the role of the foil character — the character who exists to highlight the qualities of the protagonist. The picture was a picture of African surf, with the presence of wooden boards off camera, hair wax floating in the ocean, perfect waves breaking to become the story within the story.

▶

I've only ever had the privilege of meeting Royden Bryson once; through a friend of a friend, he kindly took us out for a surfing lesson while we students had the worst hangovers. Royden is no stranger to the churn or to the foam of a river. If you look closely at the photo above, you can see him tucked neatly like a hairpin into a brownish green barrel in the Zambezi River. This photo, taken by legendary African surf photographer Greg Ewing, was composed between two river banks, between two borders of two landlocked countries: Zimbabwe and Zambia. It is the most compelling African surf photo I've ever experienced, amplified further by the fact that it is nowhere near an ocean. It is once again the correct positioning of African surfing—the story within the story within the story.

As legendary Magnum photographer Alex Webb once poignantly remarked, here are moments where instead of us trying to take the photo, we must realize that it is the photo that takes us. If we surrender to this shift, maybe we will begin to see a reframing of authentic African surf culture as diverse as the continent it inhabits. Every good photographer knows that as we train our eyes and minds to see new things, even the light must suffer, as it touches parts of our minds that have never experienced it before. This is our starting point. As The Endless Summer crew remarked of their attempts to frame a global surf culture, "We were determined, mainly because no one told us we couldn't."

And so say all of us.

Yes, on the continent we'll have to work harder in driving new ideas, images, and culture, but this is not a disadvantage; rather, it's a golden opportunity. While the Western surfing-photography oeuvre is awash with more of the same, African surf culture has a slab of what everybody else does not—we just have to let it show us. Hawaii may be too far, but have you tried surfing the Zambezi River? How many more rivers on the continent might work one week out of every year? Remember that long wave in Angola that's barely been touched? Also, what's going on in Somalia? From Google Earth it looks like point break country, all facing south—is it completely flat all the time? The possibilities are endless for us to reimagine a new future of surfing culture.

Readiness is all.

NICK NJAPHA

Hey Africa

My mom was a domestic worker, and the family she worked for was a surfing family: the Wigmores, in Southport, on the South Coast—near Umtentweni. They used to go to the beach every day. And so, quite naturally, I got to go with them.

I started off bodyboarding, but the father—Gary Wigmore—was a surfer, and he got us into surfing. He has two sons, one older than me, one younger—we grew up together and they're basically my brothers. That's what I call them. And that's how we learned how to surf, when I was 8. We just got chucked on a surfboard.

Right now I'm doing nothing, just surfing. If it wasn't for COVID, I'd be in the States working on those carnivals, setting up

photo by Ricardo Simal

rides. When I was 18, I left here. I went to Dubai and worked at the Atlantis Hotel for two years as a lifeguard. Then I went to Ireland and stayed there for, like, six months before coming back. At home, I was like, fuck, I need graft, so my friend's chick's sister told me about this gig in America, where you can earn some dollars and it's just a seasonal thing. So I did it for a season and I was stoked with the cash, but not really stoked with the work. You travel quite a bit. Start off in Miami, and do all the Southern states—Mississippi, Tennessee, Wisconsin. You go to those redneck towns. They're rides that you set up, and when you bring them back down, they fit into these semi-trailers. You learn how to make them, set them up, and break them down. This one

Miami fair, we were there for two months, and you set up, like, ninety rides. And then you help operate them. Roller coasters, spinning shit, those swinging boats with funny names like The Blizzard. The one I was working on was The Yo-Yo. The Remix! Such random names.

It was different. Quite a big culture shock. But nothing like the movies. The people are friendly—some of them, at least. A lot of them are really arrogant, in your face. "Hey, Africa!" Asking dumb questions, like, "Do you guys ride zebras to your school and work?" and stuff. And I'm just like, "What the hell?!" Oh, and "I've got a friend in Kenya, do you know him?" I was like, "Yeah, he lives just down the road from me." They don't know Africa at all. ▶

"Pure stoke hey!"

I experienced some racism there, but I'd say it's not as bad as it is in South Africa. I mean, it's shit anywhere. But I didn't feel it as strong. I guess it's the same as everywhere — the younger generation don't care about that shit. It's just sitting with the older generation.

I've grown up my whole life being called a coconut. But I know what's going on. I see what's good in life.

Compared to the local kids from Fairview and Umzumbe, I got to surf a lot of different places growing up. Local guys are just stuck here, there's no transport. They only travel for contests. I got to meet a lot more people, I guess.

Last year in July, I ruptured my spleen while surfing. Going over the falls, first wave of my surf. Was quite a big day. I took off, went over the falls, tried to bodysurf the wave, on impact I hit my stomach — no rocks or board, I just hit the water. I fell from the top of the lip. Air-dropped. I felt winded. My next wave I just took off and went straight in. Got to the carpark, and luckily there were two locals there. And they asked what was wrong. As soon as I said, "Ay, I don't feel good," I collapsed. Boom. Next thing I know, I'm in and out of consciousness, okes are calling ambulances, and I woke up in hospital. Went for a few X-rays and then I'm being rushed into surgery. Ten hours later I found out I'd ruptured my spleen and lost three-and-a-half liters of blood. It was gnarly. At the end of it, the doctor said I was lucky to be alive.

I was back in the water by October. It hurt a bit, lying on my board, but now it's hundreds. After about two months I was back, doing surf lessons, surfing. Now it doesn't even feel like I had a spleen. I was like, oh, is that what a spleen does?

Surfing has given me a lot of good experiences, and knowledge about the ocean. You want to know when the wave's good, so you learn about the weather and the geography. It expands your mind.

If I don't surf, I feel angry. I feel like I'm missing out. Like, why's God doing this to me?! And when it's good . . . only a surfer knows the feeling. Pure stoke, hey. Pure joy. Non-stop smile, ear to ear. ∎

My father was very beach oriented. He was never a surfer, but loved to bodysurf. He was also a very keen fisherman. So I'd just tag along with him while he was fishing, and I would surf, and we would spend a lot of time in places like Mapelane and southern Mozambique and in the Transkei, and in the deep South Coast and North Coast. So that's where I got my love for surfing alone, in solitude, while he fished. He didn't tell me about the sharks until I was older! I mean, he used to send me out at Mapelane to surf by myself, while he fished for sharks on the beach. . . .

I always loved big waves. When Durban got big, I loved it. From there I took that act to the coast and then down to J-Bay, where I met the Cape Town guys, like Davy Stolk and Mickey Duffus in particular. And they were like, "Boy, if you like it when J-Bay gets big, come surf Cape Town!" So I did. And then the whole Red Bull Big Wave Africa thing started, and I met Greg Long and Grant Washburn, and they were like, "Well, if you like Dungeons, you're gonna love Mavericks and Waimea." I eventually made it to Mavericks.

Winning Mavericks was a turning point. That took me from being a desk jockey to a pro surfer. I was a rep, selling T-shirts. I've done every job in the surf industry. I started in the CMT factory here, I did marketing, and I was a sales manager for a while.

Eventually, I was like, "Well, I want to surf a bit more and work a bit less," and the repping job was awesome for that. You had your own time. And we grew Billabong into the biggest trading brand in South Africa. It was an awesome time. Working is fun when you're making money.

GRANT TWIGGY BAKER

photo by Ricardo Simal

Most people here are athletes, and then they move into the company when their pro career is over. I did it the opposite way 'round, which I think was helpful because it made me very grateful to be a professional surfer, and I already had that hard work sense embedded in me—that if you don't work hard enough, people are not gonna pay you.

It's hard to be a professional surf athlete, but it's also not hard. It's the same as anything in life. If you work hard at it, it's attainable. But it's not just surfing every day, it's working

hard on the whole big picture, mentally, strategically.

So many top surfers should only become professionals in their 30s. They'd have much better careers at 40, make the top forty-four easier. A lot of them are too young and then they get dropped by the sponsor before they have a chance to actually mature into competitors.

We're obviously a lot more . . . more hardcore, here. You know it's definitely a more intense experience, surfing in Africa. We don't have a lot of surfers—and we've got endless coastline. It's just

a more raw experience of the art. And we're still finding world-class waves every year. The whole exploration aspect is wide open, and so fulfilling.

Not many other places in the world have that.

In surf circles, people know—from watching Shaun Tomson, Martin Potter, and Jordy Smith over the years—that the majority of surfers in South Africa are white. But when you meet other people around the world who are not surfers, they get confused, and say, "You're from South Africa; why aren't you black?" ▶

African surf culture? It's about to explode! It's about to explode in the way that Brazilian surf culture exploded ten or fifteen years ago. These little pockets are gonna blossom into huge movements very soon. You've seen it in South Africa. There were little pockets here in Durban, on the South Coast, in Cape Town, in J-Bay. There have been pockets of surfing excellence everywhere in South Africa. And those pockets have spread and opened it up, and now everyone's got access to surfboards. If you're a black kid and you want to start surfing now, you're gonna have a number of opportunities: including people who want to give you a surfboard and teach you how to surf, and bring you into the culture. As surfers, we've always been very liberal, very open. I think Africa is the next Brazil, just waiting to happen. Surfing is a very inexpensive sport to do. And the wealthier surfers in this country are super supportive. Anyone can take it up. Anyone can be good at it. You just work hard, you surf hard, and in twenty years . . . sheesh, I see as many black Africans on the World Surfing Tours as there are Brazilians now. I mean, there's no reason why there shouldn't be.

"Don't panic when you've panicked." That saying was from Capetonian big-wave surfer Andrew Marr. It came about after a session at Dungeons, when we were caught inside. But we could see it was bad. We were still in front of the first wave, and we could see we were going to get over that wave . . . but we knew the second wave was a monster, and we were gonna get caught, and I looked at him and I said, "Andrew, we're in big, big trouble." And we got hammered. And after that session we were laughing about it. And then he said, "Yeah, you know, don't panic when you've panicked." Because obviously, when you come over the top of it . . . you panic. But then you better get your shit together and stop panicking, and fucking get your breath and start to calm down. So it was a funny one, and we've always laughed about it.

The pandemic has highlighted the need for people to be healthy, to get close to nature and do something that's good for the soul. And that's surfing, especially surfing in Africa. That's exactly what it does.

You know you can drive up the coast here, and there's a game reserve, and there's beautiful waves. You drive a bit farther, and you're in Mozambique; and it's wide open, and you're on dirt roads and 4x4s. Or you go the opposite way, to the Transkei, and it's the same thing. Untouched beaches. And yeah, I mean, if you don't protect that, for the future, people are gonna have nowhere to go to connect and stay healthy. So I mean, these corporations that have just been raping and pillaging are gonna have to wise up. Otherwise they are just gonna kill the fucking customer base. And I mean, you can see it. They are changing. You can't just be an arsehole corporation, because you're going to be brought down pretty quick. It's moving in that direction.

I played soccer for many, many years. I started the Bong United Football Club. I love soccer. I was right midfield. My strengths were speed and crossing. Scored the odd goal. Michael Essien was my favorite player of all time. I support Spurs and Bafana, and Ghana, as my second African team.

A lot of people also don't know that I came in second on the World Kiteboard World Tour in 2004. I was a fully sponsored kiteboarder for a few years there. I didn't stop surfing completely, but I slowed right down. I was very dedicated to kiteboarding. Not many people know that, because two years later I won Mavericks, and the big-wave surfing thing took off.

WATER

KOLEKA PUTUMA

SOUTH AFRICA

The memory of going to the beach every New Year's Eve,
is one I share with cousins and most people raised Black.
How the elders would forbid us from going in too deep
to giggle, to splash in our black tights
and Shoprite plastic bags wrapped around our new weaves,
forbid us from riding the wave
for fear that we would be a mass of blackness swept by the tide
and never to return,
like litter.
The elders forbid us as if the ocean has food poisoning.
I often wonder why I feel as if I am drowning every time I look
 out into the sea,
this and feeling incredibly small.
And I often hear this joke
About Black people not being able to swim,
or being scared of water.
We are mocked
and we have often mocked ourselves
for wiping our faces the way that we do when we come out of
 the water.
Compare it to how they do it, all Baywatch-like,
and how we so ratchet-like with our postures and kink.
Yet every time our skin goes under, it's as if the reeds remember
that they were once chains,
and the water, restless, wishes it could spew all of the slaves
 and ships onto shore,
whole as they had boarded, sailed and sunk.
Their tears are what have turned the ocean salty,
this is why our irises burn every time we go under.

Every
December 16th,
December 24th,
December 31st,
and January 1st
our skin re-traumatises the sea.

They mock us
for not being able to throw ourselves into something that was
 instrumental in trying to execute our extinction.
For you, the ocean is for surfboards, boats and tans
and all the cool stuff you do under there in your bathing suits and
 goggles.
But we,
we have come to be baptised here.
We have come to stir the other world here.
We have come to cleanse ourselves here.
We have come to connect our living to the dead here.
Our respect for water is what you have termed fear.
The audacity to trade and murder us over water
then mock us for being scared of it.
The audacity to arrive by water and invade us.
If this land was really yours,
then resurrect the bones of the colonisers and use them as a compass.
Then quit using Black bodies as tour guides
 or the site for your authentic African experience.
Are we not tired of dancing for you?
Gyrating and singing on cue?
Are we not tired of gathering as a mass of blackness
to atone for just being here?

To beg God to save us from a war we never started.
To march for a cause caused by the intolerance of our existence.
Raise our hands so we don't get shot.
Raise our hands in church to pray for protection,
and we still get shot there, too,
with our hands raised.

Invasion comes naturally for your people.

So you have come to rob us of our places of worship, too.
Come to murder us in prisons, too.
That is not new either.

Too many white people out here acting God.
Too many white people out here doing the work of God.

And this God of theirs has my tummy in knots.
Him and I have always had a complicated relationship.
This blue-eyed and blond-haired Jesus I followed in Sunday school
has had my kind bowing to a white and patriarchal heaven,
bowing to a Christ, his son, and 12 disciples.
For all we know,
the disciples could have been queer,
the Holy Trinity some weird, twisted love triangle,
and the Holy Ghost transgender.
But you will only choose to understand the scriptures that suit your
 agenda.
You have taken the liberty to colonise the concept of God;
gave God a gender, a skin colour,
and a name in a language we had to twist our mouths around.

Blasphemy is wrapping slavery in the gospel and calling it freedom.
Blasphemy is having to watch my kind use the same gospel
 to enslave each other.
Since the days of Elijah, we have been engineered to kneel
 to whiteness,
and we are not even sure if the days of Elijah even existed
because whoever wrote the Bible did not include us.
But I would rather exist in that God-less holy book
than in the history books that did not tell truth.
About us.
For us.
On behalf of us.
If you really had to write our stories,
then you ought to have done it in our mothers' tongues,
the ones you cut off when you fed them a new language.

We never consent.
Yet we are asked to dine with the oppressors
and serve them forgiveness.
How,
when the only ingredients I have are grief and rage?
Another one (who looks like me) died today.
Another one (who looks like me) was murdered today.

May that be the conversation at the table
and we can all thereafter wash this bitter meal with amnesia.

And go for a swim after that.
Just for fun.
Just for fun.

JOSIE FAULKNER

AG FOK HULLE

 cousins Bertie Stuurman and Dominique Abersalie were surfers. Whenever we came home from school, we'd see them grab their boards and go surfing. Etienne Venter, owner of the local surf school in J-Bay, would take Bertie and Dominique to all the local surf comps. Bertie was a really good surfer! So they would often come home with trophies, and we were like,

"Yoh—this is sick!"

One day, after begging Etienne to take us surfing, he obliged; and he took me, Jerry, Angelo, and Rewaldo and that's how we all started surfing. We loved it so much, and we wanted to come home with trophies just like Bertie and Dominique, so we were inspired to become good surfers from day one.

Thys Strydom is the owner of Rebel Surfboards, and he took us under his wing. From the age of 11 years old, Thys started giving us boards. We'd go to his factory after school every day, just to hang out. The whole crew of us: Jerry, Angelo, Rewaldo, Dillen Hendricks . . . we'd all just chill at his factory, and surf all day. Thys would take us on surf camps, pile all of us into his bakkie and take us to all the surf contests. He made sure we went to church on Sundays, and he made us proper boards. I used to stay with him on weekends and he became almost like a father figure to me. He did a lot for me, sponsor-wise—if it wasn't for him, I wouldn't be with Billabong.

Thys took me to my first contest, the Grom Games in Port Elizabeth. It's a contest aimed at developing surfers wanting to enter the world of competitive surfing. I surfed my way from round one all the way to the finals, and won the whole thing!

My father is a gangster.

He's involved with the local Pellsrus gangs. I don't really know him. I met him for the first time when I was 15 years old, when he was released from jail. My mother was like, "Oh, that's your father." We started talking, but then he went back to jail. I didn't see him for many years; and only after he was released from prison the second time did I begin seeing him, but just in passing, on the streets of Pellsrus. We kind of talk now, but our relationship consists of basic pleasantries; we acknowledge each other in passing. I spent my formative years living with my mother, until she moved inland to Riversdale. My granny started taking care of me, and now I live with my granny. ▶

photo by Kody McGregor

FOK HULLE!

In 2015, I came in fifth at the ISA World Games. Worlds! That was one of the highlights of my professional surfing career. That, winning my first QS in Port Elizabeth, and winning the South African Surfing Championships in 2019. My biggest obstacle to winning is in my mind. Before heats, I'm the most chilled person you'll meet; but as soon as the hooter sounds, my mind starts playing games with me. As soon as someone gets a wave, I'll convince myself, "I'm out! It's all over." The contests I do well in are the ones where I just don't think about anything. I don't care. As soon as people put pressure on me, and there are coaches around saying, "You're gonna win!" it all falls apart for me. At Worlds, the coaches—Greg Emslie and David Malherbe—told me, "Ag, fok hulle!" (fuck them). From that day on, whenever I go into a heat I'm like, "Fok hulle, man!" They can do what they do, and I'm going to do what I wanna do.

Being a black surfer means a lot. It's definitely a white-dominated sport; but you know, Mikey February opened the doors for black surfers. When you go other places outside of Jeffreys Bay and you say you're a surfer, people think you're a drug addict because you're black. That's what people think black surfers do—they just smoke weed and they're not really there for the surfing, they just wanna be where the money's at. On one hand, being a black surfer has given me lots of opportunities—more than some white people even. When we went overseas, they'd put at least one black surfer on the team, and that'd often end up being me. But on the other hand, if I didn't grow up in Pellsrus and we had more money, it would've been very different. There's a lot of contests I could've been doing overseas and getting results, if I had money to travel. Where I'm from, nobody really has money. But now with Mikey opening the doors, and groups such as the Amandla Surfing Foundation and Surfing South Africa wanting to help get surfers of color to contests overseas, maybe things will be different.

It always just used to be Etienne and Thys paying for us to go to local contests.

There are some really good surfers coming from Pellsrus township. The next generation. We have Zia Hendricks, Dillen Hendricks's little sister—she's tiny, but she has a mean backhand, and charges when Supertubes gets big! There's Ernie, he does the sickest laybacks—he's so small but he surfs kinda like John Florence, low-slung arms and a cruisey style, different from everyone. Then we have Boeta, he surfs pretty sick too. There are a few other kids that surf and hang out around the Rebel Surfboards factory now, like we used to; they have the potential to get good but they're not as committed, they only surf, like, once or twice a week. If I could give them advice, I'd say, surf as much as possible. Don't care about friends. Or at least the wrong friends. Because one day those friends aren't going to be there. The little kids from Pellsrus cruise around in groups, and they all smoke weed and stuff, but there's always one guy in that group that doesn't. And often that kid is the surfer in the group. If I didn't have to work, I'd go to those kids' houses, pick them all up, and take them surfing, all day every day. And make sure they stay out of trouble by keeping them in the water.

* * *

I absolutely love fishing!

Fishing runs in the family. My grandpa made the first boat in Jeffreys Bay. My whole family, we've always had boats and stuff, and since I was a small kid we've always gone fishing. I normally fish at night, sometimes in the mornings or if there's no waves and it's a nice day, then I'll just chill the whole day on the beach, fishing. I fish a lot with my cousin Bertie. Bertie has a funny habit of swimming after the fish once it's hooked. I remember one time we were fishing in the lagoon in Jeffreys Bay, and I hooked a huge fish! I started reeling it in, but the fish fought back and took more line. Then Bertie jumped in the water, followed my line and caught the fish with his hands! He lifted this huge fish out the water with his hands in its gills! He even does it when we fish at the beach. We keep telling him, "One day there's gonna be a shark on that line!" ∎

photo by Alan van Gysen

My mam's name is Mamthelelwa Tutsu, and my father's name is Maqhuzumana Tutsu. My name is Ntombe Thongo.

I graduated as a young sangoma, who twasa'd at a very young age. People didn't trust I had the knowledge to help people with the herbs—they'd just think, this little baby is going to mix and mess up the medicines. Inside me I know I wanted to work as a sangoma and help people. And during that heavy time, I always had dreams of myself—that really cooled me down: "Don't rush, your time is coming, just be patient."

In my amaMpondo isangoma tradition, the spear—generally in our culture there is always a spear, the family spear—is to be used by only one member of the family. That chosen one, any time we have a ceremony that includes an animal that must be slaughtered for the ancestors, would be the only person who uses that spear, and that spear must not be touched by anyone but that chosen person.

When I became a twasa, I was very young. I dreamed my spear, which was at my uncle's house (my mam's younger brother), and I dreamed that my uncle had to hide it for me so I had to actually find it myself. The twasas must find it for themselves. After I got the spear, I had to go to the sea to ukuhlambulula, to clean the spear, and to hand it over to the ancestors of the sea to give it more power. Amathongo wamanzi, the water spirits, bless the spear and my work.

In isiXhosa, we have two ways of calling this spear; as a sangoma, I call it umphatho, and as a Mpondo man, and generally, we call it umkhonto. ▶

My spirit can talk with the spirit of the sea. It has always been that way, each time. This connection with the sea is very big.

photo by Ngqibandaba Maxisole

I have been speaking with my mam about the things that happened on this coast in the olden days. The very big story is that there was a ship that came, it might have lost fuel, and it was forced to come out of the sea (my mother was still young at this time). And one of the ladies who came out of that ship ended up marrying my great-grandfather. She came out and looked for any person that had the same clan name as hers. They didn't know where the ship was coming from, and she couldn't find her way home. In those days it was difficult to move around. These people are still around, they give birth, the family grows. My lineage comes from the sea.

As a sangoma, I am very connected to the ocean; my nature spirit is in the sea. I always feel, when I go to the sea, that I am being brought there to see something new in my life. Each time I walk by this sea I see something huge inside, something bigger than a whale. One day it was drizzling, and I went to the sea to pick up some isilawu from the ocean, and as I was walking along the coast I kept feeling "It is time to go, it is time to go now," and I felt like I was being told to leave the shore. There were strange waves beginning to roll in, and a wind started up, and at that time I felt emotionally very connected to the water—I wanted to cry without knowing why. I walked up the mountain, toward my mother's old homestead. From the top of the mountain, I looked back at the sea and saw a huge dish, a dark round dish bigger than a whale, this large, scary-looking head of a sea animal. I got the feeling of its meaning in my body. There was this huge emotion inside of me, when seeing this sea animal. And that same night, I had beautiful clear dreams of me being at the sea, and why I must go to the sea. And from that day, that is the reason I do not swim in the ocean, I only swim when I have a ceremony to dream. How important it is for me to come nearby the sea. I can get a little bit of water, put it in my mouth and swallow it, and then speak to the water. Makhosi.

* * *

Second Beach, Port St. Johns—people surf there, despite the disturbing news that there are many shark attacks now, which has changed the situation a bit. One of my friends from Amapondo Backpackers was teaching young people to surf, and my friend, who was a twin, was attacked by a shark and he died.

* * *

Who is black and who is white—it is your mind that is telling you that there are black and white people here. Listen to what you are saying. Who is black and who is white—it is your mind. Who actually brought these people to this Earth, who brought these people here? The government system turned God's creation into pieces.

Just be glad you are actually alive, because you are not in charge of everything on Earth.

I find it really encouraging to speak about the things we spoke of today. It has woken up my body. ■

My name is Cebo Mafuna. I grew up at Port St. Johns in the Transkei. Second Beach is my home break.

Second Beach is like a big bay with a rocky point break. All along the beach is dark green jungle. I used to love swimming, and I remember seeing the brothers Avo and Zama Ndamase surfing. They were the first local guys to surf, then I joined them when I was 12 or 13. Nothing much happens in Port St. Johns . . . just fishing and surfing. Surfing was the best thing for us to do.

Mike Gatcke was the guy who helped us all learn how to surf, and took us to contests . . . and I remember Andy Davis gave me my first board! When I was 14, I started surfing for the Border Surf Team. I surfed the Grommet Games and I surfed SA Champs in Cape Town. It was a good time. I loved surfing from the get-go.

But Second Beach . . . Second Beach is a dangerous place. The first time I saw a live shark attack was in 2009, when my neighbor Luyolo got chowed in the shorey. I watched it happen. He was screaming, "Guys, help!" But there was nothing we could do. He died on the beach.

Then, in 2010, Zama got taken. Zama and I were the same age, same grade when it happened. We were 15. After school we would usually go to Zama's house because that was where we used to keep our boards, and Zama's older brother Avo was a good surfer. We

gunned it down to the beach. All the guys. That day we were out in the water and I remember Zama caught a long wave, then he came around and started paddling out again . . . he was hit by the beach break. He was bitten on his leg and his body. He washed up onto the beach, and died at the same time.

Second Beach is the most dangerous beach in the whole country. There were nine shark attacks. No one survived. Two of my friends died in front of my eyes.

After the shark attacks, I stopped surfing . . . for three years I didn't surf. The last attack was in 2011. There were a lot of young guys surfing, but everybody stopped. A lot of okes got hooked up after that—started smoking, hitting drugs, getting fucked up. Some guys I grew up with are in jail now for murder and other crimes. It's crazy.

My dad also died that year: 2011, when I was 15. I've got one brother and one sister, but they're much older than me. I'm the last-born.

When everyone stopped surfing . . . the stoke was gone, there were no boards, there was no traveling. There was a lot of sadness.

Luckily, I was hanging out at the Amapondo Backpackers on the beach. I got some small jobs there . . . cleaning the yard, helping at the bar. It gave me good experience. I knew that I had to finish school and hit the road.

Around that time my mom died. But I passed matric and moved to Durban. Surf City. When I first came here, I went to the township, Clermont, and lived with my uncle. Then he got a job as a security guard at uShaka, so we moved to South Beach and I was straight back into the water, full time.

Since then I've been surfing every day . . . hitting it! I'm a real surfer. Surf along the wave, on the open face. I'm not progressive, above the lip. I do airs, but I prefer surfing on the face, doing turns—powerful turns, yeah.

About a year after moving here, I met Tom Hewitt from Surfers Not Street Children and I joined the guys. I started doing the program—surf lessons, teaching laaities about the ocean. Tom helps okes from disadvantaged backgrounds, okes from the street. The biggest challenge on the streets is the drugs and the gangs. If you get stuck on the streets, you need a mate or a gang, you can't be on your own.

Tom puts okes in a program and gives them a structure. I lived there at the Surf House for five years, with nine other guys. I made some good friends— Ntando Msibi aka Biggie was one of them . . . and Sfiso and Andile. Biggie now works at Surf HQ surf shop, and Sfiso does ding repairs. Andile is an awarded lifeguard—guiding the kids, teaching them to swim and to surf. Sihle is the other guy from the crew, he rips. ▶

CEBO PLAN

XHOSA

ENGLISH

When we all stayed together we were pushing! We surfed three times a day. The level was high. That's when Biggie won SA Champs. Bro, he beat Matt McGillivray at his own break, J-Bay, in the final. Smoked him. Then he went to Ecuador with the SA Team to the world juniors. He killed it. Finished in the top ten.

These days I mostly surf town, or I hit Bluff or the coast with my mate Matt Seals. I also surf with David van Zyl. Davey hooks me up with boards. He's my favorite surfer to watch. He's powerful, good style, always smiling to everyone. He's a good guy.

Surfing makes me feel good. Stoked. Refreshed. Inspired. Also relaxed.

Tom helps us connect with a lot of people, to get to know the surf community. I met Dane Reynolds once. I also met Prince Harry — that guy from the Royal Family. We chatted with him, he left some donations. It was sick.

I started working at Durban Surf Lifesaving Club as a waiter a few years back. Now I'm a barista there and I work five days a week. I noticed, like, many guys who come to the coffee shop would always ask me the same question every morning: how was the surf?

So I thought, let me create a WhatsApp group where I keep updating them about the waves, then I will make extra money. That's how I figured it out. So now I have Cebo's Surf Report. I have a WhatsApp group, and I do a clip of North Beach and New Pier first thing in the morning. I report on all the conditions—the wind, the tide, the banks. I have thirty guys in the group and they each pay a subscription of fifty bucks a month. I even do an update in the afternoon—the okes love it.

You have to learn to do things for yourself, you can't always be pushed. It feels good to be independent. The surfer's crew — we help each other. If I have three pairs of shoes, I'll give one pair away.

I'm still part of Surfers Not Street Children, but when you reach a certain stage — like, you have a job, you're responsible — you move into the independent program. Now I live with Biggie in Musgrave. We moved up so that younger guys can move into the Surf House and join the program.

It's a cycle.

In the future I'd like to travel more. That's my plan. I go and visit home in Port St. Johns sometimes, but you know what? I don't go in the sea. I won't surf there ever again. And that's just the way it is. . . .

Cebo's Surf Report

photo by Chris Jenkins

CLOTHES THAT SPEAK
by KLYNE MAHARAJ

Durban is a perplexingly diverse part of the world. It's the proud heart of the Zulu nation; home to the biggest Indian population outside of India itself, who arrived as slaves 160-odd years ago; and has an equally large population of white South Africans predominantly of English heritage. These groups are far more integrated — albeit reluctantly so — than in the country's most famous city on the opposite coast, Cape Town. Durban is hallmarked by humidity, Gqom, curry, apathy — and surfing.

While growing up in Durban that latter part — surf culture — is undeniable. Whether you actually surf is almost irrelevant; it's so prevalent and infectious that it's bound to impact you in one way or another. Even I, Klyne Maharaj, a South African–Indian suburban kid whose main exposure to the sport was through my white friends, got sucked right into the hype.

THE GATEWAY DRUG

I was a kid during what really felt like surf and skate culture's zenith. Zigzag and Blunt were the only magazines that mattered. Durban had just built its iconic Wavehouse, featuring an artificial wave and world-class skatepark (which was unveiled with the help of the world's biggest pros at the time). Tony Hawk's Pro Skater was the biggest video game in the world, even Hollywood was cashing in, producing the corny-yet-iconic film Blue Crush. Surf and skate were no longer niche, and it wasn't just a big part of pop culture — it was the zeitgeist.

I have incredibly fond early memories of my mom taking my brother and me down to the hallowed Stamford Hill Road, an area in Durban famed for its surf and skate factory stores. It was deals central, and I remember leaving those shops with bags of loot from local brands, like Island Style (who made — and make no mistake about it — one of the best skate shoes available in South Africa at the time), Gotcha, Instinct, and Lizzard, and international brands such as Rip Curl, Airwalk, Quiksilver, and (a brand that I think few could've predicted the longevity and staying power of) Stussy. Stamford Hill Road was so popular that I wondered if people ever even bought those brands at full price. Considering that half of those brands went bust, I'm guessing not.

Although I was much more partial to skating, Durban's surf culture did have a lasting impact on me, particularly when it came to style. I couldn't have realized it then, but I was very much a late-'90s counterculture stereotype, and I was in the midst of an early education in what we now commonly refer to as street culture: all things surf, skate, hip-hop, punk, and street art. That period in my life, which was strongly influenced by the surf and skate culture of the era, was my gateway into a lifelong love of streetwear.

F.I.F.O.

Under the apartheid regime, my parents lived in what was referred to as a "Group Area": a deceivingly polite name for an oppressive government policy of designating suburbs for different race groups. Shortly after I was born, and against virtually all odds — which I mean quite literally, not hyperbolically — my parents moved us into a leafy, idyllic suburb far away from the Group Areas that they were raised in, and into previously unattainable private schools steeped in tradition. When I say tradition, though, obviously I don't mean my parents' tradition: picture something a bit more Caucasian, more patriarchal and philosophically antiquated. It was like Dead Poets Society, with narrower minds and more K-ways.

Even as a young kid, I was keenly aware of how "other" I was. I was one of three Indian kids in my grade throughout primary school; and when I got to high school, I was just one of one. I didn't just stick out because I looked different from everyone else — my home life was different too. My outlook was different. I was part of a generation of black and brown South African kids who were entering uncharted territory for our nation: the first era of racially integrated schools. It was from this very early age that identity became so important to me: if I wasn't like the rest of the kids, and had no examples of representation to look up to, then what was I supposed to be like? Who was I supposed to be? ▸

CRICKET IS FOR QUITTERS

Surf and skate wasn't for the kids with Jonty Rhodes or '95 World Cup posters on their walls, and I absolutely loved that about it. Something that instantly separated skaters and surfers from any other athletes was style. They rocked long hair and caps; they sported labret piercings and pyramid-stud belts; they wore pants so baggy, you couldn't even see the equally puffy Osiris D3s bulging beneath the bootleg. They listened to punk rock—real punk, like Rancid, not Blink 182—and rap; they pulled middle fingers when they posed for photos, and they had tattoos. They were rock 'n' roll, while rugger buggers were not. Skaters and surfers were against the grain and proud, and it seemed like they told half that story with the way they dressed. I was taking notes.

Even though it was extremely uncommon to see an Indian kid at a skate shop at that time, I still dragged my parents there on my 9th birthday and kitted out a sick World Industries deck with Spitfire wheels and Lucky bearings. A few years later, I was asking my parents if I could dye my hair Day-Glo purple during the December holidays, like some little brown suburban version of a Casualties roadie. A few years after that it was a guitar, then a mohawk, then my first pair of slip-on Vans. My identity, which felt like it was mine to decide, started to form piece by piece. I went from wannabe skater to mall punk to emo kid to the millennial manifestation of so many of those subcultures, a streetwear lover and sneakerhead. As a 29-year-old, telling you who I am through my "fit" is just as important as it was to me when I was 9.

PERSONALITY CRISIS

So while I was trying to pin down my identity as a kid, so was Afro Surf. What always felt a bit strange was that South African surf and skate culture—or its depiction, at least—felt distinctly American. Including the aesthetics of

the popular publications of the time, like Zigzag; the graphic tees we'd wear that were more likely to feature a Hawaiian motif than anything remotely African; not to mention the fact that there were exceptionally few prominent black surfers being placed front and center in the sport. It was odd that surf and skate culture, which was so defining in South Africa at the time, didn't feel at all African. To my young self, the scene in Durban looked like . . . Southern California. That probably wasn't helped by the sheer amount of Pennywise, Red Hot Chili Peppers, and Warped Tour compilations being blasted at surf shops around town.

Africa often finds itself the subject of awkward and downright condescending headlines. It's not uncommon for publications, like The Economist, to punt an issue every couple of years with a tagline such as "Africa Rising!" or an equivalent that implies that our backward, dormant continent's progress is only validated when a European journalist puts it into print. African streetwear has suffered from that same condescension. It's not uncommon to read about the "New Dawn" of African streetwear, as if it hasn't existed for many decades already.

RISING TIDES

However, as much as the suggestion that Africa is only just "finding itself" is vexing, it's not entirely untrue in the context of streetwear. Like many less developed parts of the world, the aspiration is to be "more Western": that's why so many African musicians perform with American accents, and it's why you'll find kids in rural Africa wearing Nike and bootleg Supreme hats. For a long time, Africa has done itself a disservice by trying to be more like the West, instead of cultivating its own identity— an attitude that is very clearly a relic of colonialism. But the tide is turning, and it has been for some time now.

In South Africa, brands such as Loxion Kulca and Twobop have long since

defined a local streetwear aesthetic based on South African culture rather than some listlessly ripped-off Hawaiian vibe, and relative newcomers such as Grade Africa continue to embrace a more distinct and local attitude, and to push that envelope forward.

On the rest of the continent, brands such as Ghana's Free The Youth, a streetwear brand with strong DIY, punk, and skate influences, work hard to incorporate local textiles and patterns like those on kente cloth into its line. On the international stage, companies such as Amsterdam-based Daily Paper (founded by Somali emigrant Hussein Suleiman) have made African motifs, prints, and ideals central to their brand.

Most recently, Cape Town–based surf brand Mami Wata—which takes its name from West African folklore—has made a splash on the international scene by collaborating with the ultra-luxe French snowsports brand Moncler.

GROW UP

I've always felt that my differentness was also my biggest ace in the hole. It led me to uncovering a counterculture that I would later hinge so much of my identity on. It helped me stand out in social settings and in job interviews. And when I look at so many of my peers today, it prevented me from becoming a boring chino-wearer who thinks dressing like shit is somehow virtuous. Me being different would've sucked considerably more had I not been exposed to a culture full of misfits spanning unorthodox sports, music, and visual arts.

While African streetwear—which has always been inspired by surf and skate culture—continues to flourish, it seems that it will do so with a greater emphasis on African identities. At the rate things are going, when I take my kids to a surf shop in Durban one day, it'll be less Aloha brah and more Aweh Laani. And Afro Surf won't feel other; hopefully, it'll know exactly what it is. ∎

Thabiso Mkhize
photo by Ricardo Simal

SIMO

MKHIZE

My brother Sanele started surfing first. He was always going to the beach, so one day I followed him and saw some guys surfing and I thought, hey, that's a nice sport.

Dumisani, the lifeguard here at Umzumbe, was teaching kids to surf, so I just fell in with them and went for it.

I realized I might be good at this thing when people started to push me hard. They started to believe in me so I saw that I could do it. I could be better. I made the Ugu District team, I did some trials, and they took me to SA Champs. There, I saw that I can surf at a higher level. That process improved my surfing.

But then at about 17, I got in with a bad crowd and I stopped surfing for a bit. I mean, I still surfed, but maybe only twice a week instead of every day. Soon, I realized that gang life is not the life for me. So I started to pull myself back together and get back to doing what I love. In 2018, I went to Durban to doing my lifesaving course. So now I work as both a lifeguard

and a professional surfer. I want to do well and travel. I see myself more as a free surfer. I enjoy the feeling of surfing, you know, just for me. But I also enjoy contests, because it pushes me hard, to want to do more. If I get some good support, I can see myself going far in surfing.

The ocean makes me calm. I don't think a lot when I'm surfing, I just let go, enjoy myself, and see what happens.

If I didn't surf, I think I'd be a bad person. Surfing keeps me away from those bad influences. I spend all my time at the beach.

What people don't know is that I'm also a good soccer player. If I wasn't surfing, I'd probably play more seriously. But I really love surfing. Obviously. If I didn't, I wouldn't spend all my time here at the beach, you know?

A lot of us believe our ancestors are there in the water. Other guys don't like the sea because they can't swim, and they get taken by it. So they say the spirits are there,

and if you go swim, they will take you too. That's why we don't have many people surfing from our community. But it's changing now. People are starting to get more involved. There's no one resisting surfing in our community anymore. They see us doing well through surfing, and they're starting to notice that this is a good sport. It brings opportunities.

Professional surfing is quite hard for me, because I'm naturally a shy person. I always try to overcome that to perform and do my job.

One time, earlier this year, I was surfing and I ran away from a dolphin. We were surfing here in winter; and in the winter there are no shark nets and lots of animals. We get a sardine run, so the sharks are everywhere. And this thing came straight for me and it was alone. I'd never seen a dolphin alone, so I thought it must be a shark! I was scared and I came in as quick as I could. All the locals laughed at me. When I saw it was a dolphin, I paddled back out. ■

3 LITTLE BIRDS

I AM TAMMY LEE SMITH-HEAVEN AND I AM A LIFELONG OCEAN ENTHUSIAST. I WAS BORN IN ADDINGTON HOSPITAL RIGHT ON THE DURBAN BEACHFRONT AND GREW UP IN SALT ROCK, KWAZULU-NATAL, SOUTH AFRICA.

My dad was a pro lifesaver, surfer, and spearfisherman. We lived just behind the beach; and from as young as I can remember, I used to run down to the beach and ask any lifeguard on duty to help me swim to the backline. I didn't really see a difference between what boys did and what girls did.

Although I was in the ocean bodysurfing and diving with my dad from a really young age, I only started surfing at 13 or 14, which is pretty late if you want to try and "make it" as a pro surfer. I remember asking for a BMX bike for my birthday, and was really disappointed when I got a surfboard. I started competing as soon as I started surfing. By the end of that year I had already entered my first surf contest and won the novice division. At the time, you got a "sponsorship" from Roxy for a year if you won.

I had a really good group of friends: Rosy Hodge, Stacey Guy, and Nikita Robb. Competing allowed me to surf and travel with them. The competitive surfing scene really drove me in those formative years. I have a really competitive nature, so I think it was just natural for me.

I was competing to make my dad proud, but it didn't matter to him. He didn't push me at all. He really just wanted me to do anything that made me happy. I remember being a bit nervous to tell him that I didn't want to do the Women's Qualifying Series any longer, and that I actually wanted to study. I told my mom first, and I was nervous to tell my dad. She laughed at me, and said, "He's going to be happy to have you home more."

When I told him, he was so excited he sat up all night researching different degrees I could study.

My dad was my best friend, and we were really close. He would watch me surf for hours and drive me up and down the coastline. He had a bad back, but would surf with me on the really nice calm days. He used to drive me to Durban every day to surf before school. Those are some of my fondest memories, those early morning drives chatting about surfing and life with him. I don't know what his dream was for me, but he was obsessed with a book called The Goal. The gist of the book is that

THE GOAL IN LIFE IS TO BE HAPPY. ▶

LOVE AND SURF

photo by Alan van Gysen

I fell in love while I was surfing in California. I was 18 and kept delaying my return home. My family was a bit worried. Eventually I tried to return home two months after I was supposed to. I had an early-morning flight out of LAX. I had said goodbye, gone through the gates, and just before I got on the plane I heard over the intercom system, "Tammy Smith, can you please meet your party at security." I ran to security, not knowing what was happening; and it was her, standing there, asking me

not to go. I missed my flight and called home from a payphone to tell my family I'd fallen in love with a girl. My mom fought it for a little while, but my family is really supportive of me. My dad encouraged me to tell my sponsors, so that I owned who I am. I love that he suggested that to me.

From the time my dad was diagnosed with cancer to the time he passed away was about two months. We owned a surf camp at the time, and he passed away at home. I don't remember much from that day; but I do remember we had a lot of family and friends hanging out in the garden, keeping us company, and coming to say goodbye to him. At one point during the day, before he passed away, he asked everyone to sing Bob Marley's "Three Little Birds" to him. It was such a beautiful moment, and the best way to say goodbye.

After my dad passed away, I battled to surf, because when I surf, the voices in my head become louder. So surfing was completely on the back burner

for me. I was cooking on yachts in the Mediterranean. When I got back from working on the boats, I promised myself I was going to paddle big waves, like Dungeons and Sunset. I was hoping to have someone to hold my hand through getting out there and all that. But I realized, no one is really going to do that for you, and I would just have to make sure I could handle it and have confidence in my ability and strength. I ordered a board from Grant "Twiggy" Baker and started training. On the back of that, I was lucky enough to get into the first Jaws event. I still can't believe it. Even though I didn't get a proper wave, it was one of the best days of my life.

I do not miss competing. Losing wears on you.

There are so many people doing really amazing things in this life, whether it's pushing their boundaries or doing selfless things for others. But what inspires me is living simply. I want to live a really simple life, and love and surf. ∎

Sea

Mxolisi Nyezwa

South Africa

the sea is so
heavy inside us
and I won't
sleep tonight.

I have buckets
of memory in a
jar
that I keep for
days and nights
like these.

I'm 23 this year. I'm from Fairview Mission, Umzumbe. I was down at the beach, and stoked to see people, like Simo Mkhize and all the guys surfing, so I went to them and told them that I'd love to learn surfing and be a professional one day. I couldn't even swim! First they had to train us in a tidal pool or the river. They trained us how to kick and do dog-swimming. Then after that they taught us the freestyle stroke. Then they'd take us in the water.

Yoh, surfing! It's made me better. Where I'm from, I've seen a lot of youngsters grow up and they end up smoking and stealing things. Surfing took me away from that, and made me focus on my studies. It made me a better person. Now I'm a lifeguard. I work weekends and the season. I do photography. And I'm also teaching the kids to surf with Sisonke Surf Club. I surf trials too. Ultimately, for long-term work, I want a career in filming and editing.

Last year I did an IT course; but after one year I stopped because of funding. The most important thing I learned was that everything we see around us, it's all about the technology. If you want something, anything, you can go into your computer and get it.

I would love to get involved with our future stars and teach them more about the ocean. Most of our youngsters don't know anything. If they come to the beach in the summer, they'll be scared to come out and swim. In our community, now, surfing is accepted. Because most people have seen plenty of the old guys who have been surfing. They grew up on surfing. Guys such as Sandile, Meshack, and Dumisani, they opened the path for us. And now our generation is following that lifestyle.

They say there is something spiritual about the ocean. They say there is a big snake inside, and if you go in there you won't come out. But I think the fear is all in your gut. If you can take away the fear that you have inside, and go out, I'm sure you will have fun. Some of our people don't really go into the ocean. And when they do, they sometimes get sucked by the rip. And when others hear these stories, it brings back that old fear and superstition about the ocean. But we're trying to take that fear away so people can enjoy themselves at the beach.

That's my mission. To take away that fear and teach others to enjoy this thing. When I'm studying in Durban and I don't surf for even a week, I feel like something has been taken away from me. I feel empty and dry. That week can feel like a year.

When I do surf, even if the conditions are bad, I get stoked. I don't know, it's how I express myself. Excited, happy, enjoyable . . . I feel free. ■

photo by Ricardo Simal

THAT'S MY MISSION: TO TAKE AWAY THAT FEAR.

MHLENGI MBUTHO

I was born in Wynberg, Cape Town. My mom moved us up to Joburg because she didn't really have a job. Then welfare intervened and we were separated from her and put into a kids' home. But she eventually escaped with us to Zimbabwe. We went there for three months and then caught a train back, through Joburg and down to Cape Town. Because, you know, back in those days, nothing was computerized.

And within six months, I was surfing.

In 1971, a friend's father came to pick us up, because at that time, we were hanging out with some girls after school at my friend's house, and this father didn't approve. So he grabbed some boards and picked us up and took us to the beach. I was 10.

I joined Sunrise Surf Club and then kicked into Western Province, and just kicked on from there. My first board was a cut-off longboard that had been reshaped into a twinnie, but it just nosedived all the time. I was changing boards every two or three months— whenever I could, you know? I mean, we were super poor. So, whatever secondhand longboard I could swap my other boards for, I did.

I had quite a colorful history in school. I went to four junior schools and four high schools. I didn't want to play rugby, I just wanted to surf. So at each school, I'd get away with not going for about a year or so; and then they'd start fishing. So I'd just tell my mom, we're moving.

Then Ward and Kathy Walkup adopted me. I left Sea Point and they said, "Listen, we don't want you to go to the army, pull into our place." And they put me through matric, and then first year of university. I had to go to university to avoid being called up to the army.

Ward was one of the original big-wave surfers in Cape Town. He opened up quite a few spots. He was a major charger, really good mountain climber, artist, and musician. He was just really good at everything, actually. And Kathy was a professor of biochemistry at the University of Cape Town.

Ward used to make my surfboards. His boards were called Bordello Surfboards . . . as you would.

Another funny story, I made the Springbok team that was going over to surf in the States. My two boards were banned, because one of them had tits and cunts sprayed on the bottom, and the other one had, like, "Free Mandela!" and "P. W. Botha eats black babies" on it. And Robin de Kock (head of Surfing South Africa) just tuned, "Those boards are not fucking leaving here."

It was funny. We were so radical. We were all smoking weed and carrying on. I remember the time the SA Champs were in East London. So, you know, we always had the team meeting, often in the the Long Beach shithouse. And Robin said, "Okay listen, the toad squad's got hold of me, and if you're going to East London, they're going to be putting up roadblocks and you guys might get bust." And we were like, "Ay, don't worry Robin, we promise we'll just take one parcel each." Those were classic times.

I did the competitive thing, I surfed the Gunston. I turned pro just when the sanctions hit South Africa. I never really got that break, from a financial point of view. I was offered to do Europe, and I just went, "Listen, either I'm going to do it properly or not at all." You know? I wanted a proper sponsorship, to give it a proper bash, rather than the old heartbreak story of always being under so much pressure to try and get from contest to contest. ▶

SO, I GO, "WELL, I'M A COLOURED."

I met my first wife, Fatima, at university and we started seeing each other. In second year I moved out, and I was living with my brother in a commune back in Muizenberg, and things with Fatima kicked on. Then, in 1982, I got busted with about two kilos of dope. It was Vernon's dope; but I mean, I was stupid enough to sell it for him. My brother said, "Listen, things are hot with the cops." I didn't tell him I had two kilos in my room, but then the cops pulled in and everybody was there. And the cops said, "Okay, we're taking everybody in." And I said, "No need. It's mine." And everybody was just, like, "No, Davy—don't." And I said, "Hey, fuck off." I mean, that's my problem. I said, "You know, I screwed up." So, there you go.

Luckily, I got acquitted.

After going through all of that shit, I embraced Islam. I thought I needed to clean up my act; and plus, you know, I wasn't doing too well. I was smoking buttons (Mandrax) and carrying on. So I moved in with Fatima. We got married in 1985. That was also during the student riots, and we were quite heavily involved. For three months, I didn't even surf because we were in Mitchell's Plain setting up roadblocks and carrying on. We started the Wynberg Surf Club with all the coloured ous that became the South African

Surfers Union, and we organized the first nonracial SA Champs.

We were living in the Bo-Kaap, Longmarket Street, right next to the mosque. I was a practicing Muslim, and I was still kicking on at university because I was doing, like, two subjects a year, just stretching it out. In '85, I finally got my Teacher's Diploma, and that was the end of it.

Now I had a choice. Either go to the army, or make a plan. So I took a loophole: because I was living in the Bo-Kaap and married to a coloured woman, I applied to reclassify myself as coloured. Everyone was aghast. Even the authorities asked, "You sure you know what you're doing?"

We'd been married in the mosque, but then we also applied for a civil marriage because I wanted to become coloured so we could be properly married. Of course, I didn't mention the army. That all went through fairly easily . . . I just forgot to inform the army about it.

So about six months later, the military police pulled into our offices. Two proper boneheads come in and go, "David Stolk?" And I go, "Yes." Already they were amazed that anybody would own up to their own name, because they'd have to go to the army. So I go, "I didn't know that coloureds had to go to the army." And they look at me, and go, "What do you mean, coloured?"

"Do coloureds have to go to the army?" I asked again.

They go, "No."

So, I go, "Well, I'm a coloured."

"Can you prove it?" they ask.

And, of course, I had my papers with me, so I tuned, "Yes. Now, please turn around and get the fuck out of here."

Quite a few radicals in the coloured surfing community weren't really happy about it. And a couple of white surfers weren't happy either. Probably because I was kicking their asses all the time. They got fairly jealous, and a couple of times they said, "Hey, this is a whites-only beach."

I told them to get fucked as well.

My friend Shani Nagia, he's such a classic. He always used to say, "My bru, I'm telling you, the whites are always going to consider you a coloured, and the coloureds are always going to consider you a whitey."

Exactly. Thick skin, my bru. ■

MY NAME'S ALFONZO PIETERS.

JUST THAT, I ACTUALLY WISH I HAD A MIDDLE NAME, BUT IT DIDN'T HAPPEN. THEY CALL ME ALF, ALFIE, FONZI. A LOT OF OKES IN PORT ELIZABETH CALL ME

FONZI.

I was born in Mitchells Plain, Cape Town, and then my dad passed away, and that forced us to move to Manenberg because he was the one bringing in the bacon, sorting out the house. Manenberg is where all the mischief happened. I'm obviously from a broken home; and when my dad passed away, my mom became an alcoholic, and that's how I grew up.

My mom did the best she could, you know. I went to school, there was food around, and she provided the best she could.

I had this friend, and the mischief started with us bunking school to just stroll around. I started stealing small things, like chocolates, action figures, or cars, stuff that my mom couldn't afford. I would take a train and venture into Cape Town and just wander around. I was impressed by all the tall buildings, because growing up in Manenberg there's only normal houses — you never see tall buildings or bright lights. So Cape Town was basically like New York City to me. I met kids that had been on the streets longer than me, and they taught me worse things to do, like breaking into cars and snatching people's cellphones. I eventually learned the system on

the street, you know. I became street smart. How to take care of yourself, where not to hang out, what not to say, and who to watch out for. What ended up happening was I would stay on the street for two nights, then go back home. But then two nights on the streets turned into three weeks, the weeks turned into months, and then eventually years.

I was very rebellious and couldn't be told what to do. So one thing that drew me to the streets was the freedom. I could go to sleep whatever time I wanted, I didn't have to do dishes or anything, or wake up to go to school. ▶

photo by Kody McGregor

THAT'S HOW MUCH I FELL IN LOVE WITH SURFING

I must have seen guys surfing at a glance, but I never understood what they were doing out there in the sea. When I was on the streets, I was given a million chances to change my life. Ryan Dalton found me on the streets at a very early age, like 10 years old, and saw that I had some potential to turn my life around. But I would run away and come back, run away and come back. Eventually Ryan offered me a deal. If I went back to school and gave it all up, then I could live with him. As I mentioned, I don't like to be told what to do, but he gave me a curfew, I had to do homework, and I couldn't just watch TV all day. They were offering free surf lessons through school, and at the time I wasn't interested, I was more keen on playing soccer. At the last minute I realized that I lived in Muizenberg, and that's where the surf lessons were going to happen—what's the worst that could happen? So I put my name down for the lessons. I stood up on my very first wave! Everyone says this, but I promise you, that first wave I got up I was like, "What the hell is this?! This feels so amazing!" That first wave got me hooked, and from there I started surfing a lot.

And it became such an addiction that I started bunking school for surfing! But they caught on that I was bunking school, so they used surfing to help me. In order to surf, I needed to go to school and do my homework. It was a reward. There were times when I was grounded and it felt like I was in jail. That's how much I fell in love with surfing. I had to change my whole outlook and had to accept what was given to me. So anyway, I started surfing more and more, and my school work started to improve.

Eventually I started surf coaching to make ends meet. The surf shop that I was getting free boards from noticed that I surfed well and thought that maybe I could teach surf lessons. I started coaching everywhere, and that was my bread and butter, my income.

I was kinda in my party phase of life—I was there but not there, you know? I wanted to take my surfing seriously, but only when it suited me. I started competing, and got some sponsors. I wasn't taking it as serious because I didn't believe in myself.

Then I met my wife, Emma. In order for her to take me seriously I needed to take myself seriously. I needed to stick to my job, needed to get my priorities right. I was still doing surf lessons hungover, and I wasn't really there. At the same time I was still trying to sort out my life; I was living on a friend's couch here and there. But it all really started happening when I met Emma. So I thought if I pursue this, I need to take my work seriously and to take my health and everything else seriously. She said that if I wanted to win I needed to go run and train, and surf at least four times a day. She pushed me a lot. She was always in my head! She's the coach in my corner.

Ja! So everywhere, surfing is making a change in people's lives. I mean, look at me, it changed me. It can change your outlook on life. When you're out in the ocean, all you're thinking about is the waves coming, which one you're going to choose, and how well you're going to ride it. And even if you're not riding it well you feel like a kid splashing around.

I became an ambassador with Waves for Change, coming from my background and the kids they work with. We went to do a talk in Port Elizabeth and they were jokingly saying that they wanted to start a site here and they needed a manager to run things. At that time, I had surfed in PE and joked back saying that I would love to live here, and they offered for me to be the site manager. So I spoke to Emma, and she was in! So we did our interview and that's how it started.

Now they're saying black lives matter, and to me I thought that all lives matter, but then if you think about it and why they say specifically "black lives matter" is because black people have not been treated the same. We're still not treated the same because of the apartheid era—there is still lots of racism around, and it's undercover racism. You don't always see it, but it's there. To this day, in some shops, you'll get followed around. It happened to me not long ago, and I felt really embarrassed, I felt targeted. So I see where the BLM comes from, especially with the oppression from back in the day. It's still there; society has kind of molded us that way. It's going to take many years to change things, but I mean it's already a little bit better than it was in the past.

* * *

I can ice-skate. Ja, I can skate, I can stop really quickly and do some tricks . . . I had my own skates and everything. My sister even said that I should've competed.

When I'm not moving I play video games on my phone. I'm playing the WSL game, Tru Surf, and also Candy Crush. Emma beats me up about it because she introduced me to it about five years ago and I'm still playing it. I'm always looking out for new games, especially addictive games. I have some problems sleeping—I mean, last night I woke up at 3 a.m. with the little one and couldn't go back to sleep. So I just played until I was tired. ■

photo by Kody McGregor

I grew up in Umbilo. My neighborhood . . . I wouldn't say it was poor because that's relative, especially when you're talking about Africa. I could never say that we were poor, because we had a roof over our heads. We had walls around our property. But my family didn't have a lot of money. Just compared to some of the other people that were at the beach, in and around the community . . . it was nowhere near the same class.

From early on, I always saw how hard my parents worked. My dad would go to work at, like, 6:30 in the morning. He was a refrigeration technician by trade, as well as a shaper. My mom was a school teacher. So it was ingrained in me, to get something, you have to work super hard. In my neighborhood there were a lot of bad influences. Whether it was, like, gang stuff, or drug use, that kind of stuff was happening. Fortunately for me, by 6 or 7 years old, I was really

driven in the competitive surfing and soccer mindset. In my mind it was like, if you want to go anywhere, you've got to just put your head down and grind. At 10 or 11, my parents had to start having garage sales, sold their car, and sold bits and pieces of furniture just so that I could book my first ticket to go to Australia.

That's when I first realized, like, "Oh shit, they are sacrificing all these things so that I can go and follow my goal."

I don't really get doubtful at all. I just kind of play the ball. If my aim is to throw the ball into a hole, even though the hole might be miles away, I'll never doubt myself until I've thrown the ball—when I see it curving off. But before that moment, it's all just like, "Oh yeah, I'm gonna make that thing."

My earliest memory of the sea—we would go to Durban harbor, and my dad would windsurf. That was when I kind of put sand and water together. That's what I remember . . . and big ships. That and bluebottles. I got stung by bluebottles, wrapped around my legs, everywhere. It was pretty horrifying. I was crying my eyes out. My dad was like, "Ah, we'll take you to the ninja shop, and we'll get you some ninja stars and stuff." In Addington there used to be this little ninja store. I loved it.

When I'm riding a wave, it makes my life feel complete. I feel warm, and very okay with everything. Like everything's okay. I'm not too religious but I definitely believe in a higher power. Like, we are definitely made up of stardust and atoms. We're so lucky to be alive, we're this little speck in the middle of this galaxy of thousands of galaxies. Some people really don't like to think we're just, not really anything, you know? Sometimes, I'll use that as a technique to calm down. ▶

photos by Alan van Gysen

When you've got a heat coming up, and you think it's a big deal—it's really not, in the big scheme of things. The sun is still gonna set, it's still gonna rise tomorrow, you ain't gonna change a thing.

For me, I just want to be a work in progress my whole life. I want to continue to get better at anything and everything that I do. So, lately, it sounds weird, but I've been really into sewing and embroidery. I wanna know all the details about it, and how the garments are sewn, using French terry cloth, or, what kind of wool are they using. I go through these little moments of,

like, four to six months, where I'll get really into something. At the moment, I'm trying to make some SMTH Shapes hoodies; but I want them to be, like, the best quality. Perfect. So I want to know where they grow the cotton, and what they use for the stitching and the weave, right through the whole production. I dunno—I just get into these weird little gigs.

I don't play any musical instruments—the triangle maybe, but that's about it! I really love watching people play guitar and piano. My ADHD doesn't really allow me to get involved there. I think that's why surfing really works

for me, because it's such a great activity for someone who has ADHD, or anything like that, because it's constant, it doesn't stop, and you can always just keep going, catching waves. The waves are never the same, so it's always changing, always something new, even on the paddle back out, it's just foamy . . . another one, okay. I find myself getting bored with stuff that's kind of monotonous, I get over it quickly.

When I think of South Africa, I think of rarity. I think, you're a diamond, you know? Especially in our industry!

THE SUN IS STILL GONNA SET, IT'S STILL GONNA RISE TOMORROW...

I have dreamed of surfing, obviously. My dreams had these cartoon-drawn images.

I talk in my sleep sometimes. I was in Portugal one year, and I had lost that morning, and it was the afternoon and I was asleep on the couch, and I just started talking: "No, bru, my heat's coming up, I'm surfing again in about two hours." And everyone was like, "No, bru, you lost." And I was like, "No, no, I'm still in. I've got my heat in a little bit."

Music . . . it all depends on my surroundings. I listen to music that relates to the conditions. So if I'm

watching J-Bay, I need stuff with long, drawn-out . . . like a Prince guitar solo. If it's really upbeat, fast, chop-chop-chop, like Brazil, it could be rap music. Anything, really, except death metal. That's too hectic for me.

Every time we have waves on the south coast or in town, in Durban, we just go straight . . . bunny chow! For me, it's the bean with mutton gravy. If we're designing boards in my dad's factory, we'll go to North Beach Café, or that spot next to the ice rink—it's a little dodgy though, they probably sell drugs and shit on the side, but the bunnies are good.

Being six foot three, and a white person—it's very rare that people are going to assume that you're African. On the other side of it, you carry a lot of weight, and need to make sure that what you do represents it right. I want to be the people's people. Just be stoked on where we're from, and give people hope to know they can do it themselves.

For me, honestly, I go out swinging every year; 100 percent. That's my duty . . . and to do that well. I'm not able to write down the judge's scores for me. You don't pace anything. You give it 100 percent, every single stop. That's all I can control. ■

Sliding as therapy with Waves for Change coach Chemica Blouw

Banana Culture. It's what we live by, and we named it because of how the shaka looks like a banana.

Waves for Change is really about mental health. Yes, there's surfing, but surfing as a form of therapy, to help kids work through their issues and deal with trauma they've experienced or are experiencing. Water is extremely therapeutic. Even if you spend an hour in the water, if you're having a bad day, you'll come out feeling a lot better. We also teach coping mechanisms, like meditation. It works for me, and it definitely helps the kids.

We're creating a space where kids can be kids. Because they don't always get to be kids in the communities they come from. Lavender Hill, Masiphumelele, Monwabisi . . . these communities are high risk, there's constant violence, some come from abusive homes, and the kids don't have safe spaces to be a child because they've grown up too fast, taking on adult responsibilities.

As a coach here, I can make a change, have an impact, and share my love of surfing. Even though surfing only makes up a part of the program, whenever we're doing the other exercises, like meditation or whatever, the kids are always asking, "When can we go into the water?"

The community I come from helps me relate to these kids. My childhood wasn't as traumatic; I didn't come from a violent home or an abusive family. But the people around me did, and so I was exposed to these realities. And in the same way I was protected from these things, I can now try to do the same for these kids. And that's Banana Culture.

Banana Culture. It's what we live by: Protect. Respect. Communicate. Being bananas means we protect others and ourselves from harm. We respect each other and ourselves. And we practice open communication.

Usually we'll be in our wetsuits, rain or shine, at 9 a.m.; and the only time we won't go into the water is if the shark flag is up. We move onto the beach, do a check-in, do a breathing exercise, some fitness, then another check-in. These check-ins are important. We lay down in a circle, close our eyes, and just talk about how everyone is feeling. If someone's not feeling great, we'll usually discuss it privately, one on one, but sometimes the kids will share with everyone.

The very first lesson we do is immersion. We'll link arms to form a chain, and wade into the water together. After about ten steps we check in with everyone to see if they're okay, and if they are, we can go out a little bit farther. That's communication. Talking to each other, asking one another how we're doing. Then listen, be respectful, hold tight, protect your friend, and don't break the chain. If everyone's feeling good, we can go a little deeper. But if someone's not feeling okay, we respect their feelings, we stop, turn around, keep the chain, and walk back to the shore. That's bananas. ▶

117

CT

CHEMICA BLOUW

Another part of Banana Culture is TLC: Tell it. Label it. Celebrate it. So, when a kid gets up and rides a wave, you tell them what they've just accomplished: "Oh my word, you just surfed!" Then we label it, "That was your first wave — amazing." And then we celebrate: "Yeeeew!" Through everything we do we teach others to do the same among themselves. Teach the kids to teach their friends, their families, their community . . . and it becomes this ripple effect. Sisonke Simunye. Together we are one. We are one together.

When you're surfing, actually riding a wave, it takes all your focus. You can't think about anything else but riding that wave in that moment. That's the therapy coming in. You'll see kids start their day feeling a bit down, and then, after they've been in the water, there's a totally different mood. You can't be in the water and be upset. It's bananas.

There are so many surfers who are now being encouraged to stay in school, to focus on education, to be respectful to others. I've met 20-year-old surfers who are still bananas. A wave will come through and they'll be in the spot for it, and when they turn around, they'll see me and give the wave to me. "Ah, shot bru!" Something like that can change the whole mood in the water. Suddenly everyone's being bananas and giving each other waves. ■

photo by Alan van Gysen

CHEMICA BLOUW

BRA HUGH MEETING MAMIWATA

Sharing his uncle's story, Mabusha Dumisa Masekela takes us on a trip from Hugh Masekela's Witbank roots to golden-era New York City—and then back to Africa, and a meeting with Mami Wata. . . .

"My biggest obsession is to show Africans and the world who the people of Africa really are."—Hugh Masekela, April 4, 1939, to January 23, 2018

Born in Witbank, South Africa, Hugh Masekela, at the age of 14, picked up a trumpet and began to hone his (now signature) Afro-Jazz sound. In 1960, at the age of 21, he left South Africa to begin what would be thirty years in exile from the land of his birth.

Hugh's arrival in New York coincided with a golden era of jazz. The young Masekela watched greats such as Miles Davis, John Coltrane, Thelonious Monk, Charlie Mingus, and Max Roach. It was under the tutelage of Dizzy Gillespie and Louis Armstrong that Hugh was encouraged to develop his own unique style, feeding off African rather than American influences. Trumpet Africaine, his debut album, was released in 1963, and in 1968, his instrumental single "Grazin' in the Grass" went to number one on the American pop charts and was a worldwide smash, elevating Hugh onto the international stage.

From early 1972 to about 1979, Hugh Masekela maintained a most unique position of having a niche in the US music community while at the same time conducting his career from (West) Africa. What manner of wizardry and bewitchment enabled this course of events? Like some unexpected but much appreciated superhero, Hugh leads us down uncharted paths of mystery and music, able to live in three countries and four cities at once. You may have heard of the slogan "Think Globally, Act Locally"; in Hugh's case, it would be something more along the lines of "Think Locally, Act Globally."

Hugh's sojourn in Africa was incredibly peripatetic, and productive, in what was an already densely packed creative career. He arrived in Guinea with a ticket that took him all the way to Zaire (now the Democratic Republic of the Congo), with stopping points in Liberia, Gambia, Cameroon, Ivory Coast, and Nigeria. In this fecund period, Hugh was involved in innumerable collaborations that resulted in a six-album discography that would stake his claim to being an African musician. During this time, Hugh was also involved in producing various transcontinental festivals, including 1973's Higher Heights in Liberia, FESTAC '77 in Nigeria, and Zaire's '74 music festival, which was meant to accompany the Ali versus Foreman "Rumble in the Jungle." An injury to George Foreman put a six-week delay on the event, and the festival's intended audience of international tourists rescheduled their trips. But Hugh wanted to move forward, and filled the stadium in Kinshasa with 80,000 people nonetheless.

In Ghana, Fela Kuti introduced him to the band Hedzoleh Soundz, and it was with an ever-evolving Hedzoleh (that would later morph into Ojah) that Hugh would record Introducing Hedzoleh Soundz, a collection of popular traditional West and South African songs. Singing in Twi, Fanti, Ga, Ewe, and Hausa, Hugh delivered a joyous melange of fishing songs ("Rekpete") and criminal warnings to rural folk newly arrived in the urban environment ("Languta").

If Melody Maker was a balancing act between Africa and the US, You Told Your Mama Not to Worry—the last of Hugh's Casablanca albums—is a threadbare search through a depleted cupboard, coming up with just enough ingredients to make a meal. If Frank Sinatra had been born in Witbank instead of Hoboken, and played the trumpet instead of being a singer, he would have made this record instead of September of My Years—the huge difference being that instead of the musty cigarette-and-perfume smell of a New York Bowery bar, it's the muggy, tropical night of a West African roadside spot, but with all of the same existential questions.

On a groove-based record, the titular song is an extended funk blues, with some down-in-the-bar blowing from Hugh. "Soweto Blues," its close cousin, recalls the June 16, 1976, Soweto student uprising, which horrifically echoed 1960's Sharpeville; in both cases, unarmed protesters were indiscriminately shot and killed. ▶

It remained a staple of Miriam Makeba's stage show, until her passing in 2008. With Hangover and Makonko vibin' on some smooth shebeen trip, the rest of the album—"Black Beauty," "The Mandingo Man," and "Mami Wata"—all settle into an easy-by-the-beach, cold beer and cocktails, pass 'n' puff groove, dipped in jollof rice, fufu and peppa soup, with a bit of kenkey on the side. Oral traditions play a big part in African culture, from the praise poetry of the south to the griot traditions of West and Central Africa to the Berber traditions of the north. Though disputed by Western academia, these traditions still serve as a powerful foundation of African identity. For example, in West Africa—particularly in Liberia—before the advent of the internet, a common form of amusement for youngsters was story time. In this practice, one or another among the group who has the skill tells a tale.

Storyteller: "Once upon a time . . ."

The group in unison: "TIME!"

The storyteller tells the tale.

These tales are usually fables, some with a moral, some more fantastic: Monkey, Anansi the Spider, and the Mami Wata. The Mami Wata is a spirit of the water, of the sea. Like Sirens of Greek lore, she is often a temptress of ethereal origins. She abducts her victims to her dimension, and in that paradise fulfills their dreams, returning them to the surface revitalized and renewed. Along the West African coast into Central and Southern Africa from Liberia, Nigeria, Ghana, Cameroon to Togo, Benin, the Congo, and Zambia, Mami Wata has imprinted herself into the traditions.

Such was the impression of Mami Wata that on his final studio recording, No Borders, Hugh was inspired to create "Congo Women," another tale of a Mami Wata. Enchanted and mesmerized by her beauty, the narrator dances with her through the Kinshasa night. After she vanishes into the bathroom, she never reappears. His friends assure him that he was alone on the dancefloor. Entranced, he is left to ponder: was she there, or a mere figment of his imagination?

Mami Wata lives! ▪

WESTERN SAHARA

ALAN VAN GYSEN

photos by Alan van Gysen

WHUUUUUMPFF!

Have you ever heard the sound a car makes when it hits a sand dune? It's a deafening thud that fills the vehicle, as you're jolted awake and launched into the air. Heads bang on the roof; there's blood on the road all the way into the Western Sahara. We're here, billowing down from Morocco through all this desert and ocean, looking to experience something new. Another culture, another land, another stretch of uncharted water. But in the pale dawn breaking outside the window, all we can see is a yellow blanket of never-ending sand.

To access the numerous inaccessible areas in a disputed territory such as Western Sahara, you first need special permission from the powers that be; powers like Mr. Laroussi.

The minister of the Interior is dressed immaculately in a suit and tie. He sits casually behind a large polished desk, and is clearly in control, if not somewhat amused at the troop of scruffy surfers who have scheduled this appointment with him. We're lost in translation as Laroussi and Rachid engage in rapid-fire bursts of Arabic and laughing. It all bizarrely feels very much like we are back in the principal's office awaiting our fate; only this time, instead of a cane, the principal has a big rifle in his cabinet.

It's not just about translating, of course. It's about playing the game, being polite, laughing at jokes, and knowing when to keep quiet and nod.

Were it not for Rachid's smooth negotiation skills, we may well have been told to take our toys and get the hell out of Laroussi's sandbox. But instead we gulp down two servings of Sahrawian tea, politely decline the offer of a younger wife, and get Laroussi's blessing. Thanks to the headmaster of the Western Sahara, we are given select and special permission to enjoy the "off limits" stretch of coastline we hungrily want to access. If we run into any kind of trouble with the police, gendarmerie royale, or military, all that is required is a phone call to his office.

The only other thing we need before leaving town for the uninhabited coastline to the south is some meat for our tagine — a traditional stewing pot — and a good supply of tea. There aren't many cows or sheep roaming the desert, though. And if you've ever wondered what camel tastes like, it's not as rough and sour as I'd imagined. It's more like lamb, both in texture and flavor. Quite palatable, really — as long as you avoid looking at the long, furry hunks of hind leg that hang up in marketplaces across the region. Brahim and Hassan slide open the last pole blocking our entry to the Promised Land. We've become used to the procedure, after numerous checkpoints — the polite greeting, showing our special permits, and then waiting. After making the obligatory call to Laroussi's office, the military guards warm to us and invite us into their humble home to share a glass or two of Sahrawian tea before we move on.

If sand is the flesh of the Sahara, tea is its blood. The dark, minty brew is vital to survival here. It makes friends of enemies. Overcomes class. Lubricates conversation. It's the glue that binds together all social interactions. In the desert, a stranger's hospitality can make the difference between life and death. Tea symbolizes this interaction, distilled over countless generations into a sweet, pungent flavor. It is utterly addictive.

Driving slowly down the escarpment that divides right, up, and eventually down, we clear the last rise blocking our view. A tan-colored beach with emerald-green water appears over the horizon. We look up to the large rocky outcrop, where a flawless three-foot wave spins down the point to celebrate our arrival. You could not script a surf cliché better. Best of all, there's not a soul in sight. ▶

"FOR I AM NOT ASHAMED OF THE GOSPEL, BECAUSE IT IS THE POWER OF GOD THAT BRINGS SALVATION TO EVERYONE WHO BELIEVES: FIRST TO THE JEW, THEN TO THE GENTILE." - ROMANS 1:6

In my darkest hour, and in a time of greatest need, the grace, love, and mercy of Jesus Christ saved me.

MADAGASCAR

Traveling to and around Madagascar, in search of my malaria. The captain and lead surfer were at loggerheads about the expedition and were turning back — the conditions were too rough for most except this group of intrepid surfers. Fortunately, sunrise on the fourth day saved us from certain mutiny, the welcome sight of a sheltered bay settled things temporarily.

We made camp on the edge of the ancient African beach without a care. Even the knowledge that this was one of the sharkiest coastlines in the world didn't deter us too much, thanks to the anti-shark devices strapped to our ankles whenever we entered the line-up. It wasn't until sunset on the third day when things went very wrong. . . .

As the African sun set over the mountains of the Masoala rain forest, our boat — Blue Fin — was caught too far inside while collecting surfers, and the captain floored the engine directly toward an approaching wave to avoid getting swamped. The boat exploded off the back of the wave, and our trusty Malagasy deckhand Sisi was launched off the stern, high into the air. Time slowed down in that moment, our senses on high alert, and then we heard the sickening sound of bone cracking — a femur, as Sisi landed on the handrail of our boat before crumpling to the deck, his knee facing perpendicular to his hip. Everyone rushed to the boat, knowing how serious the situation was. With the collective knowledge of years of first aid, we made a splint for his leg using a paddle, and stabilized him as best we could. By the time nightfall came, we had strapped Sisi to a SUP (stand-up paddleboard) and begun the blind search for a doctor, hospital, or even a shack to last out the night. Calling my GP back home by satellite phone, we were told to watch out for life-threatening internal bleeding, and how to incise the already swollen thigh if it got any worse.

With Sisi up on our shoulders, we trekked for hours toward a river mouth that matched the description given to us by shark fishermen, and a village. There was no time to contemplate what lurked beneath the water. We jumped in and swam Sisi across the river, the moonlight as our only guide. On the far bank we soon found a small village, where we found a local who owned a car. Eventually he agreed to take Sisi to a military hospital somewhere in the jungle, so we loaded him into the van and watched as he waved goodbye and disappeared into the dark. In typical Malagasy style, he never complained or cried out throughout the entire ordeal.

Aching and exhausted, we watched as the dilapidated vehicle disappeared into the night for what we could only imagine would be an excruciatingly bumpy ride. The horrific ordeal, and the three-hour slog along the high-tide mark carrying his dead weight had taken its toll on us all, both physically and emotionally. By the light of the full moon we made our way back in silence — barefoot, and wearing just shorts, thinking only of our little camp on the edge of the jungle, and the sleep we craved more than food and water.

Ten days later, with a day to spare in Antananarivo before our departure, we visited Sisi in the hospital — his leg all bandaged, and a smile on his face. According to his doctors, had we not stabilized him correctly and gotten him to medical care as quickly as we had, he would have died for certain. ▶

ANGOLA

You have to travel through the hell that is Luanda to find the heaven that is the southern coast of Angola.

We knew we were in for a real adventure the moment our boards were denied safe passage on TAAG airlines from Luanda to Lubango, and a seventeen-hour local bus ride stood between us and the world's longest left. The destination and journey ahead suddenly felt as far and deep as the divide between rich and poor in this crazy city they call Luanda. The world's most expensive city. But as chaotic and depressing as it sounded, nothing would defeat the optimism and smile that is Dane Gudauskas. He even had a tent spray-painted with a smiley face for the trip, just to let everyone know we had come in peace and happiness with only ultra-good vibes. When Kepa (Acero) broke the news to us, Dane's immediate reaction was the "pick-me-upper" we all needed. . . . "This is going to be the best trip ever!" He couldn't have been more right.

Getting to Angola's extended, slightly more surfable version of Skeleton Bay isn't easy. The bus ride alone, as wild and core as it had been, was but the first hurdle that needed negotiating. Just when you think you've got a clear track to the finish line, another hurdle presents itself around the bend. Like getting lost in our own car on the invisible desert "road" from Namibe just after getting stuck in the soft sand yet again, an overheating radiator in an already hot environment, and blowing out another wheel

(our spare), the retread slapping the side of the car with nauseating intensity. If there's one thing you need in Angola — anywhere in Africa, for that matter — it's patience and faith. Waiting on the edge of the Angolan desert, it was all we could do to daydream of the waves we knew were pouring into the bay two hours away during this rare swell we had chased. Just when hope seemed to melt into the mirage and afternoon light, an ambulance came into view and assisted us with a spare wheel and some much-needed plugs. It never ceases to amaze me, the generosity of strangers on the road in Africa, who help you put these kinds of hurdles in the rearview. People such as the Portuguese expat hotel manager in Lubango, who put us up for a night of luxury after the bus ride (he also organized our car, as renting one as a foreigner in Angola is all but impossible); or Ana, the kind-hearted and friendly volunteer in Namibe who helped us more than a few times.

Standing on the sand for the first time after our ordeal, we didn't dwell on the past and things beyond our control. Board bags were ripped open, fins hastily screwed in, and we were out there! Rubbing shoulders with intoxicated locals and having crying babies dumped on our laps on the bus was a distant memory after the first duck dive. About two miles of tubes and empty walls was all that was in focus. ▶

GHANA

Sam Anani has a bushy mustache and large hands, thick with calluses from working his fishing nets. "It's amazing to watch people like him surf these waves," he says, pointing to South African Michael February, as he bobs in the ocean waiting for the next set. "I would like to do that, but unfortunately I am aging. . . . " He laughs. We're sitting in the shade of a big dugout fishing boat in Ghana, knees up, scratching the sand with a stick. "So I'm not sure. But I will try to influence my kids to get into it, because it is very amazing, especially this guy . . . he is very wonderful. The way he surfs . . . I have never seen this type before. Some surfers have come here before, but he is different." He smiles, and claps his big hands together. "Extraordinary!"

Rumor and research had led Michael February and me to a small fishing town in Ghana, hoping to experience and document some hypnotic waves and music in this rich and vibrant part of West Africa. It started with Afrobeat—a blend of traditional Yoruba music with jazz, West African highlife, and funk, made famous by Nigerian artist Fela Kuti—and a track we had heard from a raw and passionate musician by the name of Stevo Atambire. Interestingly, despite the hope of getting some waves, our expectations were low in this regard—an enlightening discovery in itself, and really, we had embarked on the journey from South Africa to experience rather what Ghana had to offer in the way of music and cultural diversity. Being fully open and available to whatever

opportunities came our way, our immersion into Ghanaian life led to an unlikely invitation to the home of one of Accra's highest-ranking members of society, and a private concert we'll never forget.

At first the unfamiliarity and opulence were uncomfortable—the mansion, the collection of luxury cars, five giant, pedigreed Rottweilers, the offer of anything we wanted, and the seven-piece band setting up just for our pleasure—but then the warmth of our host and the captivating sounds of the "Aborigines" Afrobeat group eased our minds and moved our souls to a steady beat and rhythm of Africa we were familiar with. Watching and listening to seven people improvise—seamlessly weaving off and back on to the beat, and then synchronizing again as they did—the depth of their connection was obvious, as was the intuitive presence of rhythm and flow. For two hours they played, and for two hours we sat in awe. That such a performance was being put on for an audience of so few was too strange to fathom, and as surreal as sliding beneath the ceiling of a curling wave.

A few days later we encountered another unexpected and natural musician, and a natural surfer— rhythm, flow, connectivity, presence, improvisation, and expression. Especially here in Africa. It's what draws us to people and places like this, and it's what inspires us to discover our own unique gifts and use them to uplift others. Looking up and then down the beach, a song caught my ear. Fishermen were chanting

while pulling in their nets to the rhythm and flow of their collective voices. I couldn't translate the words, but I understood every beat. ■

BURKINA FASO

CÔTE D'IVOIRE

Tamale

GHANA

TOGO

Kumasi

Accra

THE RAP THAT IS COMING OUT
NOW ON THE BACK OF BLACK
LIVES MATTER IS REALLY GOOD.
IT'S DIFFERENT, MORE MEANINGFUL,
IT HITS HARDER.

I WAS BORN IN INHAMBANE, MOZAMBIQUE. MY DAD IS FROM KOREA, MY MUM IS FROM INHAMBANE. MY MOM AND DAD'S MARRIAGE WAS NOT RECOGNIZED IN KOREA. SO I'M MOZAMBICAN. I DON'T HAVE ANY OTHER PAPERS.

I'M SUNG MIN CHO (MINI)

When I was in South Africa, I grew up as "the Korean kid." Because I wasn't surfing, I had lighter skin and short hair; so I guess I even looked more Asian. I had the whole schoolboy look. And then when I came to Tofo and started to surf, I became "the Mozambican kid." I always thought of myself as half 'n' half. But here, people really embraced me as "the Mozambican."

I had never really met any other Mozambican/Koreans. To this day, the only others I know are my brothers. It's a very interesting mix. My mom was an English teacher on the side—just to make some money—to people who came to Maputo. And my dad was on a business trip to Mozambique, doing something in a cashew nut factory, and he needed to learn English and Portuguese. So he met my mom for lessons, and that's how it went.

The dream I'm chasing to this day is to become Mozambique's most decorated surfer. Whatever it is, I'm going to get there. The moment I was pushed onto my first wave is like a bookmark in my life.

I only fell in love with the ocean when I was 12 years old and my family moved to Tofo—the beach town a few kilometers from Inhambane—after bouncing around South Africa for much of my childhood. Tofo was different. This little village sits like a small pinprick on the edge of the Indian Ocean, known for its iconic dive sites, sandy roads, and coconut trees, and its mellow, off-the-beaten-track vibe that attracts backpackers from all over the world. But mostly, it's known for its waves.

I was 14 years old when a neighbor loaned my two brothers and me a 5'8" neon-colored Wedge surfboard, after he decided we were spending too much time sitting on the beach.

It only took that one push, and a call from behind me—"Close your eyes and stand up!"—for me to pop to my feet, feel the glide over the water, and immediately be hooked.

Barely two years later, I found myself on one of many missions down to Durban to try to get eyes on me—in the hopes of potentially, some day, landing my first sponsorship. Every day I was out in the ocean, desperately looking for a way to take my surfing to the next level. This is when I met Tom Hewitt from Surfers Not Street Children. And even though I was traveling to Durban to look for my own personal opportunities, I became increasingly interested in this organization and the positive effects it was having on local South African kids. It didn't take long for Tom to mention wanting to branch out to Tofo—and to put me in charge. ▶

"THE POPE LOVES SURFING!"

Then Kelly Slater made an edit called "Continuance" that featured Tom and Surfers Not Street Children, and one of the Pope's representatives saw it and showed it to Pope Francis, with the suggestion that maybe they should support this thing. Funnily enough, the Pope loves surfing! A lot! He invited Tom to Rome, and I think Tom proposed the idea of opening up a Surfers Not Street Children branch in Mozambique. The Pope agreed. So now we're the only surfing program under the Pope's organization, Scholas Occurrentes.

I was homeschooling here; money was tight with three brothers, so there was no way I could just go and surf without a sponsor. Before surfing, I was clueless. There's nothing to do here. No ways to make money. Surfing opened so many doors for me. I never really had the vision of becoming a professional surfer—I started so late. It just kind of happened, because I improved so fast. That's when I started to realize, this is something I can do to make money and do my bit to support the family.

I'm the first Mozambican professional surfer. I've already achieved that. But it's difficult living here, because there's no one to really push you. That's why I go to Durban as often as possible. Durban is a high-performance center—there are so many guys surfing so good—it's a great place to be.

In Tofo I don't have access to coaches, there are no gyms, I have to do my own thing at my house. There are no good surfers to push me, so it's hard. I just take it day by day, what we call "MacGyver" here. I'm just doing MacGyver, trying to make it work.

It's a tough one, but I'm paving the way. So when there are kids who come after me, it will be all set up for them.

Tofo Surf Club is essentially an after-school program for Mozambican kids to learn English, have good meals, play team-building activities and sports on the beach, and, of course, to surf. It keeps kids away from the party lifestyle that drags so many people into its grip in Tofo. But they know that if they get hooked into that culture, surfing will inevitably fall onto the back burner.

It also keeps kids on the straight and narrow with school. This was important for me as well, and forced me to make a decision early on that surfing was more important and powerful than any drug.

I started as the head manager, and now I've taken on the role of country director of Mozambique as well. Seeing Mozambican children fall in love with the ocean and with their surfboards has been an incredible experience, and one that only enhances my own passion for surfing. Living in Tofo is unique, in that surfing seems to be the thread that keeps this small ocean community tied together.

As much as I plan to continue pursuing my work with Tofo Surf Club, I'm still chasing my dream of becoming the most decorated Mozambican surfer of all time; maybe even becoming one of the top 100 surfers in the world. I know that I started late, but I'm putting myself on the map as a surfer to be taken seriously. To me, there's just no other option.

I've always been very big into sports, and I'm very competitive. In South Africa I played field hockey and football. I was 12, and playing under-16. Most people don't know, but I'm a really good soccer player. Soccer was my life before surfing.

My dad was the only one who didn't know a thing about surfing, but he never doubted it, not once. He always says, "I know you can surf good." Even though he doesn't know what good surfing is!

To get pumped, I listen to rap. Mainly rap. I'm that kid. Travis Scott, Roddy Ricch, Gunna, Don Toliver, Eminem, Wu Tang. But the rap that's coming out now on the back of Black Lives Matter is really good. It's different, more meaningful, it hits harder. I've been enjoying it.

In Tofo, when there's no surf, or when we get bored, I play football on the beach with friends, or just hang out, watch surf films on the web, and play PlayStation.

photo by Tate Drucker

134

THE HAND PALM HOLDS 7 STARS

KUNYALALA NDLOVU

1

2

If you ask most surfers from southern Africa (the largest population of surfers on the continent) what creature they fear most in the water, they will say the great white shark. This is boilerplate, as everyone almost expects to have their chance to punch a great white in the nose (à la Mick Fanning, in the J-Bay Pro Final, circa 2015). But for this writer, the water-birthed creature that fills me with dread is the hippopotamus.

Did you know that the ungainly hippopotamus is the world's deadliest large mammal, killing on average five hundred people a year?

Growing up visiting national parks across southern Africa, near large bodies of fresh water, I was not starved for hippo horror stories. My parents, friends' parents, old bushmen, scouts, rangers — everyone in Zimbabwe has a story about a hippo.

My memory is littered with horror stories — of the one that snapped a canoe, the one that put a hole in the speed boat, that maimed the child. I cannot possibly imagine why on Earth anyone would want to get close to a hippopotamus.

Yet before me, I note — with an inappropriate curiosity — a now-famous National Geographic photo from the early 2000s by Michael Nichols. In a beautiful ocean break on Loango Beach in Gabon is a hippopotamus with its eyes and nose bobbing out of the whitewash, bodysurfing. Some people see one, some say two, but

truthfully, there are three, and that's three too many. The story goes that Michael took this photo when he was advocating for Gabon to protect its rich nature, biodiversity, and unrivaled beauty. A meeting in a New York hotel with Gabon's then-president, Omar Bongo, resulted in the small West African nation enshrining 11 percent of its natural land as national parks. And the rest, as they say, is history.

Gabon has long held a distant fascination—mostly for its peculiar history, and its semi-decent soccer team. Prior to the fifteenth century, the Kingdom of Laongo controlled the south coast, and was in fact made up of seven kingdoms. As with most of the continent, Portuguese settlers were the first Europeans to have made contact here, around the fifteenth century, before the Dutch, French, and English followed. The ones who stayed promptly named the region Gabão, an old Portuguese word for a coat of sorts, attributed to the shape of the Komo tributary, which runs for over 200 kilometers (124 miles).

What is abundantly clear is that Gabon has always attracted outside interest. I recently discovered a map of the ancient Kingdom of Loango overlaying a modern map of Africa—and like the hippo's nose, something odd rises up. This precolonial kingdom just north of the Congo made up a large proportion of modern-day Gabon, with numerous winding waterways—even making contact with the source of my hippo horrors, the Zambezi River. But facing the Atlantic side, there is a small gap that juts into the ocean—a hidden doorway, almost like a channel.

The only route from the ocean into this rich kingdom was through this funnel, which made access difficult.

It strikes a poignant metaphor. Gabon was and continues to be a rich region, with ecological and mineral resources. It has one of the highest GDPs on the continent, albeit marred by inequality. Oil is in abundance in its oceans, while the natural environments are teeming with flora and fauna. The beaches are as beautiful as the waves.

A nation rich in oil, minerals, biodiversity, land, and waves makes Gabon the perfect candidate for a new Afrosurfonomic framework. Like a number of African nations, Gabon has its challenges, but the opportunity that lies here is worth the pursuit. In fact, it has been said that Gabon could be Africa's surfing version of Costa Rica. And if so, why not then use the whole cow? It's estimated that the nation's oil reserves will run out by the year 2025. Ecotourism will become an even more pertinent economic focus for the nation's well-being. But a future with surfing would be a significant driving force, delivering both economic and community benefits. Few places on the planet could offer the opportunity to share a lineup with hippos, and paddle with elephants.

No doubt about it—Gabon is a surfing utopia. The opportunity for a developmental framework to weave the economic benefits of sustainable surfing safaris with the social and environmental advantages offered by supporting and encouraging strong local surfing communities is . . . uplifting, to say the least.

But why stop there?

In the surfing community we have a tendency toward a type of "saltwater amnesia," and often forget that though we spend a few precious hours in the water at a time, we are made up of a community of rich, diverse, and multidisciplinary individuals. Our tapestry of skill sets is rarely harnessed or harmonized together; and yet herein lies a golden opportunity, accelerated further by the recent events of 2020. As seen in the tourism-saving "work from anywhere" pivots of Barbados and Fukuoka, the death of the office now means that surfers can live and work inside the adventure, instead of saving up for ten-day boat trips to Indonesia every few years.

When this expat community of surfers arrives, aside from contributing to the local economy, it can also offer up its skills, time, and expertise for the betterment of the near-future state of Gabon. You're an accountant? Teach some, and do some locally.

You're a designer? Teach some, and do some locally. Yes, we'll need conservationists, but we'll also need engineers, advocates, and doctors.

Theoretically, this could work. But it'll be doomed if a cohort of privileged, predominantly white surfers turns up to pursue and indulge their own pleasures, as witnessed across Africa's multibillion-dollar luxury safari and hunting industry. The concept of Afrosurfonomics should not be another enabler of the white man's playground, nor should it be thumped as loudly as the missionary's Bible. It needs its own wax to keep the framework sticky.

An old friend of mine with a brief career in politics once told me about the idea of "no surprises"—that the best way to galvanize two disparate groups is to get everyone to co-create their future story together, from the start. In this instance, all the stakeholders know that if they own it, the results will not only be great and useful but there will be no surprises.

In this manner, the local community builds what it needs—it doesn't have to be grateful for what it never asks for. And the visiting surfers become facilitators of the build.

In all of this, the active and sustainable approach serves the economy in the longer term as well. With co-authorship at the heart of this, we create a network of communities that give back to the world, and with no surprises, make the world a better place—literally, one wave at a time.

Of course, all that's being proposed is to give a new spin on an old story—the missionary (the surfer) comes to Africa with the Bible (the board), but the by-product (if the community requires it) this time is a healthy, growing environment that benefits the local economy—the complete opposite of what those early settlers achieved more than half a millennium ago.

But to complete the loop, and paddle back into the channel, one question remains to be resolved: how do we ensure that this new community knows and understands the complicated colonial past of the region? If we're going to flip this narrative for good, every non-Gabonese individual has to be educated about this dark past. And the answer, I believe, sits at the bottom of the ocean, on the ocean floor, between our dangling legs and shared sets of waves.

Now, faithful reader, I'd like to introduce—much like a wild card, on day two of the tour—the deuteragonist in this peculiar, speculative narrative: Samuel L. Jackson.

At the time of writing this piece, the BBC aired a documentary that saw Samuel Jackson trace his ancestral slavery history back through the Middle Passage. After doing a DNA test, he found that his lineage was originally from—you guessed it—Gabon.

Jackson then worked closely with an organization called Divers with Purpose, which has a mandate to actively seek out and protect slave shipwrecks in order to document and honor the history of those who were trafficked into the Western machine. They explored sunken slave ships off the coast together, and reflected on this dark history, offering the beloved Hollywood A-lister a chance at some ancestral closure.

The potential for colonial ocean history built into this new type of restorative surf safari framework could be revolutionary. Some nations require a basic grasp of the local language in order to get a visa; what might it be like if you had to have a basic grasp of the history of slavery before being able to paddle into that first wave?

15 We'd do well to take notes from Canada and the Antipodes, where ancestral lands are acknowledged, in all forums, as a sign of respect and understanding of the land on which we exist.

were theaters of horror for humans, who—along with ivory, gold, and cloth— were fed into an opulent capitalist machine. We can break that cycle, and ensure not only that it doesn't happen again but that we physically learn from this past. We, too, have found a small channel in a tiny corridor that takes us back into the kingdom of Li kande likoko li simbe mbote sambwali—or, as we may prefer to call it, "the hand palm that holds seven stars"—to give back more than our ancestors took. **16**

16 In Africa, surfers should learn from the dark history of our waves, and the trade-offs made by our ancestors to build the worlds we now take for granted in the West. There was once a time when those beautiful beach breaks

None of this is impossible—it is tangible, and within our reach.

All that is required is for a few good folk to decide to try something new.

17 So decide. ■

My name is Patrick Bikoumou, but most of my friends call me Bosh. I'm living in Congo—I was born in France, and came here with my dad when I was 2 years old. I live in Pointe-Noire, right in front of the ocean, where I own my restaurant, called La Pyramide. In fact, La Pyramide is a geodetic point installed by a French seismic company during the 1930s. When I was at school, my friends and I would rendezvous at this spot, for a swim or a slide with a piece of wood that we made to ride the white water. I was 10 years old. That is my best memory of the sea.

One day, riding on that piece of wood, I nearly drowned. I was swimming, then I couldn't get back to the beach. The current was pulling me to the deep. Fortunately, two young French guys saw that I was in trouble and pulled me to the shore. I think my calm nature has a lot to do with my rescue. Since then I have not stopped helping bathers who get into difficulties in the sea. I never told. It's my payment for almost drowning.

I discovered surfing at a cinema, watching a conference talking about a volcano in Indonesia—the Krakatoa volcano, to the east of Java. And then [they] talked about a small island called Nias. That was the first time I'd seen a man riding a surfboard, getting barrelled on a wave. And I thought, "Whoo, what a feeling this guy must have." I had to try this. And exactly at this time, a friend arrived in Pointe Noire from Tahiti with a surfboard. The fever started from that day, when

I saw the first surfboard of my life. This was my revelation. I remember the wave of Nias, the color of the sea, the bay full of coconuts, the surfer on that wave. That was just magic.

At this time I'm, like, 12 or 13 years old. I met a Californian who worked on a supply boat who used to join us in the harbor at a wave called "Piege a Sable," and he had a shortboard, with real wax. Sex Wax! Smells so good. This guy surfed so good. I was so impressed! His name was Michael. Blond guy, blue eyes. And sometimes he used to lend his surfboard to me. When his contract in Congo was over, the day he was leaving, he left me his surfboard. Can you imagine my happiness?! This is when I really started surfing.

The ocean demands respect, and I will remain captivated all my life.

It's hard to describe the feeling when you're in the ocean, or on a wave. Personally, it takes me out of time. It puts me in a positive mode. At this moment, I can really feel my existence on this planet.

If I compare Africa with Australia, Indonesia, or even France, Africa is more wild and mysterious. The environment is special, there is a character you can feel here in Africa. In Congo, there are so many rivers that give the ocean that coffee color, so you surf knowing that underneath there are large fish, such as barracuda, tarpons, and other species— thank God, so far no attack has been listed in our waters. The locals at certain

beaches are amazed to see us riding on those waves so easily. They come to see us once we're out of the water, just to ask us if we're afraid of Mami Wata. Cultural stories here in Congo are very strong, and anchored in memories. Some push away their fear and ask us to teach them how to stand up on a surfboard. So I know that precise moment that they feel a certain freedom and happiness that only a surfer knows in this sport— and, I would say, in this act of living.

Honestly, I can say I am blessed to have my two sons and my daughter, and before that my younger brother Olivier, who lives in Australia, all surfing together. I spend lots of time with them in the ocean. It's like an accomplishment, something that I dreamed of in my youth, and for years I kept that dream. It is about the happiness of surfing with your family, paddling to go back to the lineup, and to see one of your children pushing into a barrel. This continues to leave me speechless, with a blissful smile. Hearing my children screaming at me to take off on a set that seems too big, and then to hear my kids tell me, "Go for it Bosh, don't look back!" Suddenly I think of Gerry Lopez and his casual attitude on the waves and then I take off in peace, not asking myself any questions; then I come out with a smile like a banana and my brain full of endorphins, to the delight of my children and my brother. "Whoo, Papa! What a nice bottom turn you did."

Here is the notion of shared happiness. ▸

BOSH

I've never been competitive with them, but I've always told them that whatever they do in this life, to do it to the best of their ability. Always pushing the limits by calculating the risk. But above all of that, have fun doing it.

My lifestyle fits perfectly with the goals I set for myself in my youth. My dreams have come true. I give thanks to the Lord every day for this.

Surf culture has been following the bandwagon for almost thirty years, ever since The Endless Summer, the movie. The surf boom exploded about twenty years ago. It will take time for Africa to contribute to surf culture, because at this date most of the population and the authorities don't understand the impact of this sport; and also, despite everything, it remains expensive—although more countries are creating federations and finding support in order to be represented at international competitions, as was the case in Senegal recently.

In a few years the world will have to rely on Africa, because we are emerging, and the world will not be able to make important decisions without us. Time will tell.

I used to listen to a lot of reggae, sometimes jazz and folk music. But the soundtrack of the movie Free Ride marked me for life. By the way, this movie was the trigger for my departure for my first surf trip out of Africa, to the island of Nias.

I'm also a musician. I have my band, called Conquering Lions Reggae Band. Music and surf—both are very enjoyable. Most of the time when I take off on a wave, I can hear a song; and sometimes when I'm listening to a song, I imagine myself on a wave.

I have run my restaurant, La Pyramide, on the beach for twenty-five years now. Life in Congo is great—slow, can be intense sometimes (especially during elections time), but most of

the time it's quiet and peaceful. I'm still here; that must mean I've found my safe haven.

After a long surf, what do I eat? Peanut butter and honey on a slice of bread, then a big bowl of muesli with fresh fruit and white cheese.

About ten years ago this guy came to La Pyramide, 60 years old, lots of character. He sat at the bar, and let me know that he was here a long time ago, in the '70s. He surfed on that wave in the harbor, "La Piege a Sable," and told me that he gave his surfboard to a young local guy called Patrick; and then he asked me, "Do you know him?" I'll let you imagine how we threw ourselves into each other's arms.

I found Michael, forty years later. ■

CONTROL IS THE CRISIS

BY BAYO AKOMOLAFE

What we rudely call "nature" today does not even have a name in Yoruba culture, because there was no distinction between us and the goings-on around us. The Yoruba religion of Ifa sees a "vitality" in the nonhuman world. Mountains could be consulted, trees could have privileges.

In Western discourse, there is a clear distinction between man and nature. But as a world dominated by the culture, ideas, economic systems, and development models of the West is plunged into ecological crisis, we need to overturn a status quo that places humans—and white men, in particular—at the center of the universe.

Nature was created in the Enlightenment: this idea that there is an external world that is independent of us, outside of us, this resource base that we can plumb and extract from and abuse because we're outside of it.

This position of detachment has led to black and brown bodies being treated as less than human, with nature ranked somewhere beneath people of color and dismissed as a site of passivity.

We need to completely rethink our relationship with nature.

The Enlightenment idea of the objective observer allowed science to deconstruct and understand the world. This hasn't just allowed us to plunder nature and leave it in ruins; it has also warped our approach to protecting it: carbon "cap and trade" schemes that mean you can buy the right to harm the climate, and "solutions" that price up nature's worth in dollars and cents.

The ocean is majestic because it exceeds us, because it silences us, because we came from it, because our bodies are composed of it. Somehow, thinking of the ocean as something potentially within the reach of a Jeff Bezos or a Putin to purchase makes it less valuable to me.

We must meet nature anew, and embrace an approach that might not look like a "solution" at all: it might look like seeing the ocean as an elder, an agency in its own right, and learning to listen to its manifold wisdoms.

At a time of multiple crises, people want concrete solutions. But the very notion of definitive answers is precisely the problem. Instead, we need to look beyond the dichotomy of problems and solutions, of crises and control.

The world is intricately interconnected in ways beyond our understanding. It is not the Western division of reality into words versus things, subject versus object, here versus there, mind versus matter, culture versus nature.

photo by Kent Andreasen

Climate change is a signal that Earth will not be told what to do. And so we have to learn to thrive, or to meet this world. And that doesn't mean mastering the new world; it means coming to a place where we recognize that we're not in control.

Stability is a luxury. The coronavirus pandemic has put the world into a state of deep uncertainty. We divined stable societies and then we forgot that stability is a luxury—it is not our God-given right.

One of the ways we are acting, as this large earthly organism, is in a binary way: kill the virus, get back to normal. But what if that way of seeing control—or seeing ourselves—is the crisis?

What if control is the crisis?

We need to slow down in times of urgency. The global economy is doing just this. We must embrace and learn from our current state of uncertainty. We're not just going to walk out of this and go back to the office. ∎

This is an extract of an article that appeared in DW (Deutche Welle).

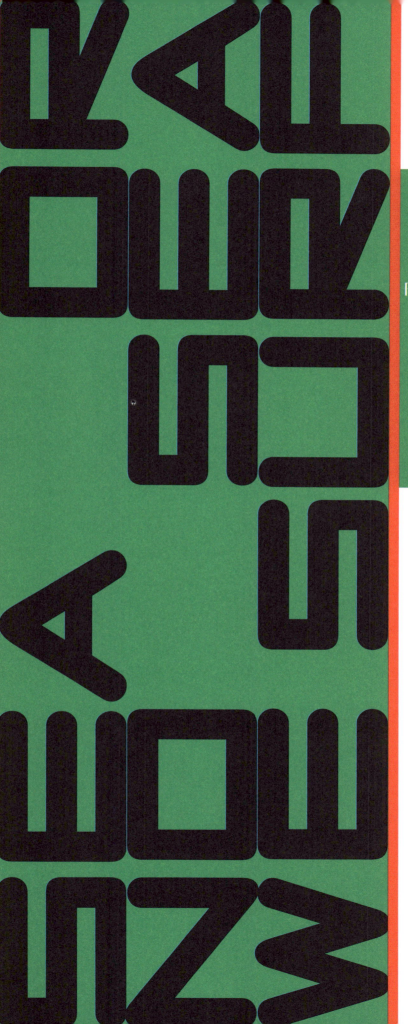

RADICAL LEISURE

PHOTOS

SKATING –
Mosaka Chalashika

WOODEN BIKES–
Ramon Sanchez Orense

BMX–
Tyrone Bradley

MOTORBIKES –
Nic Bothma

TRAIN SURFING–
Jamie–James Medina
& Matthew Salacuse

WAFFLESNCREAM
LAGOS, NIGERIA
I'M JOMI, JOMI
MARCUS-BELLO

I accidentally got into skateboarding via my mom. She bought me a skateboard from Argos. Argos is a store that sells household items and toys and they happened to sell skateboards. It was a time when the internet was just becoming a thing in Nigeria, and I didn't have any visual representation of what a skateboard does or what it is, I just thought it was a toy. I went to school in Leeds, in the north of England. One day I went for a walk and stumbled on a skate park—I saw it for the first time. I could not stay away. I became hooked.

I went there every day. I was the only black kid, and stood out like a sore thumb. Yeah, and I haven't looked back since!

I started university in England, studying urban planning, just to figure out how to create skate parks; and every break I went back to Zambia—my mom was the Nigerian ambassador to Zambia.

Zambia is a landlocked country, which makes everything expensive from abroad. So because I was flying back and forth, I became the main supplier for skateboards. Everybody gave me their order, and I'd bring it back; and that's how skate grew in Zambia. And now more than a thousand people skate, and you have three skate parks.

I started WAFFLESNCREAM with my brother Nifemi and a friend, KC, who gave me my first bit of money— 500 pounds. I wanted to create a name that was so familiar, but yet so far, because of the idea of skateboarding in Nigeria. Waffles and cream is an everyday treat in the West, you know? And also, it was such a foreign idea, but it also sounds familiar. Design-wise it was always Africa, because I knew I was not the only person who was into this. And in terms of creativity, the scene in Nigeria was only music. We are just music. Although the soundtrack for WAFFLESNCREAM is reggae and Afrobeat, francophone, samba, house, and not so much rap.

I did a pop-up with T-shirts in my room, and sold out; and so I just kept investing in it.

I came back to Nigeria in 2017. I opened up the shop. I wanted to create something for people like me, and like-minded people. The shop was very important, because it would become the epicenter of alternative sports in Lagos. It's the visual representation in a space, rather than just online. Even still to this day, people come to our store thinking they're coming to get some food. "I'm hungry!" ▸

photo by Baingor Joiner

I researched the "waffle": it started around 1869 during the height of slavery, emancipation, and all that. Such darkness was happening in Africa, and for black people in the West and around the world. The waffle machine was patented by an American — Cornelius Swartwout, you know? So that's why the logo is the guy with a top hat, because it's so contagious, 1869, and he has coins in his eyes because, you know, in Egypt or most African cultures when someone dies they put coins on their eyes because they say evil is entering the root of the soul through the eyes, so they put coins there to deflect evil from going in. So our logo is actually a dead white colonial master in Nigeria, in Africa!

When I started I used to throw parties, and just gather people together and allow people to live there. Yeah, which is not something that is the norm here, because you know, in Nigeria people want you to just work and go to school, because it's survival mode. So everybody's trying to pick the careers of their parents, in general. They don't want to take any risk. We just want things to be safe. So they go for doctor, lawyer, engineer, architect . . . the known.

I just wanted imagination. And there was no other way than skateboarding to do that, you know? Most skateboarders are artists, most of them express. So I did exhibitions with skaters, friends, and family, from photography to art

to movies to video — anything that you did in your room — and show that. That's how we became a community and created a database, which then became the basis of the brand. I know this database personally, and I know who likes what; that is very important, if you want to create a business.

If you wanna start a brand in Africa, find people who enjoy what you do, who appreciate what you do, and work with them. Make their interest your interest, you know? And see how you can align.

That's very important, because there's a lot of people who don't see what you're doing, and to find even one person that likes you and understands is a blessing. Magic happens when like-minded people come together. Like doctors and engineers, you know — they're solving the same problem.

So we do anything that is good, or anything that sparks the truth. Usually there's a snowball effect, because people want to have people around, and do things with their friends. It's like a new song. "Come listen to this new song." Yeah, so that just kind of grew the group. And if things are good enough, it will spread.

Then the world caught on to it, and you know, people . . . people have such a warped idea of the visual representation of what Africa is and what Africa can do. The diaspora has played an integral role

in making sure that we are supported, with a sense of pride. Most of the visual things you've seen around Africa have just been poverty, and war. When you see something else that gives you a different view, you're attracted to that; it becomes important for every person of African descent. A sense of connection back home.

Africa has a lot to offer. It's very important to tell our story, because the only stories, movies, and their reference points have always been from a Western point of view. Like, if you want to build a house, what are you going to do? Look at what the West has done. Houses are built from the Western point of view. But there's been architecture in Africa for so long. African clothing textiles, color, pattern. It's important for Africans to see that anything can be created with quality in Africa. And also that they need to tell their story, which is the most important. Each design has a story behind it — if you are from Nigeria, you get it. If you're not from Lagos, you will still understand.

In the beginning, yes, the West influenced me, because skateboarding is not an African thing; while the years go by, the more we create, you know, people get better, and our own style evolved and still is evolving. What is happening in the West is important, it's important to show Black Panther here, it's important to see how they see you.

▶

photo by Baingor Joiner

We don't mass-produce, you know? We feel that adds to the flavor of things. We make enough for our community, and for people in the diaspora. I want to see ranges that sell out. We don't want to burn clothes, or create waste. We make just enough for a community. In Nigeria, especially, there's no seasonality. That's why we call it wet and dry — that is our seasons. We don't have spring, summer, autumn, winter.

We made a design called "dangerous black man." It had a minstrel in front, and on the back you had a design of a guy chasing a little mini minstrel boy and it says "this nigga's done found a skateboard." So I had some customers who come in — some mixed race or white people, or who are just elderly people who are black — who go, "No!" They could not even touch it. You know? Yeah, at one point we were a caricature, like that.

Only three-fifths of all slaves were viewed as human beings. As negative as it may sound, that period happened. Even the "bastards" T-shirt that we made recently had this guy called William Bligh, who discovered the ackee fruit in Jamaica. It's a West African

fruit that was brought over to Jamaica, and the guy discovered it there, and they ended up naming it after him. The fruit that had been named and used in West Africa for so long. Let's do enough research, and we will find out who the real heroes are.

The world is like watching a movie, but we start in the middle of the movie. We've lost the context of the start of the movie — maybe the hero was the villain. I'm not saying Africa discovered everything. But a lot was happening in Africa.

Bad design does not exist — it's all perspective. The truth is the truth. Controversy is for people who aren't comfortable with the truth. The truth sometimes is mostly ugly, you know?

I don't hate white people. They lied to us, but things have improved throughout Africa for sure. They said, for example, someone is not a human being, and that is not the truth. You know? I mean, that's hate, and that's wrong. If you hate someone based on imagination, or actively trying to scare people away from the truth, that's bad. The truth is the truth.

Yeah, I think we are all spiritual people. Not just in Africa, but people are people. We believe what we believe in. I grew up in Catholic surroundings — Catholicism is an integral part of African culture, you know, the missionaries and all that. Yeah, but you know, we were all enslaved in the name of Christianity or Islam. There's a saying: "They took our resources, and gave us the Bible." I'm just Catholic.

Modern Africa also has brands, colors and nuances; in a way, the different cultures and tribes are like brands. My grandfather told me we don't wear red in our tribe — yet other tribes only wear red. We need to look at where the story started, and not get stuck in the middle without context. ◼

photos by Tyrone Bradley

Lucky Garuba
photo by Adeleke Togun

I'm Fahd Bello and I skateboard, I create art, and I try to figure shit out my way.

The first thing a lot of people assume is that I'm nonbinary. Other people think I'm a snob who would shit on strangers who see my hair and my clothes and try to talk to me. In Nigeria, people tend to wear conservative clothes, and not cause any trouble. So when they see me, with red hair and baggy jeans and a skateboard, they don't know how to categorize me. This is not just a Nigerian thing—I think even my Vogue profile and my collaboration with Alexander Wang happened partly because the way I live and the things I am interested in confuse them.

I'm in my early 20s, but I've done stuff that people with ten years on me can only dream about. I'm Fahd Bello and I skateboard, I create art, and I try to figure shit out my way.

Why skateboarding? Because I love it. It's a form of escape for me. I get a lot of negative energy for just trying to live and express myself in Lagos, and skateboarding is one of the ways I can escape all of that and just do something that pleases me. I joined the WAFFLESNCREAM skate crew, one of the biggest and most organized skate crews in the country, and have worked with other crews, like OurMotherlan and the BMX crew in Lagos. I'm lucky that being myself has gotten me all this attention and allowed me to meet all sorts of people and have those people pay to have me endorse their projects, or work with them to improve them. It puts money in my pocket, which gives me the freedom to be even more authentically myself.

Nigeria is a hard country, but Lagos is the heart of Nigeria, and it's where everybody who has dreams of living as their realest selves eventually moves to. I was born here, so I never really experienced the "coolness" of Lagos, but meeting and working with so many people who are experiencing Lagos for the first time is like getting baptized all over again in how great my city is, and how accommodating it can be compared to the rest of the country. Anywhere else, it would be much harder to reclaim public spaces through skateboarding, but Lagos makes everything easy. This was my dad's city before he passed, and now I'm making it mine. ▶

photo by Manny Jefferson

Roses that grew in concrete

Sure, you can buy a skateboard, but you can't buy skateboarding skills. Every skateboarder must learn their own tricks, find their own style, invent themselves. The more I skateboard, the more these principles change how I see life, and how I want to re-create what I see and experience through my art. My visual art is surrealist—I know that sounds elitist, but that's how I explore my mind and express my feelings. I get inspired by myself, and the possibilities I can create, because I don't have to obey any traditional rules with surrealist art.

Jomi Marcus Bello, Adesua Aighewi, Kenneth Ize, and Bubu Ogisi—I have a lot of cool friends, and they're all doing amazing work here. With them I can never have a boring weekend. When I'm not having fun or skating, I meet up with my friends and try my skills on hair art. That, too, has become a thing, and I've done a few dye jobs for Pretty Boy D-O, who has the maddest hair in the whole country.

photo by Roderick Ejuetami

I want to travel the world, and scratch all the world's most epic skate parks off my to-do list. Other people have their ways, but I think going pro as a skateboarder is how I'm going to make all of this happen. I want my skate stories to be about things other than being chased by police for skating on public walkways.

A lot of people think my dreams are too big, and have tried to put me down, and because of that I'm not really interested in trying to convince them anymore, I just want to do me. It matters to me that I stay true, and never allow our small-minded and hostile culture here in Nigeria to change me.

The moment you oppose the order society has ordained and want to do things your way, it becomes a problem, and society labels you a nuisance. They castigate you, they say, "He has gone mad!" or "She is lost." But all that does is fuel the ambitions of these "different people." I think of them as "roses that grew in concrete."

I have found that when you are true to yourself, opportunities come to you. I got an opportunity.

I am just at the start of my career, and there is so much I want to do. So many people have believed in me and bet on that belief by creating opportunities for me, which tells me I'm doing the right thing. I've been lucky; but I want to honor that luck by being the best at whatever I decide to experiment with. One of the things I am sure about though, is that I want to go pro as a skateboarder at some point in my career. But my focus right now is skating and creating and helping in whatever way I can to grow the community here in Nigeria. This is what I devote my time to.

If only people could be more open-minded, unlearn a lot of things they have been taught. If everyone is thinking outside the box, they can see new possibilities, total freedom of expression—people wouldn't be afraid of change anymore. ■

WAVES OF FREEDOM

**BY STANI GOMA
PRODUCER/PRESENTER
FLIGHT 1067 TO AFRICA**

Afrobeats and reggae are two of the most dominant musical styles in Africa today. These two genres express many of the aspirations of African people from east to west and north to south, and provide the soundtrack to everyday life, entertainment—and at times a much-needed escapism from the challenges of complex socio-political environments.

Amid the debate, confusion, or controversy around afrobeats versus Afrobeat, what is often overlooked is the fact that these genres are more deeply related than at least one side of the debate might be willing to concede.

Afrobeat is a term coined by Fela Anikulapo Kuti in the '70s to describe his unique sound. Musically, the sound is a potent, carefully crafted mélange of musical styles that he was exposed to, which included highlife, jazz, funk, and traditional African music. It's a synthesis of sounds that he heard around him and in his head. Similarly, the lyrical content is influenced by his environment. The social, political, and cultural context in the first and second decade of post-colonial Africa, combined with his personal and spiritual beliefs, were the cornerstone of his proselytizing through music. A quest for freedom is also a recurrent theme in many of his songs.

Afrobeats, on the other hand, is a more recent wave. The exact source of the term and its first use are the subject of claims and counterclaims. However, there is general agreement that it's a generic term that does not refer to a clearly defined genre, but rather a catch-all phrase that encompasses various forms of Afro-pop resulting from a fusion of elements of African diaspora music, including soul, R&B, dancehall, and hip-hop, with African music. Notwithstanding the somewhat justified criticism leveled at its proponents for misappropriating the Afrobeat concept as intended by its creator Fela Kuti, and thus prejudicing its legacy, it's arguable that even without the prior existence of Afrobeat, Afro-pop may well have acquired this title.

It's a sound deeply rooted in the urban African experience, itself characterized by a constant evolution and syncretism. Perhaps the clearest distinction between Afrobeat and afrobeats is that the latter does not seek to disrupt the political order, probably because it's the expression of a generation that is rather dubious about political activism.

Afrobeats artists like Wizkid, Davido, Tiwa Savage, and Yemi Alade are now household names around Africa. The proponents of this genre can quite rightly assert that it has achieved far more than other genres in promoting African identity and pride.

▶

photo by Patrick Aventurier

175

For a start, its primary market is firmly in Africa. It is, in a sense, a sound for Africans by Africans. It also transcends class and other social boundaries, and there is undeniable evidence that it has found resonance with the middle class and upwardly mobile layers of African society. Other homegrown styles, like Bongo Flava in East Africa, hiplife in Ghana, and Amapiano in southern Africa, have also propelled many local talents.

The level of interest that afrobeats has generated abroad with the likes of Beyoncé, Drake, and other well-established pop artists now seeking to incorporate that sound in their music is also an indication of its international appeal beyond African borders. The global explosion of this genre has led to predictions by international pundits that Africa is set to become a major player in the global music industry.

The creation of the African Music Fund by afrobeats star Mr. Eazi (real name, Oluwatosin Ajibade), that is said to be worth $20 million and is backed by at least one major capital investor, suggests that the financial market is starting to take notice of the significant potential that major record labels such as Sony and Universal have already been positioning to capitalize on for a few years now. This trend is set to continue, and only time will tell whether this is part of a long-term strategy.

The African reggae movement has had a very different trajectory. Africa's love affair with reggae goes back a long time. The Afrocentric content of many reggae songs has undoubtedly helped sustain the interest that many Africans have in reggae music. In fact, many commentators have cited the song "Zimbabwe" and the subsequent performance by Bob Marley at Zimbabwe's Independence Day celebration as a major turning point in the emergence of the African reggae movement. The fact that a successful reggae megastar from Jamaica dedicated a song to the liberation of an African country did not go unnoticed.

The classic documentary Reggae By Bus was screened in many African cities in the early '80s. The documentary, which combined footage of live concerts and interviews with reggae icons, provided a great insight into Rastafarianism and the deep connection between reggae music and Africa. The documentary emphasized freedom, equal rights, and justice, and the liberation of black people as the real essence of reggae music.

Some of the pioneers of the African reggae scene cut their teeth by doing cover versions of reggae hits by iconic reggae artists such as Bob Marley, Jimmy Cliff, and Burning Spear.

Alpha Blondy from Ivory Coast, who is arguably the most successful African reggae artist, is a self-described Bob Marley disciple and has covered many of his songs, as well recording his own politically charged compositions.

The late Lucky Dube was clearly inspired by the work of Peter Tosh, and released several critically acclaimed albums before his untimely death in 2007. He is credited with bringing African reggae to the mainstream, particularly in the English-speaking world.

The slow and steady reggae groove provides ample space for conscious lyrics, and continues to inspire politically aware artists around the continent. In more recent times, artists such as Tiken Jah Fakoly, Takana Zion, Rocky Dawuni, and others have followed in the footsteps of Alpha Blondy, Majek Fashek, and Lucky Dube, and continue to spread the message of freedom and justice.

Afrobeats and reggae sound waves have found resonance in the streets of the cities, suburbs, townships, and ghettos of Africa. The music continues to flourish and inspire a generation of young African men and women to dream and follow their passion, defy social norms when necessary, and feel confident in their ability to overcome any challenge and ride the waves of freedom. ■

LUCKY DUBE

GODSPOWER PEKIPUMA

Tarkwa Bay is my home. I've been surfing here for the last twenty years. I know the beach like the back of my hand, and I've taught many of the kids who live here to love the waves as much as I do. But Tarkwa Bay has changed. There are soldiers in boats at the shore, and there's a fence around the beach that keeps people out. All my friends and neighbors at Tarkwa Bay are gone, driven out by the military and the Lagos state government. They want the land for themselves so they can sell it to real estate developers, who will build luxury apartments that none of us can afford. When they do, they'll most likely take the beach away from us and make it fully commercial.

But until then, I will continue to surf here and I will continue to make my living here, teaching tourists and visitors from the Lagos mainland how to surf. My name is Godspower Pekipuma, and I work as a surf instructor and surfer. I have a small club that I own. My primary clients are white tourists who come here to impress their girlfriends by surfing on the waves. They give me good money, so I don't mind taking an hour or two to teach them how to surf, or renting them one of my boards.

What I really care about is teaching the young men and women who come to the beach to have some fun how to love the water like I do. I feel so much pride when they stand on their board for the first time, when they catch a wave. Far too many people believe that black people cannot surf, and every person I teach changes that.

I have a couple of boys who have gotten so good, they have started teaching under me. Lucky, Stanley, and Emmanuel have been with me for years, and now that they are older, I take their advice on everything from what music is popular to what technology we should use to share what we do in the Surf Club. I just enjoy whatever music the guests in the cabanas on the beach are playing. ▸

photo by Alan van Gysen

photo by Greg Ewing

photo by Adeleke Togun

My boys are so good, when Vans surfers Dylan Graves and Dane Gudauskas came to Lagos to make a documentary about surfing here, they said we were good enough to compete at the Olympic Games. That made me proud of my boys, and less worried about letting them teach students on their own. They are not the only international surfers who have come to check out surfing at Tarkwa Bay, but they are the biggest names, and they gave us some boards.

We have a Surfing Federation in Nigeria, but like everything else here, nobody's managing them. We find a way to get our boards, but they are expensive, and the lockdown made it even more expensive to get a board. We're managing what we have now, but it means we have to be very careful, and the best surfers are not careful, they are adventurous. We also don't have a physical space for our club, so we have to carry the boards back to our homes, which is very stressful. If we could get more boards, then we could hold more classes and teach more people. But for now, we have to set aside our best boards for the paying tourists, and teach the local visitors who want to learn on our smaller, more damaged boards.

I think once the government takes surfing seriously they will see there is more than one way to make money in Tarkwa Bay, and that luxury apartments mean only a small number of people can benefit. An open beach can carry thousands of tourists in one year. I can't personally convince them, but I hope that as I teach, I will meet someone who can.

We can't do this alone. Without deliberate investment from the Nigerian government and the private sector, surfing as a sport will not grow. I hope we can enjoy the benefits of all this work we are doing, introducing more people to surfing. I'd be happy if we achieve all these dreams, even if only the next generation of surfers get to enjoy it.

I'm spending all this time and energy to achieve that.

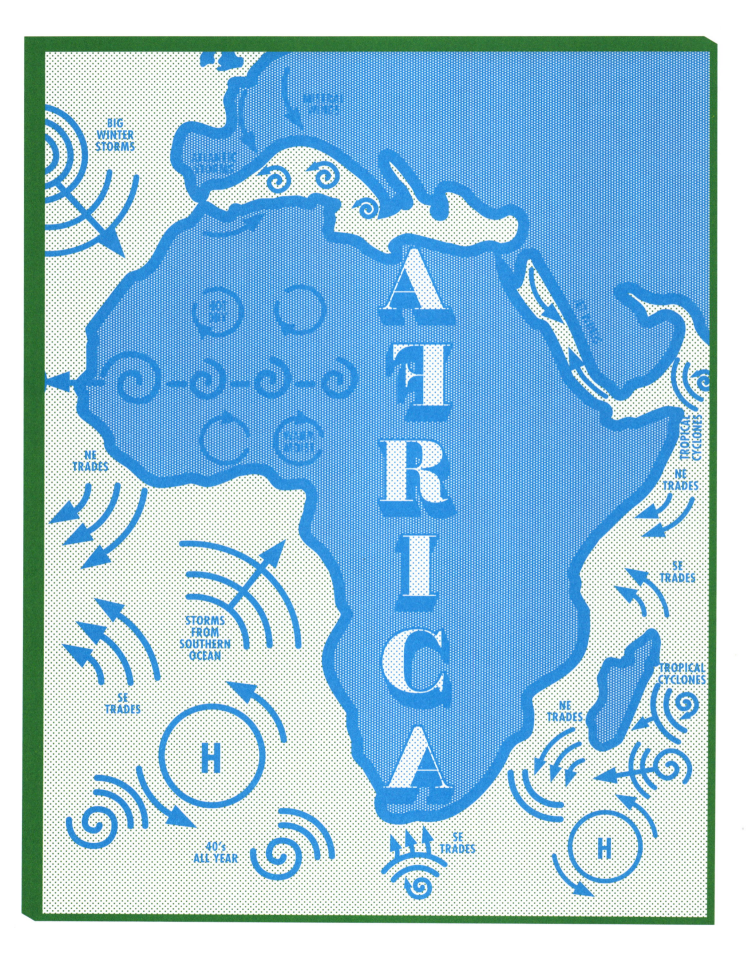

AFRICAN STORMS

With an area of 30 million square kilometers (18.6 million square miles) and a population of more than 1.4 billion people speaking 3,000 native languages, Africa is a massive continent.

It's a land mass one-fifth the size of terrestrial Earth, and the only continent that straddles the Northern and Southern hemispheres, comprising myriad bewildering angles, coastlines, and weather zones. This creates a mind-bending morass of permutations for surf forecasting, but a vast treasure trove of surf potential: realized, undiscovered, or overlooked, to avoid war zones.

No fewer than thirty-nine countries border at least one of these bodies of water — the Atlantic Ocean, Indian Ocean, Red Sea, or Mediterranean Sea — including six sovereignties (island chains) off the coast that are deemed part of the continent. These are Cape Verde, plus São Tomé and Príncipe in the northwest, and Madagascar, Comoros, Seychelles, and Mauritius off the Eastern Seaboard. Of Africa's fifty-five countries, only sixteen are landlocked.

Let's embark on an epic 30,500 km counterclockwise cruise, from the pointy bit protruding eastward they call the Horn of Africa. The Horn belongs to Somalia, that war-torn, broken land swarming with pirates, honest but struggling seafaring fisher folk, and more than a few surfers finding their stoke in challenging circumstances.

Let's start with a right-hand point break on the northern Xaafuun Peninsula, 155 km south of the Horn. This remote spot along a strip of barren sand picks up east swell from wind activity in the Indian Ocean, whether storms or trades. Like all spots in Somalia, the lineup is empty and will require an armed escort to explore.

As we turn the corner of the Horn, heading west along the north coast of Somalia, the surf potential dwindles rapidly. We are now on the southern side of the Gulf of Aden, a narrowing inlet with Yemen to the north. On rare occasions, northern tropical cyclones in the Arabian Sea blast this channel with swell. At the end of the Gulf lies an open-ocean dead-end they call Bab el Mandeb in Arabic, or "Gate of Tears." Legend has it that this narrow strait between Arabian Yemen and African Djibouti refers to the souls who drowned when Asia was torn from Africa by a primordial earthquake.

Beyond this 64-km channel, just 29 km wide in places, lies the Red Sea, and Eritrea. No ocean swell gets this far. However, this narrow 2,250-km sea that covers 438,000 km^2 (down to 355 km wide in places) does get waves. Despite the high salt content, intense monsoon winds, or "wind jets," come screaming up and down the Red Sea between mountain ranges, creating sand storms and huge wind swell, depending on the season. Waves of 14 m (more than 45 ft.) have been recorded, but rarely exceed 2 m (6.5 ft.).

Sudan and Egypt also lie on the Red Sea. But apart from windsurfing and kiting, you seldom encounter references to surfing. Egypt has coast on the Red Sea and the Mediterranean: one of three countries that abut two of the four bodies of water surrounding Africa. The other two are Morocco (Mediterranean and Atlantic) and South Africa (Atlantic and Indian Oceans).

The Mediterranean is a mini-ocean that separates Europe from Africa. It covers 2.5 million square kilometers, so it has plenty of surf potential. Swell comes from winds such as the French mistral and Italian tramontane, localized storms, and low-pressure systems tracking over Europe and North Africa from the Atlantic Ocean.

The localized storms are sometimes called "Medicanes" — Mediterranean hurricanes — somewhat misleading wordplay when stacked against real hurricanes. These are small, intense lows that form off Libya, Tunisia, and Algeria. The Med has mostly short-period chop, with storm seas that occasionally get big. On January 20, 2020, the average of the largest waves off Spain was measured at 8.44 m (more than 27 ft.) — the biggest in the western Mediterranean, with probably larger individual waves.

But no matter how zealous the hype of the locals here, this body of water is simply too small to host large, intense low-pressure systems like the deep oceans can. You need long-period swell to propagate from originating storms on a long journey to drop the chop and settle into a corduroy groove. For any African surfer spoiled by the consistency and power of open ocean spots, surfing here would not pass muster, barring desperation and anomaly. One novelty factor is that you won't need to find low- or high-tide spots: there are no tides in an enclosed sea.

And so with that we move westward between the two Pillars of Hercules on the Strait of Gibraltar, in search of the open sea. To our right, off the Iberian Peninsula of Spain, a 426-m limestone pinnacle stabs the sky. Ancient Greek and Phoenician mythology claimed that this Rock of Gibraltar — and Jebel Musa, the 842-m mountain on the Moroccan side — marked the boundary of the known world. ▸

THE WEATHER THAT BRINGS WAVES TO AFRICA
BY STEVE PIKE

We know better. Beyond the Rock, that bastion of English imperialism that stood up to Nazi Germany in WWII, we move into the open ocean, where the mighty Atlantic roils and grinds and spouts endless swell. Well . . . not quite. The Northern Hemisphere swell window is hyper-seasonal. Neptune switches on the motor for the conveyor belt some time in September, during the northern autumn, and turns it off again when summer approaches. The rest of the time, a large high-pressure system sits between the Americas and the bulge of Africa, and the storms are buffered to the far north off Greenland and Iceland.

This is the chief problem in the Northern Hemisphere: too much land, not enough sea. Consider that while 71 percent of Earth is ocean, almost three-quarters of all land lies in the Northern Hemisphere. Think North America, Greenland, and a big swath of South America, continental Europe, a big chunk of Asia, and the Arctic Circle. And it also includes the bulge of Africa, which makes Africa in the north twice as big as Africa in the south.

This contorted tangle of terra firma, with its altitude variations and its temperature oscillations, blocks and breaks the flow of ocean weather. But in the south, where the ocean dominates, the land has much less seasonal effect on the flow of storms, thanks to a less impeded upper atmosphere that largely drives storm formation.

Don't get me wrong—Morocco gets plenty of swell when the northern Atlantic swell factory is open in winter. So does its neighbor Western Sahara, as well as Mauritania and Senegal; but as we move around the bulge and start heading east toward Africa's "elbow," you find less swell from the north, and countries that mostly rely on distant winter systems thousands of kilometers south, in the Roaring Forties. One exception is the exposed archipelago of ten volcanic islands that constitute Cape Verde, off Senegal. Another is Senegal, which is blessed with a triangular coastline jutting into the Atlantic that picks up both northern and southern swells.

There are two key phenomena that reduce swell options along the western flank of the continent and boost it on the eastern side:

trade winds and tropical storms. Around the world, the trade winds north and south of the equator blow from the northeast and the southeast, respectively. To the east, they are onshore and point at the coast, bringing wind swell. But these winds blow away from West Africa. This trend pertains to tropical storms too. The tropical cyclones that cane the Americas in their summer hurricane season (June to November) mostly move away from West Africa.

Interestingly, many hurricanes have their genesis deep in Africa, as "waves" of thunderstorm volatility along a belt between the hot, dry Sahara and the humid, cooler rain forests to the south. These systems can gather enough moisture and energy to launch off the bulge and into the Atlantic as hurricanes.

This means that the likes of Liberia, Ivory Coast, Ghana, Nigeria, and Cameroon way up in the elbow, and including the tiny island of São Tomé and Príncipe, rely on long-range swell that only the low-pressure systems in the Roaring Forties can produce. These storms need to be intense—and facing north—to reach this far. But there is a plus side. Much like for Indonesia, this long-period swell has morphed into pure energy, delivering ruler-edged perfection because it has traveled thousands of kilometers. On rare occasions, these tucked-away coasts might pick up some ripples from storms off Brazil, but southern Atlantic tropical cyclones are not really a consideration.

As we move away from the verdant jungles of central Africa, the terrain dries up, and the consistency of the surf improves. However, Angola—that country of epic barreling sand bars—has a wave count a lot lower than South Africa, for instance. So has Namibia, although it picks up more southern ocean swell than Angola; but both require a western swell direction, and plenty of long-period energy.

Now we come to the mother lode—a vast tract of ocean bristling with possibility to the west, south, and east. Pushing southward into this seething wave factory lies the most wave-rich country of them all: South Africa. The reason is simple; swell all year. In winter, a procession of fierce storms

sprays the coast with big west to southwest swell. In spring, the south Atlantic high pushes in behind receding cold fronts to kink the wind fields into big south or southeast swell, which lights up tucked-away spots.

Then the summer high-pressure systems lock into place on both sides of the country. Southeast and northeast winds bring wind swell to the south and east, while sizable swells still emanate from southern storms; just a bit less consistent, and smaller. It's open ocean down there—no land masses to block the flow. From midsummer, the southwest Indian Ocean brings some grunt to the east wind swell along the east coast, in the form of tropical cyclones. And then, as these feisty, tight-ringed storms fade in autumn, we get the first stirrings of the winter swell machine that splutters back to life. Waves for days.

Of course, several other eastern lands benefit from the southern ocean storms, including southern Madagascar, the Mascarene Islands of Mauritius and Reunion, and southern Mozambique, where certain point breaks light up, but only with proper south to southeast ground swell that packs plenty of period punch. The Comoros, tucked away north of Madagascar, and the Seychelles, almost 1,600 km north of Mauritius, both pick up far less, while lands farther up the Eastern Seaboard pick up zip, such as northern Mozambique, Tanzania, and Kenya.

All the above have east-facing coast, so they will pick up any swell from the east, whether cyclone swell or wind swell from trade winds. The islands sit slap-bang in the path of cyclones at times. This makes Madagascar, Reunion, and Mauritius almost on par with South Africa in terms of consistent waves, because they also benefit from the variety.

And to close the loop that began 30,500 km ago, we move into southern Somalia and along a 1,500-km stretch of mostly barren coast, punctuated by the "self-regulating" Mogadishu, on our way back to the Xaafuun Peninsula for a warm, illicit glass of rum with the pirates. ■

My name is Benjamin Baba Haruna. My nickname is Big Ben. Through surfing, I want everyone to see that Africa is not just a place for poor people. Ghana is not a poor country. I want them to see Africa as a peaceful place, a very beautiful place, with loving people. And the culture . . . they can't take our culture away!

I was born in Madina, in Accra. I currently live in Busua. I was in Accra until I was 13 years old. There were these volunteer exchange students from Legon University who would come and help us with extra classes after school. Good people such as Aaron, Alison, and Mike—the exchange students who came frequently to Ghana from the US. Aaron had an idea to start an NGO in the town of Kumasi, and they needed someone to guide them with the language. They picked me and two childhood friends. I was around 14. They had to talk to our parents to get permission. The next six years, I only saw my family on vacations, when we had two or three weeks. Things didn't go well—the owner kicked Aaron and Mike out, and they were our people, so we followed them. But during that time in Kumasi we had been on vacation to Busua—it was my first time in the western region. We'd been told there was a really nice beach there. It was such a nice place! It was my first time going to a beach like that.

Aaron and Mike decided that they wanted to relocate to Busua—it was just a feeling they had. They debated back and forth with us—do we want to go? We were 17 at that time. We decided, no problem, we'll go and form our own NGO from scratch. One of my brothers came up with the name Teach on the Beach, and we liked it. We were on the beach! ▶

We got funding from volunteers and colleges and high schools doing programs with us—so many people joined. When I finished high school, we were the ones running the NGO. I was the program manager, handling the classes. Right now, Teach on the Beach belongs to us. And the best thing is that we've given out a lot of scholarships to kids from Busua. I love to see the kids we've helped become big boys who know what's happening in the world. I'm proud.

I'm a sporty guy—I love doing sports. When I was growing up, I liked basketball and football. When we went to Busua, I saw loads of guys in the water with boards, and I was like, "What is that?" I had no idea what they were doing. I didn't even know the word "surfing." But one guy, Clement, he was the one. I fell in love with his moves. I always watched how he surfed. I would go to the beach after school, just to sit and watch him. He was the guy—I always had my eye on him. After a couple of weeks I just went up to him after a session, and was like, "Bro, I want you to teach me. I want to learn." He told me I had to learn to swim before I could surf, but that he would help me. He had a broken fish board that Ballack used, and with Ballack's permission they let me use the broken board in the white water, as a start.

But to go beyond the white water, Clement, Yaw, and Kofit, took me out, taught me how to swim. Like a committee.

They'd put me on a surfboard, paddle out beyond the waves where it's calm, and then they'd take the board away and ask me to swim to get it back. It was very dangerous! Then it got easier. It took about six months. It was like a family thing.

Soon I was spending most of my days in the water, maybe four or five hours a day. I was doing that until I met Brett Davies—Mr. Brights. When he came to Busua, everything changed. He taught me on a really cool board, long and foamy, easy to catch waves. I remember on my birthday, Mike went to rent a board for me for the whole day. I stayed in the water so much the kids called me Fish.

My mum was so worried—saying stuff like, "You're spending so much time in the water, you're getting so dark. You have changed so much!"

I had to tell her, "Don't worry, I'm okay."

I like anything physical; I'll learn it, do it fast, and get good. I'm a quick learner. So after surfing, I learned to skateboard. I like skateboarding because it reminds me of surfing. The lines and the moves are similar. And you don't have to wait for the waves.

I've surfed all over Ghana, you know; there are loads of secret spots and points that only the surfers know about. Even the well-known places, like Cape Three Points, Kokrobite—I really like surfing there. The waves are different. I feel you can go for longer on them—it's very satisfying.

The boys here are competitive about styles. It's all about styles right now—in their turns, their pop-ups, and how they stand and move. People flex! When we're in the water, everyone's looking at everyone else, trying to outdo the styles, trying to be different. We got swag! Especially the kids. A lot of them want to surf. In my nine years surfing, it's become so big. People are getting known, the kids are so influenced, involved. Loads of them are picking up wooden boards! It's not just about football anymore—that's all there used to be. Now we have something for the good swimmers from the coast. After using wooden boards, surfboards are going to be so easy for them.

My family are so happy for me. They love where I am right now, because they're seeing the benefits in my life, my happiness, so they're very supportive.

My dream is to travel outside Ghana and surf in other places; but then to come back with that experience and share it with my friends, my brothers and my family, and give them that picture and inspiration of what is possible. And of course to keep helping the kids in Ghana, teaching, giving back what I can. ■

photo by Surf Ghana/Michael Aboya

SAINT FRANCIS OF THE PLANET PLOIESTI

BY WANLOV

195

I only respect originals. Inspiration is cyclical, like most animation in existence, from ocean currents to planetary orbits. The time things take to come back around can be regular or random, longer or shorter. Just looking at West Africa before colonial borders, music from different cultures was one of the things that traveled all around it and still did even after the borders were forced into our imaginations—resulting in Fela Kuti getting a lot of inspiration for Afrobeat from the area demarcated as Ghana, and current Ghanaian youth being inspired by Nigerian pop acts like Burna Boy, whose music is heavily influenced by Fela Kuti.

"ORIGINAL" IS IN BOOKS AND OLD PEOPLE, AND "NEW" IS IN THE STREETS, IN THE YOUTH.

Pidgin is a new West African and diasporan language, like Patois/Creole, with varying syntax and vocabulary depending on geographical location and educational background. It was created out of the need for people of different mother tongues with no formal colonial English indoctrination to communicate at a common level. So now instead of trying to sound urban American, British, or West Indian, we own our own space and fit to fully express wana body plus pidgin. English speakers should be able to get pidgin English speakers, but pidgin English is a whole new language to English speakers, especially when spoken. Even more so when there is no context.

Language, like culture, like music, like beings, should evolve . . . if it can't evolve it will, and should, die off.

Where I live, the foam of the waves has a yellowish froth from oil spills and organic waste, accompanied by the sound of the rustling of plastic bags looking like dead, black, shriveled jellyfish. In the distance,

fisher-folk in colorful fishing boats head back to shore, defeated by fishing nets full of plastic waste. The sea gulls, tired of swooping down at what they used to think were shiny fish, head toward the horizon, where huge shipping vessels wait in line to come to the port and unload electronic and clothing waste from the West under the guise of charity. The ever-faithful golden purple and orange setting sun still manages to splash color over everything through the smog-diffused skies.

I feel humor is still strong in the West when I look at Dave Chappelle, Trevor Noah, Lil Dicky, and Michaela Coel; but maybe with Trump and the Tories in power, these jokes are just not funny anymore, because the stupidity has become very deadly. Our current president is more or less a Trump fan, so our jokes will soon also start bringing more pain than joy. Basic humor is truth, and having the knack to pick out and represent the most extreme factual ironies that put fiction to shame. It's cathartic . . . lies bring pain and disorder and injustice and oppression . . . it soothes my social OCD to be truthful.

Outsiders who know wholesome world history should either be ashamed or sad to see a shop name such as "In the blood of Jesus Christ" considering the fact that colonization traumatized us and continues to do so through religion and neocolonialism. Many died for refusing to accept these alien religions, and now what we have is a hybrid of apparent European evangelical paganism with covert African spiritual practices perpetuated by poverty, which in the short term serves the interest of the ruling class. Sort of the same thing goes for Islam.

As a touring artist I find it quite annoying that most of the time Western sound engineers turn down the percussion in the band. They see Afro percussive instruments more as props than an integral part of the music.

WANLOV

I'M SIDIQ BANDA

I moved back to Ghana in 2003 — thought I'd enjoy it for a couple of years while I figured things out. Here I am, seventeen years later.

I call myself a media professional — been working in all facets since 2007. Brand management, brand building, brand ambassador for high-end companies like Moët, Hennessy, media production, advertising, graphics; and I have credits on major international films that have been shot in Ghana, working with vehicles. I'm also an herbalist — that's a hobby that seems to bear fruit — people come to me for vitamins and homeopathic stuff. I love growing anything, and I'm kind of an amateur scientist. My family would say that I live by my hobbies and obsessions. I'm definitely a journeyman. I have no idea where the journey will take me next.

My earliest memory of the sea is with my parents and siblings at Labadi beach, drinking coconuts and eating sandy bananas after coming out from a long session in the ocean. There was something about those sweet bananas after being doused in salt water that I remember distinctly. I don't even remember what age, but when we were in Ghana we were always at the ocean. And city oceans were so clean back then — that was clean sand I was eating. Back then it was unspoiled; now I only go into the ocean out of town.

I first discovered bodyboarding when I moved back. That movement on the water, how the waves would take you . . . wow. I was about 26, and I loved the feeling so much, I commandeered the board from my friend — never gave it back. It was thick as fuck, heavy as hell, but it's what got me started. I first encountered surfing on a trip to Busia beach with a girlfriend not long after. I saw the Black Star Surf Shop and thought, "I need to check this out." Had my first lesson, didn't stand

up or learn shit, but it was pretty much instant love. After that, I got my own board. If you'd told me then I would co-own a surf shop in a few years, I would have laughed. I met Brett Davies in 2009, at Cape Three Points, and he wasn't long in the country — this Rip Curl–sponsored surfer from England. I was just there, hanging out with my friend Akwesi like I always did — he'd built this magical ecolodge from scratch and by hand on the southern tip of the country. Brett was there, doing some surfing, some teaching, and we got to talking. He wanted to put down roots, bring surfing to Ghana properly, help the locals, and was looking for a business partner. I was doing well then, was getting into surfing, liked the idea, and told him that it would only be viable if we did it at Kokrobite. Fine, the waves aren't as good, but there are more people to reach on a regular basis, and once you've got them hooked, you can go further afield for surfing trips — check out waves all over the country. My dream is to eventually have a chain of shops and schools all up and down the coast, selling boards and African-branded merchandise, doing teaching and tours, just everything. I know it'll happen soon.

When I first started surfing, when it was new and I was just in love with the movement, I used to have wave dreams. It gets you, man. I don't get them anymore — it's like a first-love thing. When you first fall in love with the sea through surfing. It's like light-blue walls, and you're flying. That's when you get hooked, when you just need to keep going back because you're constantly dreaming about waves. Sliding down the face of a perfect wave, sometimes it's translucent and you can see straight through the ocean, blue and bright, and you're one with the wave. Then you're riding down it and you feel the energy and power of it, and you can actually feel the adrenaline rush, in the dream. It's crazy. ▶

photo by Nana Yaw Oduro

GET THE FUCK OUT OF THE HOUSE AND GO SURF

I just love it, man—just the challenge of it all. Makes me feel fucking amazing. When you catch a wave and you ride the wave, it's just you and the wave, man. And it's special. I pray in the sea; I meditate. When I'm in the ocean, I feel privileged to be there, it is a privilege—and I always give thanks to God for being in the sea, for being there, and to be able to have that experience. Because so many people aren't really living in this world. It makes me feel so fortunate in my life.

I tell you, sometimes it's spiritual, sometimes it's war. Sometimes you look out at what you have to face, see how far you have to paddle out, see inhospitable waves, and you're like, "Oh shit. This is not going to be an easy day." Know what I'm saying?

The thing about African surf culture is that there is no surf culture out here, so we're making it up as we go along. It's truly original. They have nothing to compare it to. They're just enjoying the surf. The kids that surf out here are not trying to be the next Gabriel Medina—they don't think about that; they're not competitive, they're encouraging. You go out to a wave in Africa, the boys go with the flow. It's like a schoolyard thing; there's no competition, just encouragement. They're not trying to be anything; there's nowhere to go with it. They're just there, enjoying the waves, enjoying the sea, and doing it as much as they can when the waves are good. There's no glory or recognition for it, no chicks or status, no aspiration. It's pure.

I've been listening to a lot of Led Zeppelin and Jethro Tull recently, but that's just now. Like my work, I'm eclectic in my tastes—everything from Wu Tang to Led Zeppelin, that's my range of music, everything except for Country & Western.

I think people need to start understanding the main fact about Africa is that we're just like everyone else—we are advanced, intellectual people who span the range from Bentley drivers to barefoot cyclists. We are a part of the whole; we just haven't had the positive exposure yet, haven't told our own story enough.

My wife would tell you that surfing comes first. She actively tells me that I need to go and surf. She'll say, "Get the fuck out of the house and go surf." I'm more serene when I do. I like to box and surf. Those are the things that help me with my excess energy, and if I'm not using it, then my wife will kick me out and say, "Take your board and go to the beach." The ocean just naturally takes it out of you. You can't fight the sea, man, you just go with it. My arms are too short to box with God; it's too great a force. It was one of my old friends out here, the kid of a fisherman, who taught me how to flow with the ocean. This guy could be bobbing around out there for hours, literally in the ocean, riding waves with his body for hours. He was a fish. Fishing boats would go and look for him, find him, and he'd tell them to sail on and he'd swim back. He told me, "Go with the flow—it's about the motion of the ocean." ■

Emmanuel "Bebe" Ansah
photo by Greg Ewing

Streetwear is what you wear when you step out of your house to the "street." No matter what you wear, I still consider it streetwear, because it goes beyond T-shirts and sweatshirts—it's a lifestyle. I think the idea of streetwear has always been that it's a fabric of our culture, with influences from all around the world. Feeling free and comfortable in whatever you're wearing is streetwear; and that's what makes it special.

Streetwear is art, self-expression, rage, beliefs, and love, among others, with specific cuts, fonts, graphics, and more. You can tell where someone is coming from just by looking at what they're wearing or how they're wearing it. People can be friends just from the connection they had from what each other was wearing—or hate each other, just from a color or font.

It's bigger than what we know. Streetwear is a greater force.

The basis of streetwear is in the idea of collectivism. Since we all come from different backgrounds, it's important to come together and share the values and interests from our different communities, to create something that will be generally accepted by all.

We always make statements with our clothes. Because we can physically connect with people in power, we choose to use what I call "A Walking Advertisement" to always carry a point across. Fashion has no limit in terms of expressions and cuts.

Surfing enables the individual practicing it to feel free mentally, spiritually, and physically. So I'm happy that young people here are getting involved in it. It's the type of sport that helps people build their confidence. Surfing and

streetwear are interconnected—not only in terms of what is worn but the overall way of life, and mindset. Most of what surfers wear to surf is streetwear, in my opinion; they are just riding the waves with it, while I'm riding the streets.

Growing up in Tema, I was always inspired to do more, or be a creative. Tema was exposed to a lot of foreign cultures, such as hip-hop magazines, the newest Bape Sta, or the freshest clothes. Every gathering in Tema was a 'hood fashion week, because young people would gather to show their freshest styles and accessories. Every weekend was a rap and dance battle, which saw the rise of many popular Ghanaian artists, including Sarkodie. You have to show up to the battlegrounds looking your best—or else you've already lost!

I would describe my personal style as "confusing." I always feel like I don't have to dress to suit an occasion. Like, I'll wear a slightly cropped T-shirt with denim for my meeting with the US ambassador, but wear a suit to a pop-up shop. Basically, I dress up for the mood I'm in, or how I feel at a particular time.

What really inspires me to design is everything I experienced before the age of social media. I want to show the world what I was exposed to. Whenever I'm designing clothes, I make sure whatever I'm designing has a significant Ghanaian or African story behind it, but is dope enough by way of font, graphics, and cuts for a 14-year-old to want to wear it anywhere in the world, while still embracing their roots. We humans categorize clothes by gender, but for me, clothing is universal. It can be worn by all genders, despite the cut or shape. You just have to be confident enough ▶

Young Biit

Free The Youth

to know what you're wearing suits you, and that's all you need.

Basketball was a dominant sport in Tema. Every community had its own basketball court, and young people would meet to play and network. Of course, it goes without saying that there were unmistakable signs of the influence of the basketball streetwear culture among the Tema youth. If you've seen any Free The Youth campaigns, with all that I've said, I'm sure you have a perfect picture of where I get all my inspiration from, and why the Free The Youth aesthetic looks the way it does.

I would say who I am today is because of who I was growing up. Free The Youth is a representation of my true life story.

For me, youth has nothing to do with age. It's a mindset that enables you to live life freely, and make decisions for yourself

without taking into consideration how society wants you to conduct yourself. I feel like Ghana, or Africa, is at a stage where the youth are ready to find innovative ways to connect to the world without being physically there. I believe the youth are in a good space right now to change the narrative and create a solid foundation for the generations to come.

Free The Youth started with a lot of research on fashion and streetwear, taking photos that showcase Ghanaian/African streetwear culture to compete with all these foreign kids on Tumblr and Instagram. As time went on, we connected with the now-permanent members of FTY, who were also aligned with the same motive and intention as we were. We came together to form a fashion collective, and now are the biggest streetwear brand in West Africa.

We are only local manufacturers and artisans. Manufacturing a simple T-shirt is easy-peasy — very few constraints. We use screen printing or vinyl print, but if we're manufacturing something as complicated as our denim, we source each material separately and then start the production process one after the other. Other finished products can go through four different people before they reach the consumer, depending on how complicated the designs are. We believe in community work and generating income for each person specializing in each field of work during our production process. I'm happy to create here.

Collaboration, to me, means connecting communities. By doing this, you expose whoever you're collaborating with to a different community, a different crowd, a new set of believers and new inspiration to grow your own community. I believe great feats can

only be achieved with collective or collaborative effort, because it signifies a lot of strengths coming together to create a greater force, with a solid foundation. Also, I believe working hand in hand equips the involved parties psychologically, financially, physically, and emotionally to build a stronger community.

Whenever people hear our name, they won't have a choice but to allow us to do whatever we want! ◼

FTY

photo by Nana Poley

My name is Bernard Bannor. I am a proud 18-year-old Ghanaian. I am proud of my dark complexion. I learned somewhere that the black skin is stronger than others. I have been surfing for six years!

I met Mr. Brights long before he started his surf school. My friend and I were swimming (swimming in the ocean is so common in Ghana it isn't considered a sport). He was giving a surf lesson. We were excited, and expressed interest in learning how to surf, and naturally, he agreed to teach us. Unfortunately

my friend couldn't catch up quickly, but I was able to make it to the second wave. Mr. Brights asked me to join his surf school, and I agreed immediately.

Surfing didn't come easily at first. I must have shown some promise, and that's why he asked if I would like to be part of his school. I applied myself during our lessons, and eventually I became really good. I learned to respect the ocean, and developed a connection. I believe it'll take me places some day.

Growing up in a close-knit family of six, I was raised to be humble but also ambitious. Just like in almost every other family on the coast, my father is a fisherman and my mother is a fishmonger. My parents are Christian, and they raised me as such. I think I'm just as religious as the next guy.

My day usually begins with a good breakfast of tea or Milo with bread, butter, and eggs. After about an hour, I join the beach yoga squad for a session, and then check if the waves are suitable to surf. Then I jump in!

Little Ben

On days when the waves aren't really impressive, I play basketball with my friends, or man my grandma's little provision shop.

I would say my way of life has changed a lot since I started surfing. I think it's largely because of the people I have met. Through surfing I've been meeting all types of people. I recently realized that since I started surfing, I wear a lot more surf shorts. In fact, I wear a pair all the time, so that I'll be ready just in case there's a perfect wave. I used to only wear long trousers. My favorite pair was the Adidas three-stripe track pants. Surfing has changed the way I dress.

Meeting people who are comfortable enough to wear whatever they want and stand out has made it a little easier for me to be comfortable with what I wear.

On the beach, the soundtrack is reggae. I enjoy it too. Reggae and afrobeats. Everybody loves afrobeats.

Over the years, I have come to discover that Ghana has really good waves for surfing; so I think the surfing community will definitely grow, even though there are a few organizational problems. Most of the people I meet are surf tourists who drive miles, or fly in, just to catch the wave. But with the growing

number of surf schools, I believe the community is bound to grow, which will in turn be good for tourism in Ghana.

I'm always excited when I see girls competing. Competition is imperative. It will definitely encourage them to aspire to greater heights in the sport. I believe our collective aim, as a surfing community, is to be recognized at the World Surf League.

I am currently not in school; I am completely focused on surfing. I want to be a great surf champion one day. ■

Whenever I'm a bit unhappy, I grab my board and go into the water. I put everything aside—when you're out there, your mind is just on the waves, the water, the surfboard; everything is better.

My name is Michael Bentum, and my nickname is Ballack. I come from Busua. That's where I was born and grew up. I'm a surfer and surf instructor. I don't come from a fishing family; my people are farmers—my mum sold watches. But we lived close to the beach, so I was always there. I used to go swimming with friends—that's my earliest memory, but when I got home I got beat up for it by my father. We weren't allowed to go—they had many fears, people were drowning. But still, I was always there.

At first my parents weren't happy with what I was doing, but they started to change when they saw me getting better and better. I remember when I got my first trophy at a contest in Busua, in 2013—they were really happy seeing me holding this trophy, with people all around shouting my name.

In 2005, I saw an American called Peter teaching a local boy how to surf. I think I fell in love then. At that time it was not easy to get a surfboard, so I actually started with a half longboard. It was broken, and I made my own fin. There was no wax on the board either. No one taught me; I started by myself. I surfed with my broken board with that wooden fin for about two years before getting my own board that was complete! In 2009, I met Mr. Brights—Brett Davies. He was in town for a surfing competition. I wasn't a good surfer at all then, but I was dedicated.

In 2011, Mr. Brights sent me my own surfboard from the Ivory Coast.

I felt amazing when I got that first board. People were fighting over it, because it was such a special board. He gave it to a couple of surfers to bring it over for me. But because the board was so nice, they didn't want to give it to me, so they kept it and gave me a different one, one that wasn't very good. But it all got sorted out. Mr. Brights went to the boys and got me my board back. I was so happy and grateful to have that board.

I began teaching when Mr. Bright moved to Busua, when he started his surf shop in 2012 and he taught me how to be a coach, how to teach others to surf. My whole life is at the beachside—everything is there! I really love the ocean. I mean, I'm so happy when I'm there. It gives me a lot of good thoughts and memories. I feel calm, good, free. Surfing makes me feel better.

My favorite place to surf is Busua—I'm lucky that I live right there. We have Beach Break and Point Break, these two spots. Point Break is more gentle; it's very easy to catch the waves, and you get a long ride. But at Beach Break it breaks really fast, you can do jumps there, tricks. They're so different. Now, there's a lot of competition between the kids at the beach. All the locals are so interested in surfing. We even have women surfers at Busua—that's amazing. I love seeing that. At first I think the community didn't understand much about surfing, but now, seeing the women and the

kids, I think they're happy about it. They see Busua kids doing something with their lives, doing something good in the ocean.

I love reggae dancehall, and hip-hop, and afrobeats. My favorite is reggae dancehall. I listen to Stonebwoy a lot before I go surf. He's my favorite artist in Ghana—everyone loves him. My hidden talent is that I'm a really good dancer. I prefer Ghanaian dance styles, like Azonto and Shaku Shaku. But I dance everywhere, any way, and any chance I can.

I think I want people in Ghana to know more about surfing; I want it to get bigger. I used to want to be a surfing pro, but I'm not sure if that's possible. Either way, I definitely want to be a surfing coach, leading others to different spots to discover surfing; maybe traveling outside Ghana to see different places and surf. When I see the smiles of my students, when they manage to stand up on a board and I see how happy they are . . . this makes me feel so happy. I love it.

Africa is the most beautiful continent. I think the world doesn't know how peaceful it is, the nature that we have. I know a lot of people think that other places, Europe or wherever, are the best places; but they don't know Africa at all. The world needs to know that there is a lot to do here, a lot to discover. ■

photo by Nana Yaw Oduro

BALLACK

SURFING IMPROVES LIVES

Booming youth populations tend to improve both economies and society. With two hundred million people aged between 15 and 24, Africa has the world's youngest population. Internet access is rapidly increasing and poverty rates are falling across the continent—Africa's future is bright. Against this backdrop, African surf culture offers a unique opportunity for sustainable development, environmental conservation, and personal well-being.

The term "surfonomics" was first coined by the organization Save the Waves, an international nonprofit with the mission to protect surf ecosystems across the world. Surfonomics determines the economic value of a wave and surfing to local communities, to help decision makers protect their coastal resources.

It's a concept that is particularly relevant to understanding the potential of surfing as a framework for growth in Africa. Evidence shows that localities with quality surf breaks tend to develop between 3 and 5 percent faster than the country's growth rate. Ideally, this financial momentum should improve living standards and quality of life while safeguarding the local environment. But how?

"Surfing is a non-extractive coastal resource," says Save the Waves Executive Director Nik Strong-Cvetich. "As long as the environment is protected, a surfing wave is a completely renewable resource."

Imagine a wave—world class. Now imagine a surfer who spends $150 per day to visit, and is likely to hang out for 30 percent longer than the average tourist. You don't need big numbers to make it work. Just one hundred surf tourists at any one time, for eight months of the year, creates a $3.6 million influx of capital per year.

But don't get swept up in the dollar signs. While the cash is an essential ingredient for growth and development, money alone doesn't automatically translate into sustainability, environmental safeguards, or social benefit.

"Local ownership is the best model for long-term sustainability," says Strong-Cvetich.

Central to the concept of surfonomics in Africa, or Afrosurfonomics, as we like to call it, is the recognition that surfing benefits people beyond the tourist dollars that quality waves attract. Local surfers, invested in the simple act of riding waves for their own enjoyment, are often more than just active participants in surf culture; they are stewards and custodians of their local breaks.

"Tourism can be super damaging," says Strong-Cvetich. "Communities shouldn't be entirely reliant on tourism, because of the booms and busts. If an area gets overpromoted it can damage both the community and the ecosystem. It brings in a lot of drugs, crime, prostitution, and the kind of travelers who seek that."

Save the Waves has defined three key ingredients required to protect a surf ecosystem: (1) a mobilized local constituency; (2) legal protection of the area; and (3) effective stewardship to combat pollution, water quality trash, and erosion.

"When you protect that quality surf break, you also protect the other components of the ecosystem, like coral reefs and mangroves. These break the wave action up, reduce erosion, and reduce the impact of climate change—related coastal flooding. If you're protecting your coastline, then you're going to protect the other things that people could be dependent on, like local fisheries."

The motherland has an abundance of natural resources, and a long history of colonial exploitation and extraction that have left parts of the world's richest continent poor and conflicted. Afrosurfonomics is a concept that puts the destiny of Africa's unspoilt coastlines in the hands of a dynamic young population increasingly interested in surfing them. ∎

SURFING IS A NON-EXTRACTIVE COASTAL RESOURCE

AFROSURFONOMICS

photo by Ricardo Simal

PIERRE NICOUD

THE WEST FACTORY

Four years ago, we sat down together and realized there are already two surf shops in Ivory Coast, but not much knowledge concerning surfing. The technical knowledge is really important. Formerly there were two shapers in Ivory Coast, but it was very underground. We wanted to create something more identifiable. We wanted to make good boards, with shapers invited from all over the world. The most important thing was for them to share their expert knowledge with the local community, to teach the art of shaping.

It was important for me to help the community. I've been in Ivory Coast since I was a baby. I learned my surfing here. It's like giving back. This country gave me everything, and I wanted to give it back, to create a community. The surf culture is growing in Ivory Coast, and the level is getting higher all the time.

My parents moved to Ivory Coast in 1973, one month after I was born. My father got a job, and he was looking for an adventure. When I was about 12, we were driving through the coconut trees on the way to Assinie, and we met two guys with surfboards and we gave them a lift. They'd just had their bags stolen, with all their passports and things, so my parents offered to help them. Later that afternoon they paddled out and I saw them ride waves; I was like, "Whoa! That is amazing!" After that, it was all I could think about for weeks. I asked my parents for a surfboard many times. The next Christmas, my parents made a plan to get me a surfboard.

* * *

The most important thing I've learned from starting and running The West Factory is that the shaping art is not the kind of talent given to anybody. It has been four years teaching the guys how to shape, how to glass, how to sand. It's like giving birth to a board. Not even a magic board — just a board. It's something really sharp, technical, and accurate. We need to improve and improve and improve again. I think in Africa it's more important than in Europe or the US. This shaping culture is really absent. Surfing can be a way of life. It can give you a better life, give you some real passion, and lead you to something, such as a job, or fulfillment. It's something that creates a community. This is really important.

We are not going to become rich with the Factory. What's really significant is that we're creating our own models, defined by the waves that we have. We're developing new rockers for the boards. Doing more hybrids. There is a big demand. Some of it is from the expat community, and people looking for a souvenir board from Ivory Coast. We have our team riders from Senegal, Ghana, and Ivory Coast.

We know a lot about surfing here, so people are coming to us for advice.

The demand is growing, but it's still a small business, and we need to improve.

What is so special about surfing in Ivory Coast is that it is so uncrowded. Everyone has their own hut, and the space in front is your surf spot; it's your bank. So you go and surf your place and you invite your friends. You have special vibes. And you can have such perfect waves. Three hours to the west there are perfect point breaks. You get these perfect river-mouth A-frames. Wherever you go, you can find a good wave — and almost guaranteed, it will not be crowded. ▶

photo by Sylla Cheick

HADI BEYDOUN

THE WEST FACTORY

The West Factory supports surf culture in West Africa by providing quality, accessible surfboards, equipment, and accessories to surfers in the region. We are representing and developing the surfing scene by manufacturing these things locally. Our presence is crucial for the development of surfing.

Imported surfboards are available, but we want more surfers to grow and develop their own skills by providing the right surfboards at the right time and in the right context. There is also a big cost difference between an imported and a locally made surfboard.

* * *

My father came here to work because Lebanon was in a crisis—there was a war. My mother is from West Africa.

photo by Sylla Cheick

So I'm a fourth-generation Lebanese/ West African, even though I was born in Montreal, Canada. But I grew up in Ivory Coast. I moved to Australia for university, because we have family there too. I spent five years in Sydney, and that's where I figured out how to surf. It became a passion. It became part of my life, and I thought that I must bring something back here to Ivory Coast.

Around here, it's just empty beaches, so everything is for yourself. You can have the best day of the year, and no one is on the waves. You're free to surf as many waves as you want. It's always sunny, the weather is hot—we don't really get winter—the food is nice, and the people are welcoming. It's very pleasant here.

You can surf throughout the year, but during the period from October to April, we surf in the east. From May to September we surf in the west. We don't miss a weekend. Surf season is on all the time.

We've developed a specific surfboard shape for Assinie, after a lot of trial and error. It's called the Mami Wata. It's a magic board, because it goes really well in so many different wave sizes and surf conditions.

There's so much untapped territory here, it's just the start of the adventure. There's a lot to discover, and a lot to do for the sport and the culture of surfing. To me, that's very exciting. It means we always have to find solutions, to look ahead and put something together—not only for my generation but also the next generations to come. And that is very rewarding. ■

WHEN GOD WAS CREATING THE WORLD, THEY MADE EVERYTHING AND WHEN THEY WERE DONE THEY RUBBED THEIR HANDS TOGETHER AND DROPPED TEN PIECES FROM ALL THESE DIFFERENT PLACES AND CABO VERDE WAS BORN.

I'M CLAUDIO CABRAL

photo by Greg Ewing

THE Ten Seeds and other mythology have existed in my country since forever. In the time before electricity, my mother used to sit at her doorstep and listen to these stories. She then passed them on to me, to inspire goodness with the morals behind each tale. My favorite was the one about Uncle Wolf and the Fig Tree. The Portuguese were the first to arrive on the islands, forcing people onto boats along the West African mainland and taking them away as slaves. They started to populate the islands around 1462, forty years before they landed in South America and long before Creole culture started in Cuba, Brazil, Haiti, and other Central American countries.

So Cabo Verde was the first place in the world with Creole people from African roots. That's still visible in the population today. There's an identity crisis that exists though, where some don't see themselves as Africans and others don't see themselves as Europeans, which for sure we are not. We have a unique Cabo Verde identity; but essentially, we are Africans, with an African culture, carrying some aspects of European influence. ▸

CAPE VERDE

MORABEZA

Creole, or Kriol, like we spell it here, comes from the mix of different ethnic groups; but it's far more than that. Here we say we're the first Creole people, because this was the first place that had a mix of Europeans and Africans creating a population. Creole is also our language, a mix of different African languages and Portuguese.

Today we are a nation that has more people living outside than inside our borders. You can't find a single Cape Verdean who doesn't have a relative abroad. Immigration to Argentina, the United States, Senegal, São Tomé, Portugal started early . . . so when these immigrants returned home, they brought their stories with them. Physically we are located on ten small islands; but mentally, Cape Verdeans have a lot of input from all over the world. Because we're filled with curiosity, we don't feel so isolated.

Living in a group of diverse islands makes a mosaic where each island has a particular mindset and flow, and depending on where you are, you experience life differently. Common to all is a sense of joy and simplicity. Cape Verdean people like to have a good time. That's why we are ocean addicts, and most of the time we are outdoors.

Family gatherings and birthday parties were always at the beach. My uncles would take me camping, fishing, and spearfishing. When I discovered the pleasure of hiking, that's all I did, walking the island; but as we are limited in space, becoming a surfer was the best thing to happen to me. Life was never the same after I found surfing. It opened a window of possibilities, and made me sensitive to a creative life connected with nature. The ocean is a place that provides food and joy. It's a great playground and also a place of healing.

As we live in a place that is always windy, Cape Verdean surfers are diverse in our surfing. It's rare to find a surfer who only surfs. The majority of us windsurf, kitesurf, foil, SUP, bodyboard, and surf. Surfers here don't limit their fun. It's an aspect I admire a lot.

Living on a small island means every break becomes your local break. Being a regular foot, I have a favorite right-hand point that breaks over a shallow reef of coral and lava. It provides a barrel section and opens up for turns as well. It's a wave so perfect you would think you're at Kelly Slater's wave pool. And it's not only the wave that's special, but the surroundings — a desert landscape, with a mystic peacefulness.

We use a lot of our local Creole language to describe surfing. Bomba or tapona means to wipe out. Xibadura for drop in. Paulada for the snap. Bico pato for the duck dive . . . or we just whistle.

"Morabeza" is a word in our language similar to "Aloha." I remember as a kid living in my grandparents' house, my uncle brought home this European guy who we hosted for two weeks. Basically, he was homeless. That was weird, because normally the tourists would stay in hotels, and would be clean and well dressed. But our people are genuinely welcoming, even to a stranger. A lot of times when I've traveled to the other islands, I've stayed with people I've never met.

Among all my other interests, surfing is always present, and it's really important for me to make time for it. I've consciously designed my life to be as simple as possible, so I can surf as much as I can. My work with photography and excursions allows me that freedom.

Because we are a young, emerging surf culture, we still have the possibility of creating a vibrant, inclusive culture, where economics and improvement don't mean losing your personality and cultural identity. There is a lot of potential and talent on the continent, and we deserve to enjoy and express that too. Africa is the last frontier. By nature, surfers are adventurous, and there's a huge amount of coastline that hasn't been experienced. We are just scratching the surface. ■

photo by Greg Ewing

UNCLE WOLF, HIS NEPHEW, AND THE FIG TREE

There was Uncle Wolf with his nephew. They separated, to one day meet again at a fig tree. When they met, Uncle Wolf asked him, "Nephew, how is it you are so fat and I am so hungry? What are you eating?"

"I've been about, gathering rats under the stones, Uncle Wolf. That's what makes me fat."

"This is the seventh day I've been eating lizards," said Uncle Wolf. "I've a little tail in my teeth. Come take it out!" His nephew took a needle to get it out. "No, Nephew; don't you remember, it was a needle that sewed up the death cloth of our mothers?" His nephew took a pin. "No, Nephew; don't you remember, pins were used as nails in the coffins of our mothers?" His nephew took a straw. "No, Nephew; don't you remember, it was a straw that choked our mothers to death? Why don't you take it out with your fingers?" His nephew went to take it out with his fingers, and Uncle Wolf caught his fingers in his teeth. "Nephew, you are a smart fellow—but I am smarter than you. Remember, I'm your uncle. I won't let you go until you tell me the truth about where you eat."

His nephew said he would tell Uncle Wolf. There was a fig tree, loaded with ripe figs, in the middle of a stream. But the figs were high up in the tree. "You've got to learn the rule," he said. "You cannot reach the figs; they are too high. You have to say, 'Come down! Come down! Come down!' The tree will come down, and you can get on it and say, 'Go up! Go up!' and it will go up as far as you wish. Then it will stop. When you have had enough to eat, you say, 'Come down! Come down!' and then it will come down."

Uncle Wolf was hungry, and he went to the tree, and he said, "Come down! Come down!" and then he said, "Go up! Go up!" and then he said, "Stop!" When he got through eating, he forgot the rule; and instead of saying, "Come down!" he kept saying, "Go up!" and the tree kept going up. It went way up to heaven. ▸

When Uncle Wolf got there, God said, "What are you doing here?"

Uncle Wolf told God he wanted to go home. God said, "You take this piece of leather, and go down and wash it in the sea, and bring it back to me. I will make a drum for you, and then I'll tie a string to you and lower you down. When you get down to the bottom, you play your drum so I'll know you're there, and I'll cut the string." But when Uncle Wolf went to wash the leather, he was hungry, and he ate it. When he came back, he told God the water carried the leather away while he was washing it. God gave him another piece of leather. He was still hungry, and he ate that too. And when he came back, he told God again that the water had carried the leather away while he was washing it. God gave him another piece of leather, and this time God sent an angel along with him to watch him, to see if he was telling the truth. Every time he went to put the leather into his mouth, the angel said, "Eh! What are you doing?" And he said, "Oh! I'm not eating it, I'm just smelling it." Then God made a drum for him. And he tied him to a string. "When you get down, you play the drum," God said, "and I'll know you're down; and then I'll cut the string and let you go."

On the way down, Uncle Wolf saw a crow carrying meat in its beak. He kept calling out, "Bird, bird! Give me a piece of your meat!" The crow said, "You play your drum for me, and I'll give you some meat."

So he played the drum, and God cut the string, and Uncle Wolf fell. As he was tumbling over and over, he kept hollering to his nephew, "Nephew! Nephew, put hay down for me!" The bird flew away, laughing. And when his nephew heard him, he took all his forks and knives and razors and broken glass, pins, nails, all the sharp-pointed things he could find, and put them in a pile for his Uncle Wolf to fall on.

And that was the end of Uncle Wolf. ■

Morris "Manchild" Gross
photo by Greg Ewing

GREG EWING

Making a living as an African surf photographer is not impossible

I grew up in Cape Town. While I was a teen, I started collecting surf magazines from all over the world. I still do today. I would buy whatever surf mags I could find or afford. So through all that time I guess it just lit a fire in me, and I started dreaming of traveling and shooting waves. At 15, I asked my dad for a camera for my birthday. He flat out said, "No! It's a waste of time!" By the age of 20, I was shooting surf and had my first image published.

Shooting surf in Africa can be a very long process. You don't just get given a ticket and a time schedule when it comes to doing trips in Africa. There are no package tours to the places I'm after. It all starts with either an image you've seen, a story you have heard, or a country on a map that you just know has to have waves.

Once I have a country, I start by Googling, looking at maps, time of year . . . but the key is finding someone on the ground there who can help, and from there you figure everything out. Sometimes the trips are self-funded, other times they're sponsored. There is no set formula. You just hustle and make it happen. The surfers who come along, that's not a set thing either. I have guys I get on with and we work well together. But you have to mix it up; you can't take the same surfers every time.

There was a movie called Sliding Liberia that showcased some beautiful surfing and waves there. It was on my list and I was going to tick it off, but then Ebola happened in 2014. We had to postpone.

We pulled the trigger in 2015 just as things were starting to slow down. I took Simon Fish, a great goofyfooter and a guy I got on with and had traveled with before. To mix it up I invited Jordy Maree—he must have been 15. It was crazy; I had to speak to his dad and ask if I could take his young son to West Africa pretty much in the time of Ebola.

I did a trade exchange with a surf house called Kwepunha in Robertsport. That covered our bed and food. I paid for my own flight. I would need to bank on selling the story to at least two magazines before I broke even. I was waiting for the best days to shoot and hoping it would stop raining. It just rained and rained. So getting all the elements to align is crazy. You need a lot of patience. You can sit in a room for a week and be on standby the whole time to jump in the water and get the shot.

Driving in Liberia is wild! We all thought we were going to die between Monrovia and Robertsport. I'm pretty sure our driver was on crack. Kwepunha was an amazing place. It was started by two guys to help the community with work and surf tourism. They supplied boards for the kids, but there weren't enough and they had to share. The boards were locked up at night to keep them safe.

Publications want something different—a new place and new wave and new angle. Brands just want fresh content. Simple. It's not simple to get, but they need to feed the machine. The surfers want exposure, which is also simple, but it's not that easy to get because I want to show something original and memorable.

There is this island in Africa somewhere—I'll keep the name a secret. They went there on the original Rip Curl Search with Tom Curren, like, twenty years ago, and that's how long I've dreamed of going there. I've spent maybe five or six years trying. This wave is a real hidden treasure and must go unridden almost always, as it's a huge mission just to get there. It's so out there that people who know about it don't even try. You need 4x4s and boats. It takes forever. There are no locals, no nothing. I tried to chase a swell there a few years ago and we missed it by a day, but got to see its potential. It's an eight-mile sand point . . . mind-blowing! My camera drowned on day one and my backup decided it didn't want to work properly either. It would only take three images before seizing. I had to constantly switch it on and off. Then my drive crashed and I lost the RAWs. I managed to salvage a few hi-res and got the TIFFs, which ran in mags. For me that kind of says it doesn't want to be exposed, and that just adds to the mystery of the place.

Making a living as an African surf photographer is not impossible. If that's your dream, you can do it. Never, ever, ever give up. Everyone tried to deter me. Well, everyone besides my mom. There are so many grumpy photographers out there who say you can't make a living, but I have for over twenty years and I'm proud of it. ■

A BIRD IN THE AIR

ITS MIND ON THE GROUND

I am Alice Wesseh. I was born right here in Liberia, Maryland County. And I'm still right here. Liberia is a free land. The land of liberty, where freed American slaves came from different African countries and backgrounds.

When people shake hands in Liberia, they click their fingers together at the end. It has many different meanings; you don't do the hand-click thing with just anybody. It's almost like identifying with one another. If you have a close connection, you can click.

George Weah is our president. To run a country, you have a lot of challenges to face. You have to be a team player, so I think his football background may help a little in making him a good leader. Could a surfer make a good president of Liberia? Yes, of course! A surfer is like any other human being. You know surfing is challenging, right?

I love so many things. The freedom to speak, to think clearly, to interact with the kids. I learned to surf in Harper. At first when I got on a board, I was very afraid to touch the water. I was always someone very afraid of the sea. When I saw waves rolling I was

worried it would roll me, then I would drown. So I always stayed away from the water. My first time I touched the water, it was okay. And the first time I got on the board, I felt good. I didn't even ride a wave. I was just lying on the board and touching the water. I didn't really know if it was called surfing or sliding. I didn't know anything about it. I didn't know this thing existed in Liberia, and they called it sliding. I feel so good, strong, and happy when I'm riding waves.

Right now I just know how to catch a wave and ride it straight. Next I want to learn to turn the board. I really want to turn it fast up and down the waves. I get jealous when I see them doing that.

Before, when I was growing up, I thought I might like to be someone different, but I don't want to be anyone else. I just want to be myself. I have two mottoes that I live by. Perseverance and determination lead to success. With unity and togetherness, success is sure. I'm my own hero. If I was to die and come back, I'd like to come back as a green plant. A beautiful green plant, like a flower.

Masale
photo by Arthur Bourbon

NARRATIVE

For far too long, Western media and brands have leaned on African aesthetics for inspiration, without any real understanding of the nuances and sources of their references. Likewise, Western image makers and news outlets would paint their own pictures of the continent through their own biased, ill-informed, or post-colonial lens. You had either the "noble African" story or the "war and famine" story. Around a decade ago it moved to the "Africa rising" story. But now, the tables have turned.

Jean Severin
photo by Mous Lamrabat

The younger generation are demanding their own agency and writing their own stories. They are reclaiming their heritage, curating their own futures, and not waiting for external validation. It's this fresh and thrilling output that the rest of the world wants a piece of. There's been talk of this being a trend, but a continent isn't a trend. The movement is real and unstoppable, both in Africa and the diaspora.

After meeting through a commercial fashion project in Senegal in 2012, Nataal's three founders (Helen Jennings, Sara Hemming, and Sy Alassane) discovered that they shared a desire to celebrate the incredible creative energy coming out of Africa, and a belief in the power of diverse storytelling. Originally, we were supposed to just do a film festival in Senegal, but we soon recognized that we could best use our combined skill sets and networks by developing an editorial platform that could act as an international springboard for emerging talent. ▶

NATAAL

We launched digitally in 2015, and our family of contributors across Africa and the diaspora soon grew as we developed a brand dedicated to promoting new voices in fashion, visual arts, music, film, and culture. From the initial website we moved into curating talks, events, parties, and exhibitions. Notably, we partnered with Red Hook Labs in Brooklyn to create an annual group show, New African Photography, featuring young and unsigned artists. Some of our other cultural partners have included Afropunk, Design Indaba, Africa Centre, ART X Lagos, 1-54, AKAA, and Africa Utopia.

In 2018, we brought Nataal into print as a large-format publication. For us, it was about bringing together and showcasing artists who are building fresh narratives in and around the spirit of Africa. It was about offering up a magazine that could give global exposure and opportunities for those whose work uplifts each page. Our core team has evolved too. Hailing from four continents and based in London as well as Joburg, Nairobi, Accra, New York City, and Paris, we are united in our passion for promoting positive change, learning from and sharing intersectional perspectives, and developing mentorship opportunities. As indefinable and impossibly vast as the term "Africa" even is, it is certainly inspiring today's revolutionary thinkers and doers to embrace a multidisciplinary, cross-cultural approach to shining a glorious light on the continent, and in recent years, we've been part of this progressive and growing narrative. When we launched, there was less mainstream attention on African creativity, and now it's on everyone's lips; so with our various endeavors, we hope to have helped bring some opportunities to individuals and access to the scene.

But there would be no scene without the artists themselves—it's their work that we are here to serve. We'd be nothing without our contributing artists, many of whom have been collaborating with us since the beginning. We'd never claim to have made anyone's careers, but we're so happy to have been part of people's journeys. In particular, many of the photographers who took part in our three Red Hook Labs shows have prospered since, such as Kristin-Lee Moolman, Lakin Ogunbanwo, Ruth Ossai, and Alice Mann. And we're super proud of Mous Lamarabat, who shot one of our magazine covers.

Today, there is so much good work going on in the African creative space from art fairs to fashion weeks, retail concepts to festivals—too much to mention! In terms of media, there are some fantastic voices. We love Bubblegum Club in South Africa, Boy.Brother.Friend and Thiiird in the UK, Native in Nigeria, Something We Africans Got in France, Contemporary And in Germany, and The Art Momentum in the Netherlands, to name a few. Each publication has its own distinct point of view and special focus, and is adding to local and international dialogues.

Social media has been revolutionary for African creatives, and remains an invaluable tool allowing young artists to share their work, processes, and voices with the world. This has democratized the landscape, fueled collaborations, and helped bring down walls. It's allowed the world to shrink, and for us all to feel connected in ways not possible before.

The downside is that we are now drowning in visual stimuli. It's easy to focus too much on likes, or to feel undue anxiety about making the right noise. We enjoy sharing the work we create and debut on social media, but this should not be all that matters. We remain wedded to longform journalism, in-depth visual essays, and expansive fashion stories—which is another reason we went into print. The artists we work with deserve their work to be published in a format that has some longevity and substance. It's also why we are always looking for new digital and virtual mediums through which to develop narratives, especially in these current trying times.

Nataal remains a passion project for its founders, one dedicated to positive and inclusive dialogue. Going forward, we hope it can continue to be a useful prism through which the next generation of African media professionals, artists, and creatives can continue to thrive. ∎

Fallou Mboup
photo by Ricardo Simal

My name is Kadiatu Kamara

I'm from Bureh Beach, and I am the only woman surfer in Sierra Leone.

Sierra Leone is a small country with 7 million people. Surfing here is different from everywhere in the world. We say big wata. We also say bangalanga. And we listen to "Duduke" to get amped.

I think in the next ten years surfing is going to be one of the most popular sports in Sierra Leone. That's because 65 percent of the boys around the peninsula are surfing now. Surfing is being established around the coastal areas, and we are trying to get recognized by the Ministry of Sport and Tourism.

When I started surfing I was afraid of the ocean. I didn't know how to swim. One day, the boys took my surfboard away from me in the middle of the ocean and I swallowed lots of water. I think I was drowning. I was screaming. I was shouting. But I liked it.

That helped me to build my self-confidence and motivation. It made me become a good surfer.

For me it's really challenging as the only female surfer among all the boys. But it's nice to be surrounded by so many hot surfers. That doesn't mean I only date surfers. It just depends if the person has what I'm looking for in a relationship. It doesn't matter if they're a surfer or they don't surf.

But the boys, they've helped me in so many ways, and are really supporting my dreams. I appreciate everything they have given me, helping me toward my success.

Now I'm sponsored by the Black Girls Surf organization based in the United States. For the past four years I have been sponsored by an American

woman. Her name is Rhonda Rokki Harper. I have benefited from so many different people all around the world. It is important for us to have more women of color joining us in the ocean.

It's been lonely for me to be the only girl in the water with all the guys. In Sierra Leone, women are afraid of the ocean. They think there is evil in the water. And that makes them scared. But now they are having confidence, and loving to be in the ocean and share the waves.

Surfing is a hobby for me and also a kind of a job for me as well. I'm a trained and qualified surf instructor now. I do surf lessons for locals as well as international visitors. To see someone surf for the first time is really exciting. That's why I have so much passion for this sport.

249

Zahher Benga helped form Sierra Leone's first surf club

I was born in Bureh Town, Sierra Leone, West Africa. Because I have access to the ocean, I started surfing. But it wasn't actually surfing — I was using a broken canoe like a bodyboard, to get the feeling. When the fishermen were finished with their boats, like, they didn't need them anymore, we would take a machete and an axe and shape a surfboard or bodyboard out of it.

When I was 7 or 8 years old, I saw two men surfing at Bureh Beach. Who feels it, knows it. You just need to have that one special moment when you catch your first wave. That's all it takes. It's not an easy thing to learn, but once you catch your first wave, you're in. I believe that surfing was already in my DNA, and once I started, I couldn't stop. It's been over twenty years now, and it's still important to me.

The break at Bureh Beach is a beach break, and the waves can be both left and right. The rainy season is the best time, and the waves can get pretty big. In Bureh Town we don't have to play by the rules, because we're all brothers, and we drop in and cut each other off all the time. Nobody gets mad. It's just the way it is. When you're not in Bureh, you have to respect the rules of surfing and the other surfers in the water.

Being a surfer in Sierra Leone means that you are a trailblazer. Many Sierra Leoneans are afraid of the ocean and swimming, and when visitors from Freetown came and saw us riding on top of the waves, they were in shock.

It's like walking on water. We surf where the mountains meet the ocean, and it's beautiful.

There were a few Sierra Leoneans in Bureh Town who started surfing before my generation (Alfred and Tommy Douglas, Tito and Samuel Small), but they gave it up, and our generation took over and kept with it. John Small (Shamak), Francis Small (Balo), Daniel Douglas (Uncle), Sheriff Palmer (Shero Bobby), Mohamed Bangura (Koiba), Kabba Kamara (Tilolo), Kadiatu Kamara (KK Dot), Alpha Barrie (Evera), Charles Samba (Snake), and Donald Macalley (Big Don) — we were all born and grew up in Bureh Town, and have surfed and hung out together most of our lives.

Whatever I'm doing, even before I go into the ocean, I will say a prayer. Because I believe in God. Before, when I was a kid, I used to go to church; but then when people started fighting about Muslim and Christian, all those things, I stopped going to church. Now I'm a free thinker. I'm simply a believer. The prayer that I say, I ask Jah for guidance and protection, for safe and sound, because the ocean can be dangerous at times and we need to respect it. So I ask Jah to:

Keep me safe and watch over me and have a good surf. Amen. ▶

The ocean is my church

I respect the ocean; I'm not afraid of it. I won't panic if I see a shark or a jellyfish or whatever. It's their home, and if you're going to respect them, then we are all going to play together. As I said, surfing is in my DNA, and the ocean is part of me. I am not afraid of anything in the ocean. I respect its power, and the creatures that live in it. It is my church.

Bureh Beach Surf Club was started in 2012. As the one and only surf club in the country, it quickly became the place to hang out, rent boards, and get lessons. The club provides a safe place for the community to learn, work, and educate people about surfing. Very few Sierra Leoneans knew what surfing was when BBSC first opened. We say "no wahalla," which means no problem, the waves will make you feel fine.

Our club's trip to Liberia was an educational experience for me. Because people there don't know what surfing is, we had to take pictures with us, or show the authorities videos of surfing, so that they could understand what we were doing. It was nice to meet other African surfers and experience their surf culture and life. I will never forget the incredible waves, the journey, the film crew, the Liberian language, food, and interactions with members of the community.

African surf style is different from the rest of the world. Most African surfers have to share and ride different surfboards. You don't have access to your own equipment. You have to learn everything the hard way. So I think our style is different.

But it drives me crazy when Africa is referred to like it is a country. The continent of Africa is large and diverse, and has so much to offer the world. Beautiful cultures, delicious foods, amazing music and arts, breathtaking natural habitats, and wonderful ways to live life. Much of the work my wife, Hannah, and I do is to change the narrative about Sierra Leone, and to show that the country is much more than diamonds, civil war, and Ebola.

We had eleven years of war. Afterward things got better, and then we had Ebola. It wasn't easy. The only thing that kept me going was surfing. Because the whole country was shut down, just like with the coronavirus. I was so lucky to be in Bureh, and that they didn't stop us from going in the ocean. The only hope that I had at that time was surfing. It's really changed my life. I've traveled, met new friends, and I met my wife—all through surfing.

Surfing makes me a better man, because when I have an issue or problem, I take my board and go out and catch some waves, and find clarity. Traveling to different places helps me to understand different ways of living life, and appreciate things I would have taken for granted. There are many ways to exist in this world, and no way is the right way. You have to experience and keep an open mind to appreciate the wonderful people, cultures, and lifestyles. ■

MARYAM EL GARDOUM

MY FATHER GAVE ME THIS NAME. ALL MUSLIMS KNOW MARYAM,

ONE OF THE MOST FAMOUS WOMEN IN ISLAM HISTORY.

SHE IS A STRONG WOMAN, THE MOTHER OF Isa. ALLAH GIVES HER A BIRTH WITHOUT A HUSBAND AND THIS CHILD IS ONE OF THE MOST IMPORTANT PROPHETS IN ISLAM.

THEY CALLED ME MOHAMMED

I heard a lot of stories about my grandma and grandpa fighting the Portuguese people who came to Tamraght for, I don't know what its name is in English . . . uh, colonization! My grandparents and the other Berber people were fighting them to take it away from here. I'm really proud of them. My grandma had a big farm, and had to walk 20 km (~12 mi) carrying all these heavy things to Agadir, to the city, and another 20 km back again. So it was not easy. Everything was hard for them. They didn't go to school. They don't even know what school is. But they worked hard, and they were strong.

My family, we are Berber people— 100 percent. First people in Morocco. So we are local. All of my family were born in Tamraght, a small fishing village, where they are working as fishermen or farmers. So where I'm living, there's either banana farms or fishing boats. But now there's surfing too.

In the beginning, as a young girl, it was super hard for me to be with all the boys. But at the same time, I improved a lot. I learned a lot of things from them. I got a lot of respect. That's why they called me Mohammed: because I was surfing like a boy. I was really strong; I didn't let anyone put me down. I was wearing boys' clothes, and even acting like a boy. So that's why they give me this nickname, because it was rare to see a girl surfing in my village. Now surfing is growing in Agadir, in the city, and even in my village, Tamraght, there's a girl who is surfing, which is good. Watching her do the thing that she loves makes me happy.

It was hard to get the surf equipment, but my parents were supporting me and buying me the stuff I needed for surfing. Their support, it makes me stronger, and I work hard and win surf competitions and get more help. So this is the thing. My hope is that all parents will support their kids to do what they love.

The first board I got was from my cousin. Then my brother's friend gave me a wetsuit. And then there's a guy, Dakhouch, he was supporting me with materials, buying boards for me, wetsuits, supporting me to go compete in the Morocco championships . . . he really pushed me. I didn't want to go, I thought I wasn't good enough; I was only 14, and would have to compete with the older girls. But I went, and I won.

In the beginning, surfing was a hobby, but now it's become like a job. I'm not doing it just for money, though. I'm doing it for my heart, because I love it. When I'm working as a surf instructor, I work with my heart, because I love to help people surf. And I love the feeling of helping people surf for the first time, seeing them ride their first wave. So I'm really happy to do this job, and I'm happy to have clients from all over the world. I'm sharing the thing that I love with them, we become friends, and then I see them back in Morocco. This makes me really happy—shows that I'm working well.

Surfers come to Morocco from all over. Especially in the winter, when there are really perfect waves. From north to south, we have the perfect coast. And you don't have to drive really far

to the spot that you want. Especially in Taghazout, where there's one spot next to the other one. All the long right-handers.

If there's no surf, we go to the Tamri Dunes in the desert and do sand surfing there. We also have one of the biggest traditional markets in Africa, Souk Elhad. People coming to surf a perfect wave and see our culture don't have to drive for hours. Everything is close. In one day you can surf, visit the sand dunes, and go to the market. You can do three activities in one day. This is why people love to come here. Sunny days, and perfect waves.

My goal is to start a surf camp. That takes more time and more money, so I have to work hard. I have to work hard for more local girls to start surfing. Just to see a woman paddling out, in the lineup or carrying a board, makes me really happy. It makes me really, really happy to see a girl surfing. And not just from here—any girls. Doesn't matter if they're from Morocco or outside of Morocco. It gives you more confidence, you know?

Women are strong.

We can do whatever we want.

We can do everything.

photo by Samantha Hunt

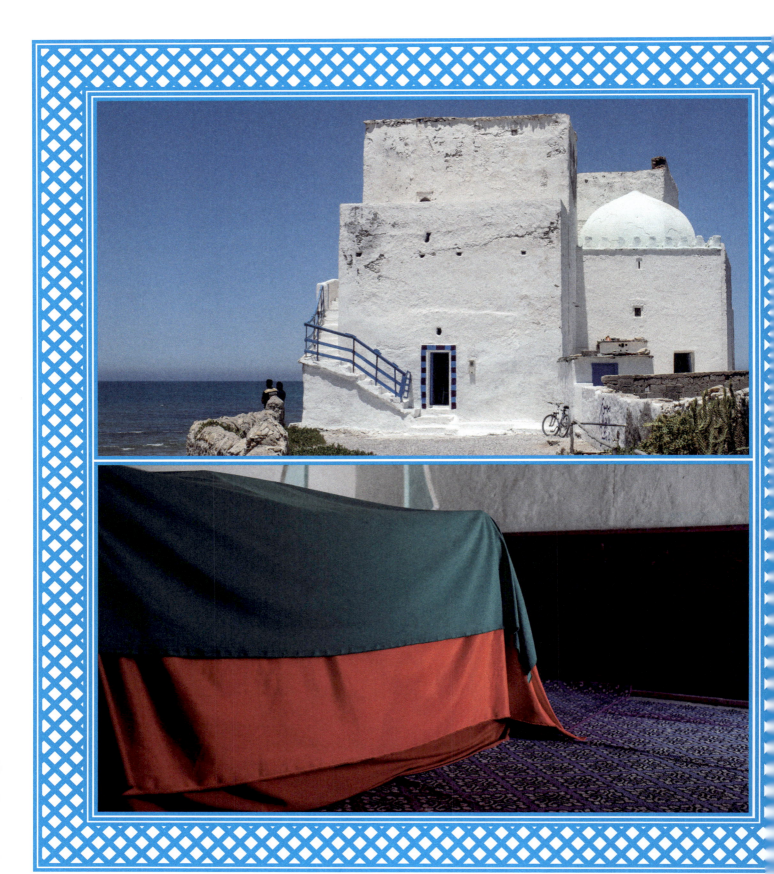

Sufi shrines in Morocco breathe the mystical practices of Islam. There are all sorts of shrines, from tiny, almost forgotten village shrines to shrines of unknown saints we know nothing about to large, well-endowed, wealthy shrines that have patronage from the king, and everything in between. Most are associated with burial and healing, and pilgrimages to the saints of the shrines. A really important custom here in Morocco is that by law, non-Muslims are not allowed to enter Muslim mosques and shrines.

Over the past twenty years, surfing has taken off as a Moroccan thing, equally accessible to girls and to boys. This is a rarity for sports in Morocco, which tend to be reserved for boys. Civil society groups and social movements have done a great job of popularizing this sport, taking the fear out of it. Because in Morocco, anything that comes from Europe is treated as suspect.

The communities around Essaouira form a religious brotherhood called regraga. The shrine Sidi Kaouki, south of Essaouira, stands half-ruined and eroded away, on a low outcrop of rock just above the beach and crashing surf. Typically, shrines such as Sidi Kaouki are important, mostly to women, because of the limited access they have to the usually male-dominated spaces of mosques. Women can visit these informal religious spaces on their own terms.

Moulay Bouzerktoun, north of Essaouira, is a larger shrine complex that would have an annual celebration, bringing people from farther afield each year. The shrine is perched precariously on a bluff pounded by the waves. There is a small village at the site, and this is the only place in Morocco I have ever seen neighborhood girls playing football. Like Sidi Kaouki, which is popular among intrepid surfers, Moulay Bezerktoun is frequented by surfers seeking extreme conditions—they call it simply, Moulay.

In the town of Safi there is a major shrine that deals with healing. It is called the Zâwiya of Sidi Bou Salih. People who go there can spend the night, and meet with spirit mediums. Dream interpretation and natural medicine is offered. In Asilah there is the urban shrine, Lalla Mennana al-Misbahiya, built right into the city walls—actually at the foot of the sea wall, facing the ocean, directly above the crashing waves. This saint was the daughter of a famous Sufi sheik who had fought the Portuguese all along this part of the Moroccan coast. She is said to have died on her wedding night, and to have taken the form of a white dove before departing this world. Her lovely whitewashed cemetery-shrine is truly exquisite. People visit it to seek help with skin ailments.

Sacred practices that involve water are related to women's fertility. Many of the shrines specialize in matters of fertility. In Morocco, fertility is always a woman's problem, not a man's. Women go to these shrines seeking intercession or aid, because they want to have children. One of the common practices at these shrines is for women to immerse themselves in water. In the ocean shrines, this involves bathing in the sea. And there are often secluded masonry, cubicles almost, that have been created in the rocks, which allow women to do this with some measure of privacy.

Sidi Abderrahmane, in Casablanca, is situated in Casablanca's fashionable west-end neighborhood of Aïn Diab. Traditions say that Sidi Abderrahmane was from Baghdad, Iraq. He was reputedly an "ecstatic" Sufi, so intoxicated by his state of closeness to God that people thought he was crazy. (The line between spiritual intoxication and craziness is often hard to determine, as in both cases one appears to be "possessed" by an outside force.) Seeking isolation from men, Sidi Abderrahmane settled on this rocky outcrop along what was then an uninhabited coast. Though the shrine is only accessible at low tide, there are people there all the time. The shawafât (spiritual mediums, literally "seers," and always women) who receive the pilgrims live there, as does the shrine's guardian. People visit Sidi Abderrahmane to deal with mental issues. Mental illnesses are thought to be caused by a jinn—a spirit who has taken possession of the individual. In Arabic, they say a person is majnûn—possessed by a jinn.

MOROCCO SPIRITUAL LINK DR. ERIC ROSS

Jinns are beings that are mentioned in the Koran. They are legitimate Islamic entities, made of fire. Humans are made of earth and mud, angels are made of light, and jinns are God's creatures made of fire; and they come in all shapes and sizes—you have male jinn and female jinn, you have Muslim jinn and Jewish jinn and pagan jinn. Some jinn are good and some are harmful. A lot of traditional medicine deals with this. It is not so much exorcism, which gets the jinn to leave the body; it is to get the individual to come to an understanding of the spirit that has come to inhabit them. Some kind of mutual agreement between the individual afflicted by the jinn and the jinn is negotiated during the processes of healing.

At Sidi Abderrahmane, treatments can take several days, and consist of exposure to the crashing waves in various crags, purification with incense, and washing of hair with holy water. Sidi Abderrahmane is assisted in his therapeutic work by a female companion, Lalla Rissania, who is also believed to be buried on the rock. ∎

photos by Geoff Billet
This page: The Sidi Kaouki Shrine
Next 2 pages: The Moulay Bouzerktoun Shrine

MY NAME IS RAMZI BOUKHIAM.
I AM AN OPEN BOOK.
I AM FROM MOROCCO
AND AM 27 YEARS OLD.

After a long surf, my favorite thing to eat is chicken with French fries.

I grew up in Agadir, and started surfing at the age of 9. As a little baby, I could already be found on the beach with my parents. My dad loved fishing, so every weekend we were on the beach.

The beach I used to go to with my parents, Devil's Rock in the village of Imourane, was full of surfers. We watched them all the time. We started very young, with bodyboards. My brother Samir started surfing before me. He was the one who pushed me to try a surfboard.

During the summer holidays, I used to go to Europe to attend lots of surf contests for kids. I was doing quite well, and got sponsored by a surf brand at the age of 10, which was a great help for me, to be able to travel and compete all over the world. After my dad passed away, I went to live in France, in 2007, with my brother and mum. I was able to attend a sports studies section in a school in Biarritz. At the age of 16, I decided to be a professional surfer, and since then I've competed all over the world in the Qualifying Series, trying to qualify for the World Championship Tour.

Between the competitions I go back to Morocco, where I live again now.

Surfing for me is a pleasure, for sure. I am so lucky that surfing became my job. I am living from my passion! It makes me feel happy, strong, free, and passionate. I miss the ocean when I'm far away. But sometimes, the ocean can hurt you. I have suffered a few injuries. The ocean is different every day, and it's up to me to adapt to all its conditions. ▶

photo by Yoriyas Yassine Alaoui

Surfing is my work and my life, for the moment. I am not married, so I do not have any family responsibilities yet. I can concentrate 100 percent on my surfing.

The best thing about Morocco is the hospitality of the people, and the 3,000 km of coastline; the culture; its world-class waves; the amazing food. The beautiful nature, and the lovely climate.

Surfing in Africa is different, because it is at home. Everything is just easier and cheaper. The only African countries where I have surfed are Morocco, South Africa, and Namibia. I would love to go to Senegal this winter for a swell, if we are able to travel.

I want the world to know that we are definitely on the surf map. Morocco is a surf nation. We have world-class waves, and the fact that the WSL organized an important QS competition in Taghazout in January this year — which was a great success, with beautiful waves — showed this once again.

Every winter we have more and more top surfers traveling to Morocco, and they all enjoy the waves and their time here.

Surfing has become more popular in Morocco now that surfing is part of the Olympics, and with my qualification. I hope this will be the same for the other African surf countries!

I am extremely proud to represent Morocco, and the whole African continent. Being an Olympian is like a dream came true! I can't wait to go there, and I cross my fingers for it to happen.

Can Africa be a surfing superpower, like Brazil? I hope it will be.

What surprises me is that surfing is getting bigger, but on the other side, the athletes are getting paid less. Or not at all!

We'll need a lot of support for our younger generation. We definitely need sponsorships from national and international companies to help our young talent to train with good coaches and travel the world for competitions. The governments have to give more money to the surf federations in the African countries, so that they can organize regular training with good coaches and accompany surf talent to the ISA world championships every year. It is very important to go abroad and attend international surf contests and to measure yourself against surfers from all over the world.

You can be the best surfer in your country, but you will only know your real level by going abroad. ∎

People often ask me about a photo on the internet of myself and Rihanna in a jacuzzi. I always laugh and say, "Do you really believe this was me?" The guy is just a lookalike. A friend of mine tagged me in an Instagram story just for fun and it went viral!
So no, I never met Rihanna. I hope you are not disappointed.

photo by Peter King

NAVIGATING THE TRIPLE CONSCIOUSNESS OF BEING BLACK, MUSLIM, AND THE CHILDREN OF IMMIGRANTS, YOUNG SOMALIS ARE FORGING A NEW IDENTITY THROUGH RAP.

BY ABUBAKAR FINIIN

"CIYAAL BARAF"

refers to the generation of Somalis born in Canada—a nickname that translates as "children of the snow," but with a much deeper meaning. While their parents fled war-torn Somalia in search of a better life—only for the cold Toronto streets to reintroduce the scourges of gun crime, poverty, violence, hostility, and lack of opportunity—this generation faces a new battle: one of belonging.

The young Somali diaspora has to navigate the triple consciousness of being black, Muslim, and the children of immigrants. As a result, they find themselves in the middle of a Venn diagram: being black, in unprecedented times of police brutality and racial profiling; Muslim, in a post-9/11 world; and the children of immigrants, in Brexit Britain. These are difficult things to face separately, but together, it's a deadly mix.

Years of negative media portrayals and social exclusion hasn't helped Somalis find their voice, but fresh UK and Canadian rap talent are doing it through music. In the UK, rap duo 38 and Alz make up YMN, Young Mali Nation (Mali is often used as an abbreviation for Somali in the UK), fusing English and Somali in their raps, a powerful symbol of dual heritage. Alz raps "Lacaag (money) on my mind" on "Hotspot," then mentions how he "grew up on bariis and moos," a popular Somali dish of banana with rice, in a gravelly tone that's perfectly balanced by the mellifluous trill of 38. The balaclava does not mask the youth in his voice. Yes, the pair are young, but their songs are essentially melodic eulogies, packed with RIPs, indicative of their troubled upbringing.

Manchester's Mastermind is a UK artist ensuring that Somali representation is not confined to London. Hailing from Rusholme, the rapper's wavering pitch is common among UK-Somali artists, a nasally flow that's enervated yet refreshing. And at only 19, Northwest London's GeeYou already has several hits under his belt, with a hypnotic flow that shouldn't detract from the heavy content matter. He grapples with issues such as drug dependency, the justice system, and gang culture—all symptomatic of the lack of social mobility in Somali communities. ▸

photo by Marco Gualazzini

269

"SHE FEELING MY TUNE MALI SEASON,
NOT TIME FOR TREASON,
FAMILY MY BROS KNOW THE MEANING"
—SHAKK

"Grey skies in the Eastside, it's just another day in the hood and my mum asks me maxaad haysaa, just got to pretend that I'm feeling good"—Musti

While the media has limited Somali coverage to piracy and terrorism, stereotypes are being reconstructed. The Pirate movement, founded by Megz and Somali boxer Fuaad "The Pirate" Huseen, is emblematic of the shift in Somali perception from ridicule to acceptance. "The whole idea was about empowering the youth," says Megz, who epitomizes the spirit of young British Somalis trying to unveil the pervasiveness of stereotypes.

A Canadian news reporter asked people in Toronto if they knew the meaning of slang terms such as "ting," "bucktee," and "wallahi." While a lot of this slang originates from Jamaican patois, you can see how the small Somali demographic has had an influence. "Bucktee" (bakhti) is a Somali term that loosely translates to "low life," while "wallahi" is a religious word that means "I swear to a God," and is popular among the Somali community.

Over in the UK, Somali slang has been incorporated into street culture and language, and it's common to hear "lacaag" (money), "xaasid" (greedy), and "cadaan" (white) in playgrounds and clubs and used even by non-Somali kids. In his "Mad About Bars Freestyle," British-Jamaican drill rapper Digga D has a verse that is almost exclusively Somali:

"Caasis, caasis, the akhis (brothers) call us caasis (rebels), aksar (police) trying to raid my guri (house), they want man back in xabsi (prison), grab the xabad (gun/bullet), I'm charged up fully."

Canadian-Somalis achieved success earlier than their UK counterparts, largely due to Toronto's demographic, which has more than 80,000 Somali residents—the largest African immigrant population in the city. In the UK, other diasporic influences have saturated the country, such as the resurgence of grime in 2014 followed by the rise of afrobeats, meaning it took a while for the Somali scene to break through.

The Canadian-Somali and British-Somali experiences run parallel. The council estates of Britain are nearly identical to Canada's housing projects. Same conditions, different country. This hasn't limited the creativity of Somali artists, but has instead instilled a fierce hunger and determination. Rapper Top 5 had a hit song already in high school, while Somali-born K'naan's international hit "Wavin Flag" was the unofficial anthem of the 2010 World Cup.

The concept of belonging is complex for young Somalis living in the West. For a lot of us, we feel like we are straddling two homes, while never really belonging to either. For me, Somaliland is my motherland; but when I visit there I'm treated as a foreigner, and the local youngsters call me "fish and chips"—a nickname given to British-Somalis born in Britain. However, back in Britain, following the EU referendum in which the result was largely influenced by anti-immigration rhetoric, I'm not wanted here either.

Which is perhaps why this new Somali identity boasts an unparalleled solidarity, which cares very little about "qabiils" (tribes) or territorial disputes, as being Somali is all that matters. The identity of young Somalis living in the West transcends tribalism. Instead it's a product of immigration, discovering home, struggle and hope for a better future. This intersectionality naturally breeds unique stories and experiences that were once untapped. Now it's everywhere, most importantly on the airwaves. ∎

photo by Feisal Omar

"I'm the top Mali moving gully on the Gaza" – Puffy L'z

"You cripple me you shackle me you shatter my whole future in front of me, this energy is killing me, I gotta let it pour like blood, soobax"—K'naan

MY NAME IS

JAMAL SALAD ABSHIR

I WAS BORN JANUARY 1, 1999, IN MOGADISHU, AT A TIME WHEN THE CITY WAS A DIFFICULT PLACE TO BE. BUT IT'S HOME, AND I'VE LIVED HERE MY WHOLE LIFE. IT'S WHERE I STARTED MY EDUCATION AND FINISHED MY DEGREE. IT'S ALSO WHERE I STARTED SURFING.

Although Somalia has the largest coastline in east Africa, the whole concept of surfing only arrived on our shores recently. When I was younger, security issues had got to the point that I couldn't even think of doing something like surfing. There was a list of challenges that made it difficult for me to explore my options.

The unrest in the country and the lack of employment obviously affects us greatly. But we are trying to cope with the pressure by surfing and finding new solutions. Today there is change and people are open to new ideas. Nothing I've experienced so far has been more exciting than this.

I first discovered surfing while watching TV. This was a fascinating concept. Something that I admired but didn't ever think was for me. You don't see it here. It's just not something that my people are familiar with. For us, surfing is an elite thing that rich people in the Western world do for fun. In Somalia we're more interested in football.

Actually, playing any other form of sport is not that popular. It's because of the security problems we've been facing since Somalia's unrest began thirty years ago. You can see in the pictures that there are guys with guns on the beach. They are from the police authority in the capital, and are there to protect and safeguard the bay from anyone who

might harm or disturb the activities that the youth are doing, like surfing.

Weekends involve spending time at the beach playing football and swimming. Tea and conversations. And by evening, we enjoy Mogadishu's music scene. I like to listen to Somali rap music from America. The rapper KFP.

Somalia is a place of poets. I like poems, and if I have to pick a favorite poet it will be Sayid Mohamed Abdulla Hassan. I like any poet who talks about patriotism. If I could swap my life with anyone in the world, this is a big question, but the person I would like to be is a historian and a religious scholar, Sh. Mustafa Haji Elmi.

SAY: "GREAT SHOUTS ACCLAIMED THE DEPARTING OF MY SOUL."
SAY: "BEASTS OF PREY HAVE EATEN MY FLESH AND TORN IT ASUNDER."
SAY: "THE SOUND OF SWALLOWING THE FLESH AND THE FAT COMES FROM THE HYENA."
SAY: "THE CROWS PLUCKED OUT MY VEINS AND TENDONS."
— SAYID MOHAMED ABDULLA HASSAN

I'm now 22 years old and on a completely different path from where I was headed just two years ago. I may now dare to surf.

Surfing clears our minds from the negativity we encounter.

Through surfing I've gained a perspective that's different from anybody else's. I've developed a talent I didn't even know I had before. ■

HOME

BY WARSAN SHIRE

No one leaves home unless home is the mouth of a shark. You only run for the border when you see the whole city running as well. Your neighbor's running faster than you, the boy you went to school with who kissed you dizzy behind the old tin factory is holding a gun bigger than his body. You only leave home when home won't let you stay.

No one would leave home unless home chased you, fire under feet, hot blood in your belly. It's not something you ever thought about doing, and so when you did, you carried the anthem under your breath, waiting until the airport toilet to tear up the passport and swallow, each mouthful making it clear that you would not be going back. No one puts their children in a boat. Unless the water is safer than the land. Who would choose days and nights in the stomach of a truck, unless the miles traveled meant something more than journey.

No one would choose to crawl under fences, beaten until your shadow leaves you, raped; drowned, forced to the bottom of the boat because you are darker; sold, starved, shot at the border like a sick animal, pitied; lose your name, lose your family, make a refugee camp a home for a year or two or ten; stripped and searched, finding prison everywhere, and if you survive, greeted on the other side with "Go home blacks, refugees, dirty immigrants, asylum seekers; sucking our country dry of milk, dark with their hands out, smell strange, savage, look what they've done to their own countries—what will they do to ours?"

Dirty looks in the street feel softer than a limb torn off, the indignity of everyday life more tender than fourteen men who look like your father between your legs. Insults are easier to swallow than rubble, than your child's body, in pieces—for now, forget about pride; your survival is more important.

I want to go home, but home is the mouth of a shark. Home is the barrel of a gun, and no one would leave home unless home chased you to the shore, unless home tells you to leave what you could not behind even if it's human. No one leaves home until home is a damp voice in your ear saying, "Leave, run now, I don't know what I've become."

MAMAN GERMAINE ACOGNY

IT IS TRUE THAT MY GRANDMOTHER, ALOOPHO, WAS A VODUN PRIESTESS.

And my father always told me her story. I didn't know her, but when I was born I had my grandmother's special mark, and I was called Yatundé, "the mother is back."

I cannot say that I am a priestess for everyone, but when I arrived in Toubab Dialaw, the women who do the "Ndeup" saw in me that I was one of those women. I was very reserved, but they told me that I was from here and that I came back, so they did the "Ndeup" ceremony for me, to bring back the spirits of my ancestors here in Toubab Dialaw. There was a ceremony; we sacrificed an ox; we danced for seven days.

So I am a family priestess. Once a week, when I'm here, I make the offerings to the ancestors. I mix a bit of what is happening in Benin and a bit of what is happening in Senegal, because I have access to both cultures. I do rituals with palm oil, with gin, with cola and cornmeal and all. It's a bit like the Catholic religion.

Here, it is the people of "Lébou." The Lebou are fishermen, and have a good relationship with the sea. Yemanja is the name of the goddess of the Yoruba in ancient times. In the great ritual of the "Deup," it was men who held the power and performed the rituals. But to do these rituals, they were obliged to disguise themselves as women. So for me, the power is in women, and men disguise themselves as women to do the initiation and transmission ceremony.

The sea is a very important element where I live in Toubab Dialaw, where we make libations by the sea. Every Thursday when I am there, I make curdled milk libations for Yemanja (the goddess of the sea in Benin). There is Maam Comba Bang in Saint Louis, Maam Coumba Castel in Gorée, where I lived, but they are all goddesses of the sea. Like the Virgin Mary, she has the goddesses of the earth and of the sea. Yemanja, the goddess of the sea in Benin, her colors are blue and white. Christians have not invented anything! This is why my Yoruba grandmother told my father not to convert, because Christians have nothing new to bring to us.

My grandmother used to say that water is the strongest protection; it breaks all bad things. Water is also important—for Catholics, holy water. Every morning, I pour water in front of my door to remove all the bad things.

In the Yoruba baptism, it is the mother who comes out of the house, and we pour water on the child, and we put salt and dried fish in his mouth for the baptism.

When the colonizers arrived, they saw our strength. To lead us, to remove this force, the colonizers tried to minimize our culture and impose theirs, in order to show that their belief was better than ours. They tried to put us below.

I'm lucky to be an artist and to be known, but I don't feel superior to other women. In Toubab Dialaw, the women work in the fields, the women take care of the fishing. They sell the products of the fields and fishing. The women do ceremonies, they take care of the children, they educate the children. Women are amazing. ▶

photos by Nicole Sweet

There are husbands who go to Europe and leave their wives alone. There are extraordinary women, and thanks to them, the tradition remains. They educate the children and have the responsibility to be there, by the sea, to involve the spirits of the land, the sea, the trees, the rocks. And that is what unites us.

I say that African dance is the mother of all dances, because life was born in Africa—it is proven, and the gesture was born in Africa, and therefore, I learned.

The symbol of infinity in Benin is a snake biting its tail. The spine is a very important thing in the human body. The spine is solidity and flexibility; it is also a force, its opposite. The spine is something essential in my technique, and you have to feel it, and you have to live it. It's always having the idea that a snake is climbing on a tree — the tail is down, but it is climbing. So you have to be aware of this spine that vibrates and makes waves, and it gives that strength and that vibration, this oscillation of the body and of the spine, which is very important. The spine is very solicited in all the dances in Benin; the center of gravity is lower. In Senegal, while dancing the Sabar, the take-off is upward; but there is still the anchoring on the ground with the supporting leg. Without anchoring on the ground, it cannot have verticality. This awareness of the spine, the anchoring and verticality of the vertebral column, the snake of life, is central to my teachings. It's within the surfers of Senegal and West Africa. It really has to be said, it is also good for surfers all over the world. This is the truth.

My dance technique is linked to nature. I continue with it every day—I get up very early, I walk by the sea, I meditate in front of the sea, I pray in front of the sea, I pray in front of the sun, and I tell myself that when I put my feet in the water, I have contact with the whole world, because there is no border in the sea. My dance school, L'Ecole des Sables (School of Sands), is like the sea; there is no border of dance, not between people, nor between religions. L'Ecole des Sables is a communion, the encounters with francophone, anglophone, and lusophone Africa. We have united Africa through dance, which politics has not yet succeeded in doing, and even us, we have connected the whole world by dancing.

L'Ecole des Sables is the mother house of dance, and we welcome the whole world; we are very happy for that. The ancestors, nature, helps us to remain who we are. It's not the color of the skin, it is the respect of cultures that will make racism disappear, and racism has hard skin. It is not now that it is going to disappear; we Africans must try to change the mentalities of others. It is not the others who will change; it is up to us to change the mentality by our behavior, by our dances, and by the value of who we are. ■

I AM JOSEPH DIATTA

I'm Joseph Diatta, born in Cabrousse Mossor in Lower Casamance in the south of Senegal. I have two brothers, Eldor Diatta and Marcel Diatta. We all surf. We learned to surf from the Italian tourists who were there and taught us. I only started surfing when I was 25. I really wanted to start earlier, but the situation was not right, and I had fears. Surf is a passion that gives me distraction—it's fun and it's a sport.

We have hand signs we use to show other surfers in passing that there are no waves; the waves are good; or it's dangerous.

I am Animist. This is the belief that objects, places, and creatures all possess a distinct spiritual essence. All things—animals, plants, rocks, rivers, weather, human handiwork, and perhaps even words—are alive.

I pour water on my face in a spiritual way before entering the ocean. As I told you that we are Animist, so we practice circumcision. It is done at an age between 25 to 30 years old. We take men to the bush and stay there for three months without seeing a woman. There are only men. The women prepare the meals and the former initiates bring them to the initiates. We prepare the songs for the day of the release, and we make masks. This was hard, because we had not been told what was going to happen there. Suddenly we could not surf. It was very painful, because it was something that we had never imagined.

Since then I have changed my behavior. I learned to keep a secret. I limit my discussion with women. I respect elders. And most important, it decreased my fear. This made me a much better surfer. I became a real hero.

Today I can say thanks to surfing that I manage to get some money from the clients that I teach. I cook at the beach for clients—fish that I catch myself. We grill the fish and serve it on a big plate with rice and sauce with as many spoons as there are people, and everyone eats from one plate. We love putting Lucky Dube reggae on, then make a beach fire, drink some Lougoulo, and do some Djembe Tam Tam dancing.

That's life for us. Young surfers love Europeans just for the sake of mixing; it's a color we like a lot. Sometimes when I surf, I dream of traveling, traveling to Europe.

photos by Lupi Spuma

CHÉRIF FALL

photos by Nicole Sweet

Despite our similar look due to dreadlocks, I'm not a Baye Fall. Like most of the natives of Ngor, Senegal, I'm Lebou. Our ethnic group is very present in Dakar. Lebous are mostly fishermen or footballers. My parents wanted me to have a career in football, too, but I wasn't interested. I was magnetically attracted to surfing as soon as I discovered it. I started on a wooden board, at the end of 2008.

Oumar Seye—the first black surfer with a professional contract in Senegal—spotted me, and came to talk to my parents. He said I could progress quickly. He saw my potential, and he is now my manager. My entourage supported me. But I was punished for a while, because my grades at school were bad.

I was too focused on surfing. I had to stop school during competitions, and in the end I had trouble keeping up. Today I take courses mainly to develop my English.

I'm very religious. Islam plays an important role in my life. I often listen to reggae music, especially my favorite Senegalese singer, Lëk Sén.

In the past, we saw only white people surfing. Many people in our families looked at surfing as a white sport; but now we know that we have a place, because our level and style are present. We have made a lot of progress, and have the chance to travel and surf in other countries, and participate in high-level competitions.

In Dakar, no one shapes boards, despite the high demand. And it's expensive to import them, because of the taxes. Oumar managed to get some help from his friends in Europe, or from his sponsors.

When I get into the water, all my worries disappear. It's my second home. We often say, "Bi sokhornaa deh" when someone does something incredible in the water, and you want to congratulate them.

I love the feeling of being able to enjoy the waves as much as possible every day. One day I was so thrilled on the way to surf, I forgot my board at home! ▸

Since I started surfing, I have had good results in local competitions. I have already competed in Morocco and Cape Verde. I won the West Africa Tour twice—was the first black surfer to win. My goal now is to qualify for the CT and the Olympics, to prove that black surfers are legitimate in the surfing world. A lot of white people are looking forward to seeing us on the international circuit. Morocco and Senegal have to qualify. There is a lack of diversity alongside South Africa.

I have taken part twice in the World Surfing Games—in France and Japan. The first time I was well prepared, but I felt too much pressure; there were a lot of other surfers, and I was the first of my generation.

Locally, I am respected; I am their champion. It gets complicated when I travel. We are not well received everywhere. In France, some people were mean when we were training, and I didn't like it. We've also been confronted with localism. To be respected, you have to be excellent, and surprise others. Constantly upgrading your level. Whereas in Dakar, we don't have this spirit, thanks to our motto: teranga (hospitality). Everyone is always welcome. We share everything, especially Lebous. In France, you arrive at the lineup at 7 a.m., with fifty surfers there already. Here, we have enough spots, and we don't fight to find our place.

My favorite spot in Dakar is Ouakam: hollow waves with big barrels. When I'm in it . . . oh, man. This is paradise. When I come out of a tube, I scream! Some day, I would love to experience the mythical Tahitian and Hawaiian spots.

I have always dreamed of becoming a surf champion. I'm constantly pushing my limits. Now I'm well known, and it gives me a lot of opportunities I'm willing to embrace.

AITA DIOP

photo by Djibril Drame

I'm a 15-year-old Fulani girl from Yoff, in Dakar. My mum sells rice and fish for lunch at the beach, where I watched kids having surf lessons. Five years ago, I asked the surf club there, Malika Surf Club, if I could join, and Aziz said yes! I never thought I could surf one day, thinking of how much the equipment costs. Once I stood up for the first time on a board, I knew I wanted to feel this sensation my whole life.

The ocean has been by my side for as long as I can remember. I spend my time at BCEAO beach, where the grill shacks meet the surf schools. There's always a friendly atmosphere. This is a good life. My mother's restaurant is right at the shore break. I am used to seeing the sea stormy and messy, or glassy and small . . . it just feels good to always witness the sea, and be in the water as much as possible. It's part of my life, and I hope one day I can see different beaches and waves around the world, like in Biarritz, France.

Since surfing became my passion and began to be a huge part of my life, my family has supported me from the beginning. A lot of people in Senegal want to see local girls surfing. But I have mixed feelings, being a young female surfer here. It's cool, but not that easy. Older surfers are always giving me tips in the water, but nobody gives me presents. The sticky part is about the local culture. My mum says I must avoid staying with boys all day, as people around may talk badly about my education and my family. I always have to behave in a correct way. After surfing I don't casually chill at the beach, I prefer to go home. Also, I'm not going by myself to other surf spots without my coaches Marta or Aziz, or one of Malika Surf Club's instructors. People say I'm courageous, but that I must be receptive to the tips coaches give to improve my level. And that I have to listen to my mother. I don't pay attention to critics.

I feel free and happy in the ocean. It is always challenging. It's my playground. I play with the waves, with the other surfers. I also can be scared, and push myself. Once I was in Ouakam and I made the wrong entry into the water, so my feet got full of sea urchins before even reaching the lineup.

The first time I surfed at Secret Spot, the waves were big for me, and I was scared of rocks. I came back to the beach after five minutes. Then I gathered my courage, and went out to catch a good one! Secret is now my favorite spot in Dakar. It's easy to get to the backline without too many duck dives.

When I close my eyes after a long day in the waves, I can still feel them.

Surfing opened my mind, and gave me knowledge and the chance to go back to school. I was so happy when the International Surfing Association (ISA) gave me a scholarship. Thanks to it I have access to some equipment, and a private teacher at home. With the COVID-19 situation, schools have been closed in Senegal since March. So I am taking catch-up courses until they open again.

Now, kids from 8 years old can start surfing, and the level in Africa is improving so much. Also, our national team began to compete internationally with the Senegalese Surf Federation. My goal is to be a champion surfer representing my country. I also want to be a role model for the next generation, and show young girls they can surf and keep up with school at the same time. ■

LAST BUT NOT LEAST, I SECRETLY WOULD LOVE TO DYE MY HAIR COMPLETELY BLUE.

IBRA SAMBE

I'm 23 years old, from the Lebou village of Ngor, Senegal. I have two sisters and a brother. We all have a close connection to the ocean. My father was working at the Diarama Hotel, near home. When I was little, I used to windsurf before I discovered surfing.

European tourists settled in the neighborhood. After Koranic school, we often saw them crossing toward the island to surf. Thankfully they gave us their boards when they left. We learned to ride on our own.

Standing for the first time on a board is a unique and inexplicable feeling. I was so astonished to succeed,

I screamed! I was about 12 years old.

Surfing, surfing.

From the start, my mother didn't want me to surf. She preferred that I concentrate more on school. And she was scared. My father was cooler with the idea, since I was already windsurfing. At that time, my friends and I weren't allowed to go to the beach because our parents were afraid we would drown, like surfing is a dangerous sport. Plus, there are a lot of rocks and sea urchins at our spots in Dakar.

In the beginning it was said that surfing was reserved for whites only. We didn't have any equipment. The little we

had was left by tourists passing through. It's a noble sport, you see. It's expensive, we don't have sponsors to help us. So we consider surfing to be a white man's sport. But we are starting to find solutions, sending emails to sponsors. Before, we had neither phones nor social networks. It's easier now to contact them. They try to send us free stuff, but it's difficult.

One day we came across a kid whose board was half burnt. The kid lived in a shack with his family. There was a fire—fortunately nobody was in the house at the time, but the board caught fire. It was very moving to see him, as he still tried to surf with it. No solution was found for him, despite calls on ▶

photo by Djibril Drame

social networks. We want to help the next generation, but we don't have the means. It's a pity.

As a regular, I feel very comfortable when I ride Ngor. This is where I learned to surf, right next to my house. I can see the waves from my terrace. Every morning when I get up from my bed, the first thing I do is go to the water. I have all my good and bad memories with my family and friends. The ocean means everything to me. It's like a drug.

And it's also my job. When I'm not surfing, I work out on the beach with the team, play football with my friends, or

we meet at the Almadies—a district on the most westerly point of the African continent—around some Touba coffee or Attaya tea.

Last year, I injured my knee. I was sharing the lineup with two strangers. I took two, three waves. I misplaced myself, and all my weight rested on my knee. The pain went away for a moment and I didn't think it was that bad. I took another wave to check, and that was the sledgehammer blow. The surfers helped me out, and took me to the hospital. Nothing was broken, but the ligament was partially torn. I was in the lowest spirits when I was told that I

might not be able to surf for at least six months. What a frustration, when you live right next to the sea . . . staying out of the water, but seeing it every day. Impossible! Thanks to the rehabilitation I feel better, even though I'm not yet 100 percent back. In the end, I didn't touch a board for eight months.

I have already competed locally in Senegal, and at the World Surfing Games in Japan. We are currently preparing for next year. And I am hoping to find a place in the Olympics. Japan was the first time I have been so far away.

It was difficult at first. ▶

photo by Nicole Sweet

On the plane, we sat for too long! We're not used to it. And we didn't know Japan was that far. We arrived two days before the official start, so we didn't have time to acclimate before the competition. Then a typhoon shifted it by one day. The spot was very confusing: big waves, with a lot of wind. The waves are different here in Dakar—mostly on rocks, not beach breaks like in Japan. But we were well received by the Japanese. They have

a beautiful culture; they are well educated. I particularly appreciated the way they greet you with their heads down as a sign of respect. Greetings are also very important in Senegal. Oh, and I enjoyed Japanese soups!

I'm truly generous when it comes to supporting our little ones. We genuinely share waves, and we have fun. I want to bring our style of surfing internationally, to be a model for future generations.

In the village, other parents didn't want their children to surf, thinking a black person would never make it. When they saw us leaving the village with our boards under our arms, nobody believed in us. Thanks to those who have succeeded, they changed their perception. I want to show them there is hope. I want to show that it was worth spending so much time surfing and investing in myself. ■

photo by Ricardo Simal

WASH YOU HANDS BEFORE EATING

ALWAYS EAT WITH YOUR RIGHT HAND

CHIP ROLL

"Carbs on carbs. Because you want to be full."—Dylan Muhlenberg, Cape Town, South Africa

INGREDIENTS

Any white bread roll
Packet of NikNaks, Ghost Pops, or other corn-based chips

METHOD

Tear open the roll. Pull out the soft inner.

Pour the chips inside.

Squash down.

Eat up.

MASTERING HAND—TO—MOUTH ETIQUETTE

MIGHT TAKE A WHILE

FISH AND RICE

"After surfing all morning, I want rice and fish, to give me strength to head out for another session. I will share grilled fish and rice with my friends. It gives me the energy to surf again."
— Cherif Fall, Dakar, Senegal.

INGREDIENTS

Rice
Olive oil
Onions, diced
Garlic, minced
Peppers, chopped
Carrot, chopped
Fresh dorado
Vinaigrette dressing for serving
Lime for garnish

METHOD

In a pot, boil the rice in water to cover.

In a pan over medium heat, warm a bit of oil, add the onions and garlic, and fry together. Add the peppers and carrot to the pan and stir to combine. Season the fish and cook.

Serve the fish with the rice and vegetables passing the dressing and wedges of lime.

EATING FROM A SHARED PLATE OF FOOD
UNDERLINES EGALITARIANISM

CHICKEN TAJINE

"First thing, all Moroccan food is good. My favourite is couscous. I can eat it every day—I don't mind. Or chicken tajine."
— Maryam El Gardoum, Tamraght, Morocco.

INGREDIENTS

1 teaspoon paprika
1 teaspoon ground cumin
¼ teaspoon cayenne pepper
½ teaspoon ground ginger
½ teaspoon ground coriander
¼ teaspoon ground cinnamon
1 lemon, zested
5 garlic cloves, minced
4 skin-on chicken thighs or drumsticks
Salt
Freshly ground black pepper
1 tablespoon olive oil
1 large yellow onion, cut into
 thick slices
2 tablespoons all-purpose flour
1¾ cups chicken broth
2 tablespoons honey
2 large (or 3 medium) carrots,
 peeled and cut into thick coins
½ cup cracked green Greek olives,
 pitted and halved
2 tablespoons chopped cilantro leaves
1 tablespoon lemon juice
Couscous for serving

METHOD

In a small bowl, combine the paprika, cumin, cayenne, ginger, coriander, and cinnamon; stir to mix; and set aside.

In another small bowl, combine 1 teaspoon of the lemon zest with 1 minced garlic clove; set aside.

Season both sides of the chicken pieces with 2 teaspoons salt and ½ teaspoon black pepper.

In a large pan over medium-high heat, warm the oil and brown the chicken pieces, skin-side down. Once browned, flip the chicken and brown the other side, then transfer to a large plate.

Pour off and discard all but 1 tablespoon of the fat from the pan.

Turn the heat to medium, add the onion, and cook, stirring occasionally, until browned at the edges but it still retains the rings.

Add the remaining garlic and cook, stirring constantly, until fragrant.

Add the spice mixture and flour and cook, stirring constantly, until fragrant.

Stir in the broth, honey, remaining lemon zest, and ¼ teaspoon salt, scraping the bottom of the pan with a wooden spoon to loosen any browned bits.

Add the chicken (with any accumulated juices) back to the pan, turn the heat to medium-low, cover, and simmer for 10 minutes.

Add the carrots, cover, and simmer until the chicken is cooked through and the carrots are crisp-tender, about 10 minutes more.

Stir in the olives, lemon zest/garlic mixture, cilantro, and lemon juice and remove from the heat.

Serve the chicken with couscous.

BUNNY CHOW

"Every time we have waves on the south coast, or in town in Durban, we just go straight . . . bunny chow! For me, it's the bean with mutton gravy."
— Jordy Smith, Durban, South Africa.

INGREDIENTS

BEAN CURRY

½ cup sunflower oil
1 onion, chopped
3 whole green chiles
2 tomatoes, chopped
1 teaspoon curry powder
1 teaspoon crushed ginger
1 teaspoon crushed garlic
½ teaspoon ground turmeric
½ teaspoon ground coriander
½ teaspoon ground cumin
1 cup fava beans, boiled until soft
Salt

MUTTON CURRY

½ cup sunflower oil
1 onion, chopped
¼ teaspoon ground turmeric
3 small cinnamon sticks
1 bay leaf
1 teaspoon fennel seeds
4 tablespoons mixed masala
2 teaspoons ginger paste
2 teaspoons garlic paste
1 tomato, chopped
1 pound mutton, in bite-size chunks
1 sprig curry leaves
2 teaspoons salt
6 potatoes

Quarter loaf white bread
3 sprigs cilantro, chopped
½ cup grated carrot
1 tablespoon chopped green chiles

METHOD

BEAN CURRY

In a pan over medium heat, warm the oil and gently fry the onion and chiles until soft.

Add the tomatoes and cook until the moisture has evaporated.

Stir in the curry, ginger, garlic, turmeric, coriander, cumin, and a splash of water.

Continue cooking, stirring, until the ingredients and flavors have combined.

Add the beans with a little more water if necessary and cook gently until the gravy is thick. Season with salt.

MUTTON CURRY

In a pan, warm the oil and gently fry the onion until soft. Add the turmeric, cinnamon, bay leaf, and fennel seeds and fry for a few seconds.

Add the masala and ginger and garlic pastes and cook, stirring constantly. Take care not to burn the spices.

Stir in the tomato, then, when it is almost cooked, stir in the meat. Turn the heat to medium and saute.

Add the curry leaves, salt, and water to cover. Bring to a boil, then cover and turn the heat to low and simmer for about 25 minutes.

Add the potatoes to the pan and continue cooking until the meat is tender and the potatoes are soft.

Hollow out the bread loaf, leaving a thick layer at the bottom. Put aside the soft white center for dipping.

Spoon the bean curry into the bread loaf, leaving space at the top.

Top with a few spoonsful of mutton curry.

Serve with the chopped cilantro, grated carrot, and chiles.

photo by Tate Drucker

BHAJIA & MATAPA WITH RICE

"Straight after the surf, we go to the market. You grab a pao, hollow it out, and put the bhajia inside. You need the bread to soak up the oil. Then you just chow on it. The matapa you get just down the road, but that's a sit-down thing."
— Sung Min Cho, Tofo, Mozambique

INGREDIENTS

BHAJIA

2 cups fava beans
2 tablespoons sunflower oil,
 plus 1 cup
1 onion, diced
1 teaspoon curry powder
Salt
Freshly ground pepper
1 pao (Portuguese-style
 white bread roll)

MATAPA

1 pound young cassava leaves
1 garlic clove
2 tablespoons vegetable oil
1 onion, diced
1 cup cashews
1 cup fresh coconut milk and pulp
Salt
1 cup cooked rice
Peri-peri sauce for sprinkling

METHOD

BHAJIA

In a large bowl, soak the beans in water overnight. Then, rub the beans to remove their skins.

In a pan over medium heat, warm the 2 tablespoons oil and fry the onion, curry powder, salt, and pepper.

When the onion is soft, add the beans and stir to combine.

Set aside and allow the mixture to cool.

Return the pan to medium heat and warm the 1 cup oil. With your hands, shape the bean mixture into small patties, drop them into the oil, and fry until golden brown.

Place the bhajia in the pao and eat while hot.

MATAPA

Mash the cassava leaves with the garlic clove.

Fill a pot with water, set over medium-low heat, add the cassava leaves mixture, and simmer gently.

In a separate saucepan over medium heat, warm the oil and fry the onion.

In a blender, finely blend the cashews.

Add the cassava leaves, cashews, and coconut milk and pulp to the onion; season with salt; and cook until combined.

Serve the matapa with the rice and a sprinkle of peri-peri.

CATCHUPA

"I enjoy our traditional meal called Catchupa, similar to the Brazilian Feijoada. It's a stew of corn, beans, vegetables, meat, or fish. Being pescatarian, I enjoy the fish version of it. Especially with tuna."
— Claudio Cabral, Cabo Verde

INGREDIENTS

1 pound red kidney beans
1 pound mixed yellow
 and white maize
4 tablespoons olive oil
1 yellow onion, chopped
6 garlic cloves, chopped
1 tin tomatoes
Red chili powder
4 fillets tuna, cubed
1 carrot, sliced
2 sweet potatoes, chopped
2 eggs, fried

METHOD

In a large bowl, soak the beans and maize in water overnight.

In a cooking pot over medium heat, warm the oil.

Add the onion and garlic.

Next, add the tomatoes and chili powder, to taste.

Add the fish to the pot, stir well, and add water to cover the ingredients.

Stir in the carrot and sweet potatoes, as well as the beans and maize, then give it a stir to mix all the ingredients.

Turn the heat to low, cover, and simmer for about 2 hours, until the stew reaches the desired consistency.

Serve with a fried egg or two on top.

MAMI WATA AFRO SURF PLAYLIST

1.) Manu Dibango — Electric Africa
2.) Fela Kuti — Zombie
3.) Hugh Masekela — Bajabula Bonke
4.) Sam Fan Thomas — African Typic Collection
5.) Brenda Fassie — Black President
6.) Burna Boy — Ye
7.) Mafikizolo (feat. Uhuru) — Khona
8.) Aya Nakamura — Djadja
9.) Yemi Alade — Johnny
10.) Dizzy DROS — Cazafonia

SEAWATER

"WE TAKE THE WATER HOME TO SHOW THAT WE ARE PROSPERING." —ALEX NKOMONYE, SWAZILAND

"THE WATER HAS HEALING PROPERTIES, AND BY COVERING THE BODY IN IT, BODY AND SOUL ARE RECONNECTED." —BONGUMENZI NGOBESE, TRADITIONAL HEALER, DURBAN, SOUTH AFRICA.

NKOSI

"YOU ARE REBORN AFTER YOU DRINK IT. THE WATER IS CRYING WHEN IT LEAVES THE OCEAN, AND IF YOU TAKE IT HOME WITHOUT THE SAND, IN THE MORNING THE WATER WILL HAVE DISAPPEARED AND RETURNED BACK TO SEA WHERE IT WANTS TO BE." —SABELO MLABA, SEAWATER COLLECTOR, DURBAN, SOUTH AFRICA

"THE SEA SAND ITSELF ALSO HAS ITS POWERS AND IS OFTEN SPRINKLED OVER HOUSEHOLD GARDENS TO DISPEL EVIL SPIRITS. IF WRONGDOERS COME IN THE NIGHT, THEY WILL NOT SEE THE YARD, THEY WILL SEE THE OCEAN AND NOT ENTER." —SABELO MLABA, SEAWATER COLLECTOR, DURBAN, SOUTH AFRICA

★ ★ ★ ★ ★

★ ★ ★ ★ ★

THE END

PHOTOGRAPHIC: Surf Ghana/Michael Aboya, Yoriyas Yassine Alaoui, Kent Andreasen, Patrick Aventurier, Delali Ayivi and Bubby Nurse, Geoffrey Billet, Nic Bothma, Arthur Bourbon, Tyrone Bradley, Claudio Cabral, Martin Caprile, Mosako Chalashika, Samora Chapman, Sylla Cheick, Imraan Christian, Teju Cole, Richard de Jager, Djibril Drame, Tate Drucker, Roderick Ejuetami, Magnus Endal, Greg Ewing, Tao Farren-Hefer, Clinton Friedman, Marco Gualazzini, Iñigo Grasset, Pieter Hugo, Samantha Hunt, Manny Jefferson, Chris Jenkins, Baingor Joiner, Peter King, Mous Lamrabat, Louis Leeson, Klyne Maharaj, Ngqibandaba Maxisole, Kody McGregor, Jamie-James Medina, Shafiq Morton, Daniel Naudé, Kunyalala Ndlovu, Michael Ochs, Nana Yaw Oduro, Feisal Omar, Ramon Sanchez Orense, Nana Poley, Brisco Quayee, Matthew Salacuse, Ricardo Simal, Lupi Spuma, Nicole Sweet, Adeleke Togun, Stephan Vanfleteren, Alan van Gysen, Rogan Ward, and Abdirahman Yusuf

EDITORIAL: Germaine Acogny, Bayo Akomolafe, Rajaa Banda, Sidiq Banda, Bernard Bannor, Fahd Bello, Jomi Marcus Bello, Jahbez Benga, Michael Bentum, Patrick Bikoumou, Chemica Blouw, Ramzi Boukhiam, Claudio Cabral, Samora Chapman, Sung Min Cho, Cass Collier, Andy Davis, Kevin Dawson, Leanne de Bassompierre, Joseph Diatta, Aita Diop, Tate Drucker, Nick Dutton, Chérif Fall, Joshe Faulkner, Michael February, Abubakar Finiin, Maryam el Gardoum, Anais Gningue, Stani Goma, Benjamin Baba Haruna, Kadiatu Kamara, Wanlov the Kubolor, Cebo Mafuna, Klyne Maharaj, Brimah Mahmoud, Mabusha Masekela, Selema Masekela, Mhlengi Mbutho, Kody McGregor, Simo Mkhize, Dylan Muhlenberg, Cyle Myers, Kunyalala Ndlovu, Michael Ochs, Edwin Okolo, Godspower Pekipuma, Robyn Perros, Peet Pienaar, Alfonzo Pieters, Steve Pike, Julia Raynham, Eric Ross, Ibra Sambe, Gabby Saranouffi, Jordy Smith, Tammy Lee Smith, Davy Stolk, Ntombe Thongo, Alan van Gysen, Alice Wesseh, and Abdirahman Yusuf

DESIGN: Peet Pienaar, DTP: Christopher Bisset, PROOFING: Dave Buchanan, THANK YOU: Britton Caillouette, Conor Cronin, Brett "Mr. Brights" Davies, Dave Davies, Carla Ford, David Gilmour, Carmen Hogg, Chloe Keleny, Nicholai Lidow, Floris Loeff, Luke van der Merwe, Nik Strong-Cvetich, Calvin Thompson